Tattoo
COLOURING BOOK

CATO JUKES

Copyright © 2016 CATO JUKES
All rights reserved.
ISBN-10: 1539915662
ISBN-13: 978-1539915669

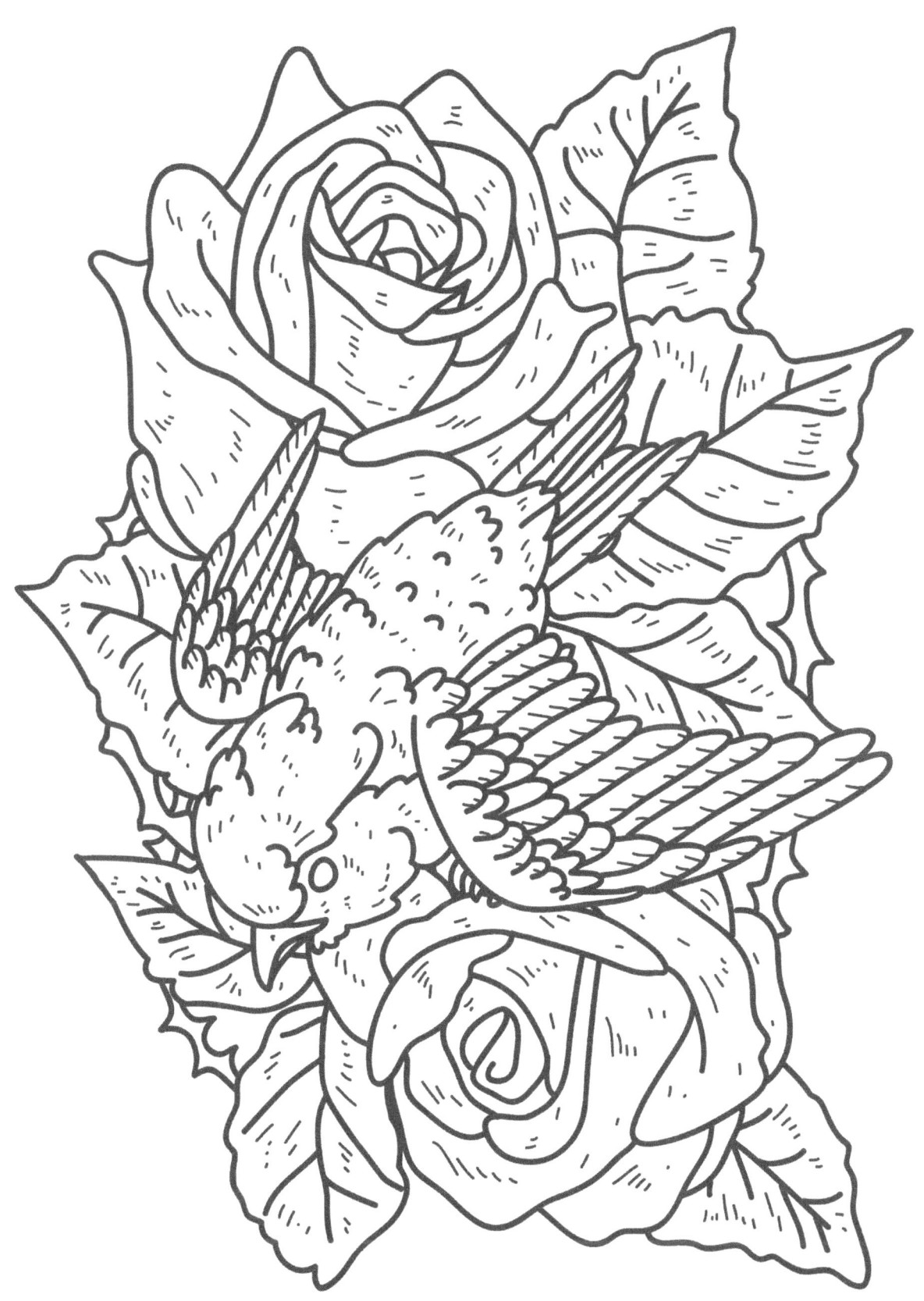

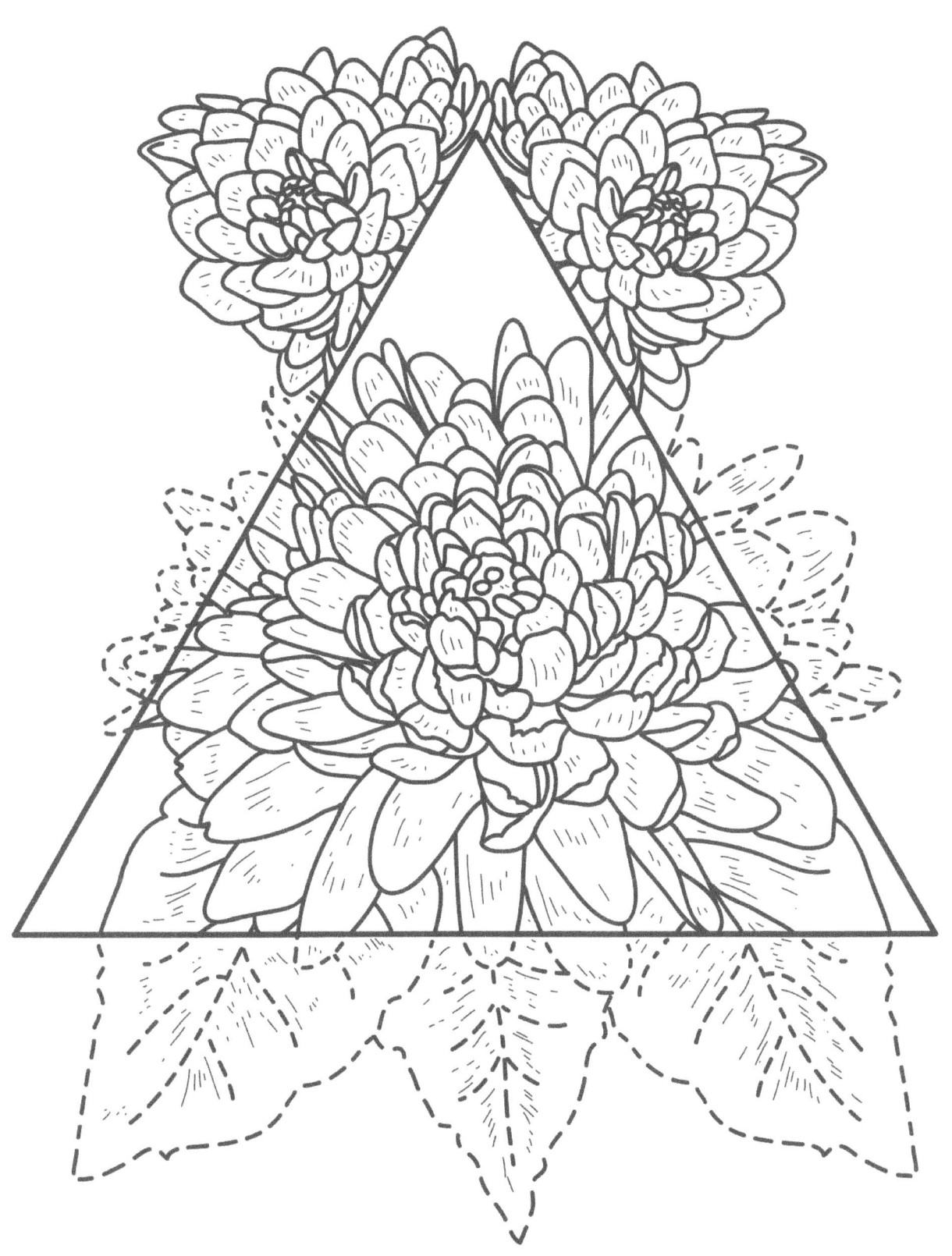

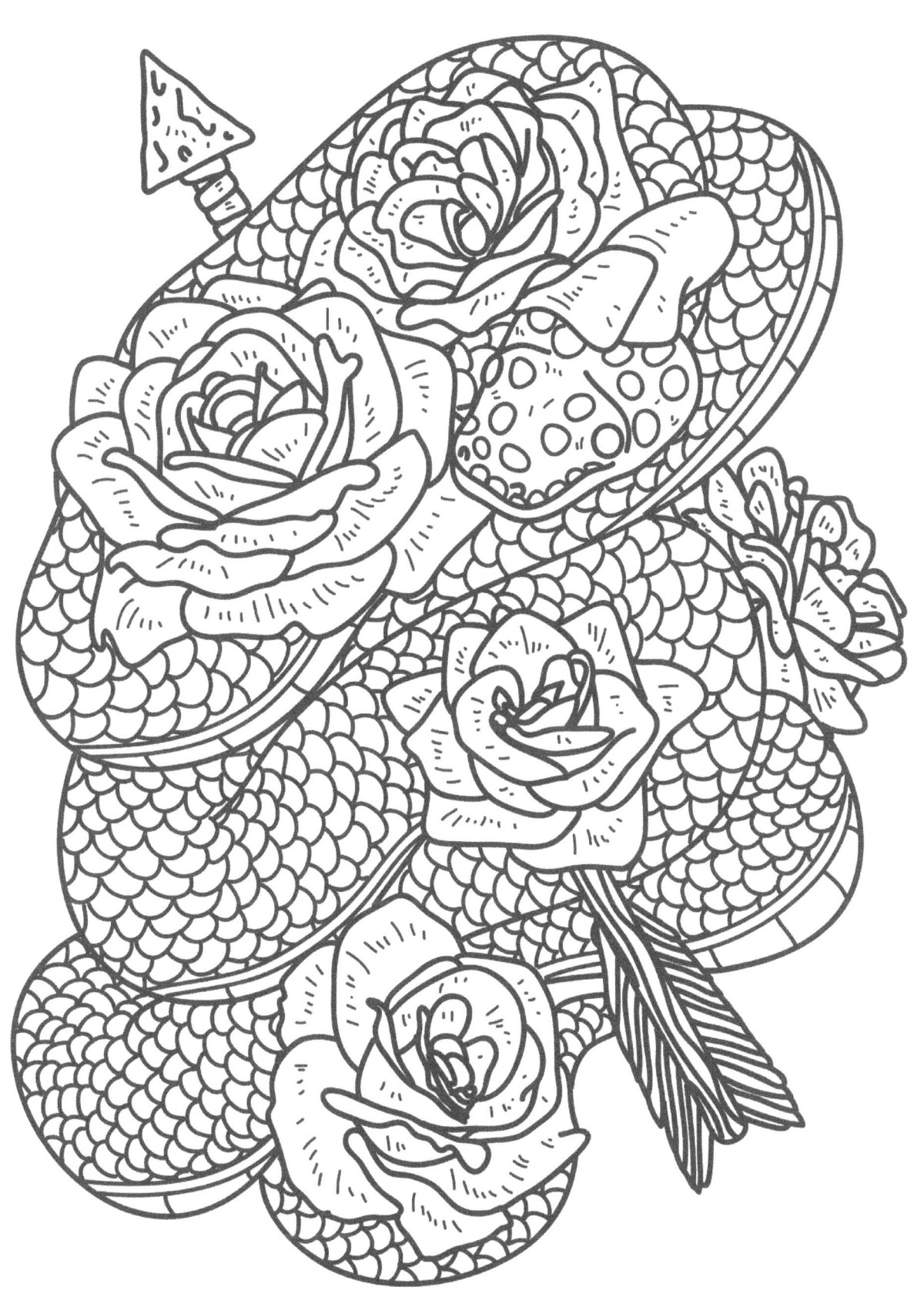

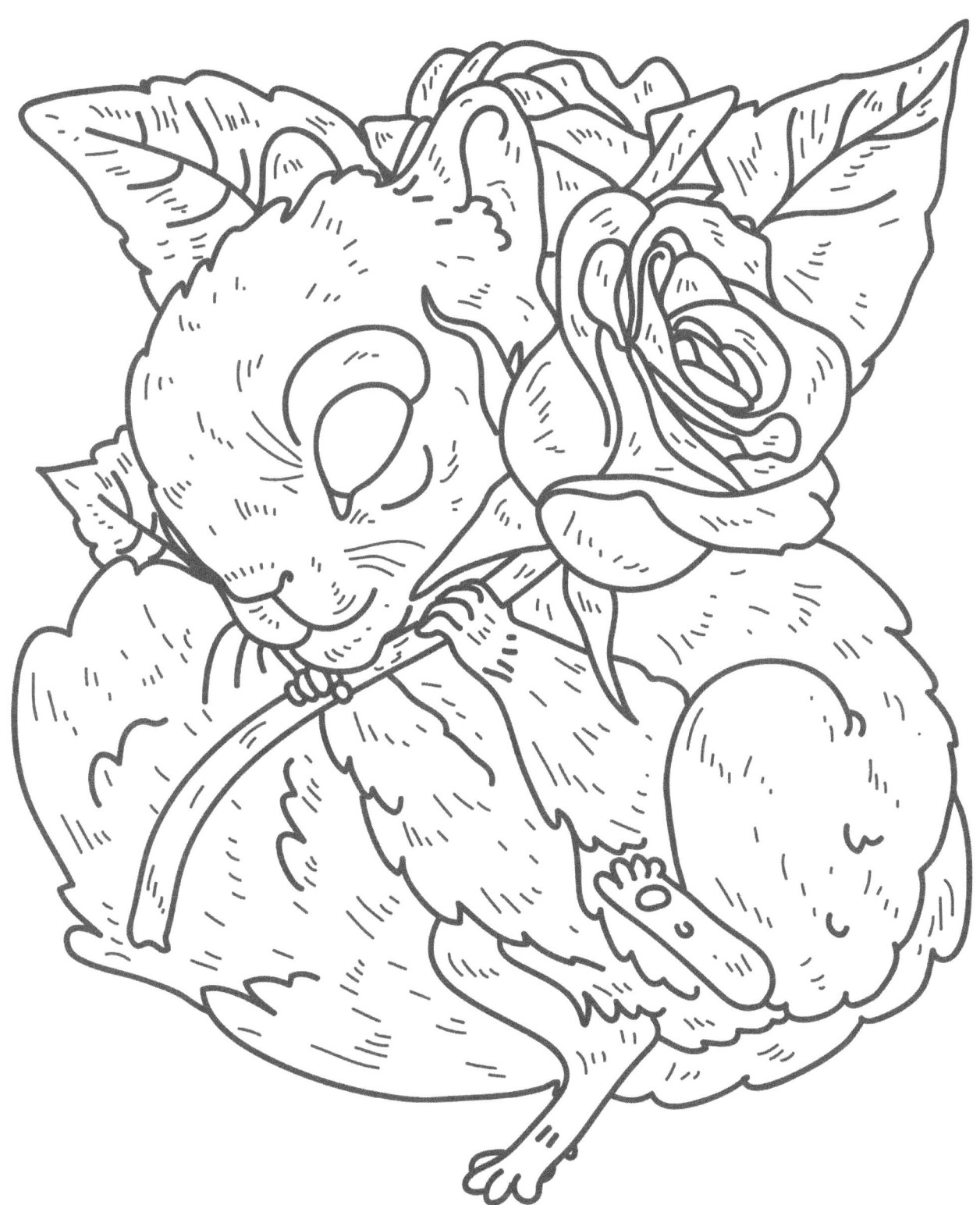

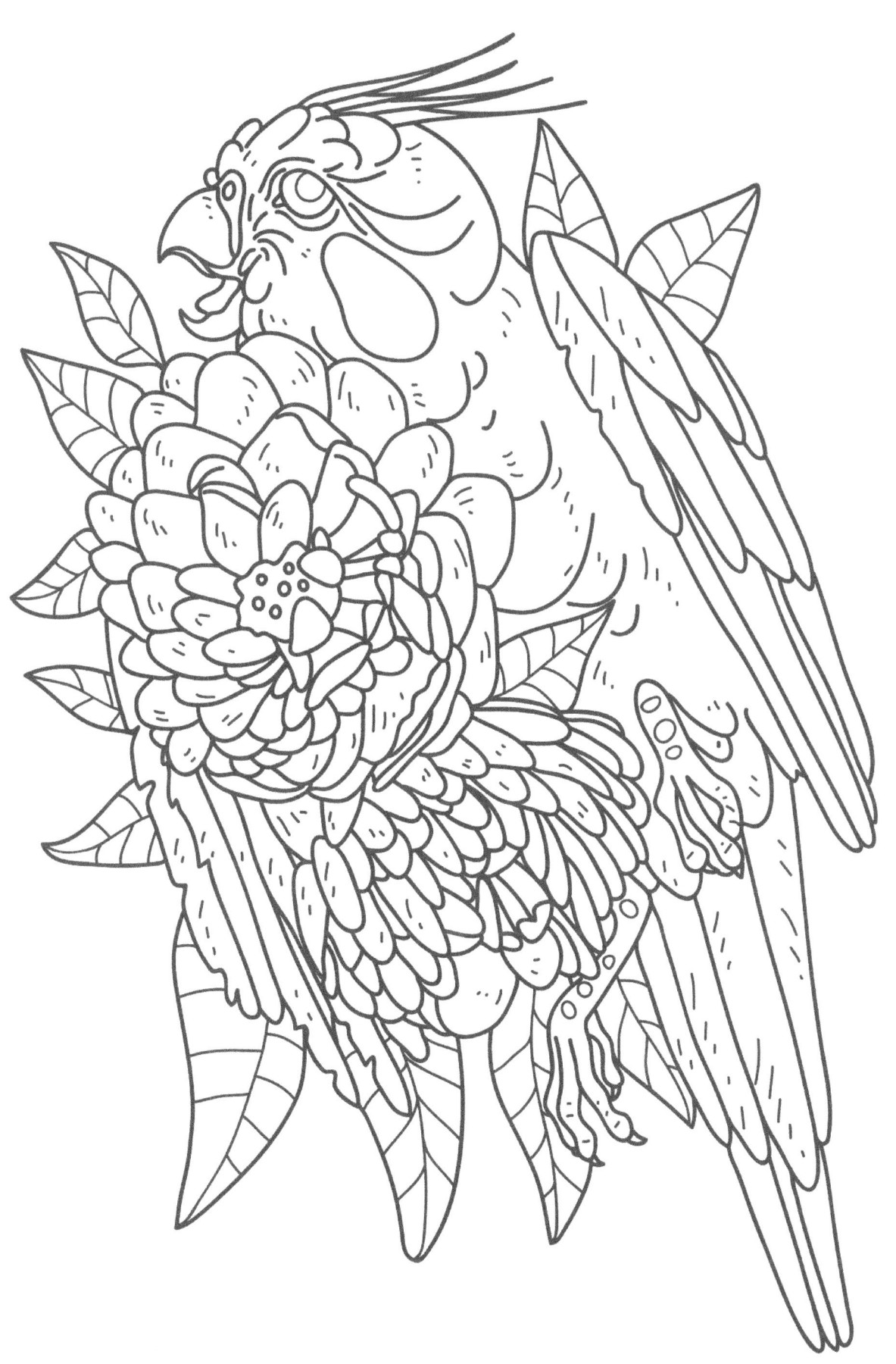

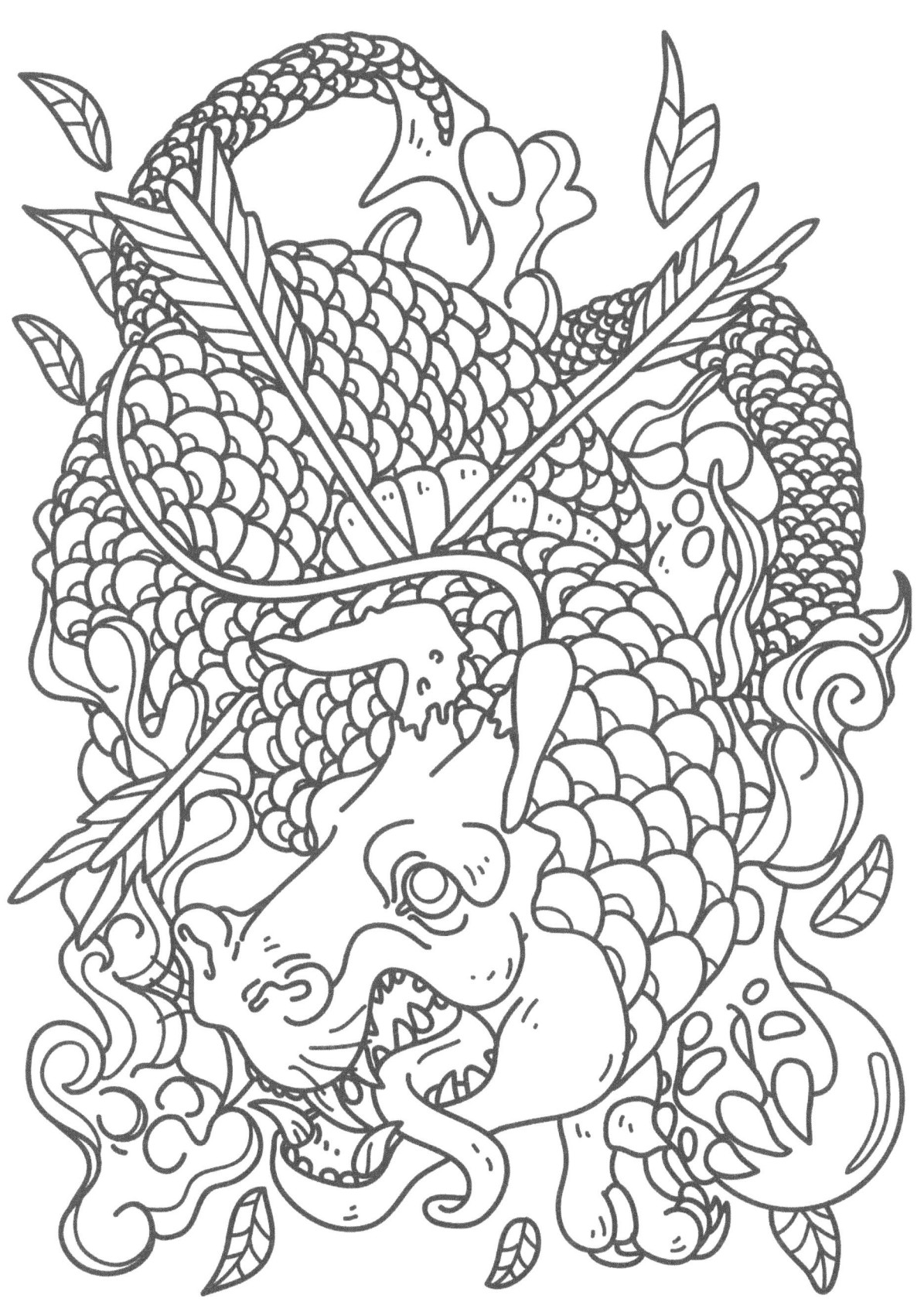

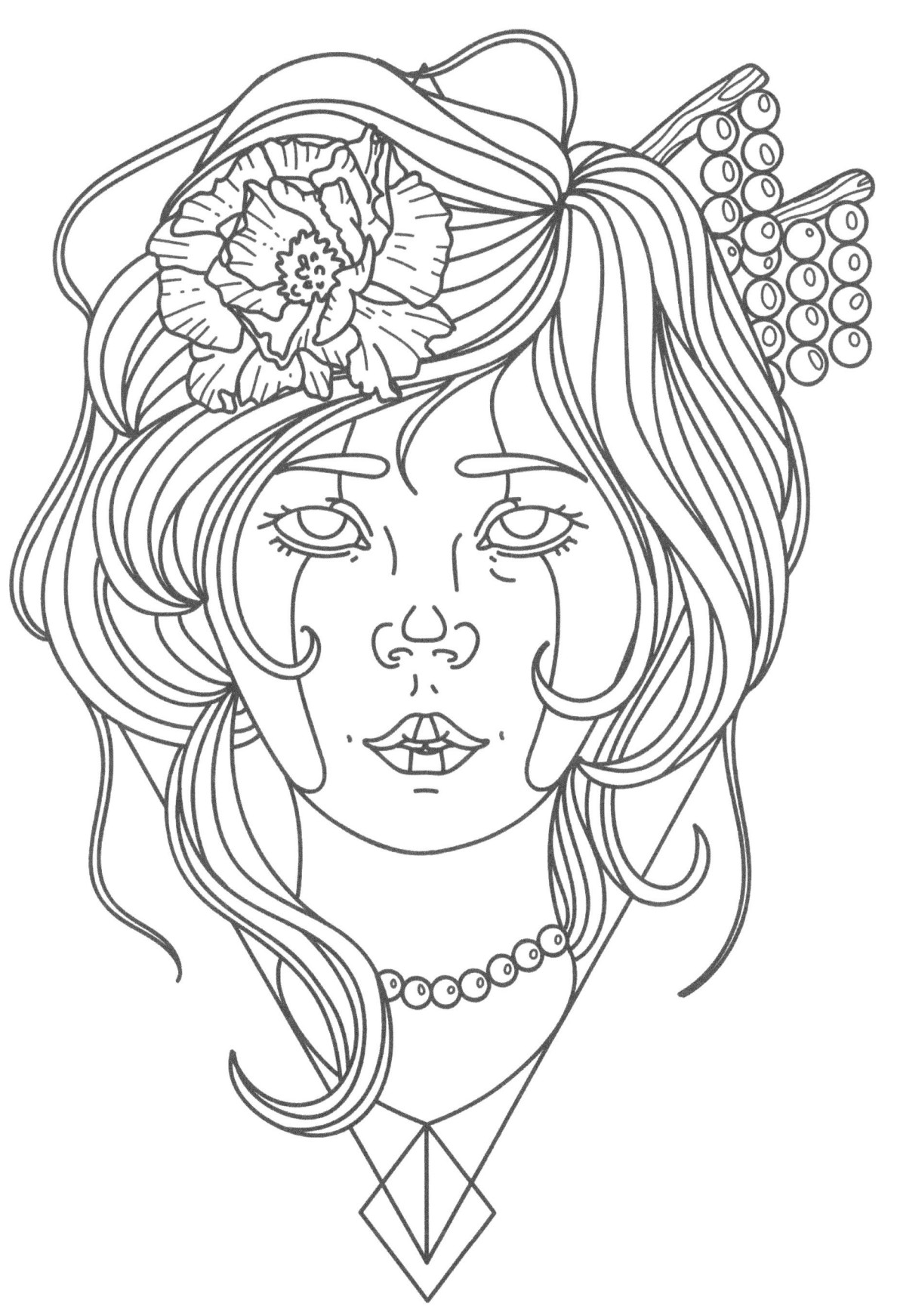

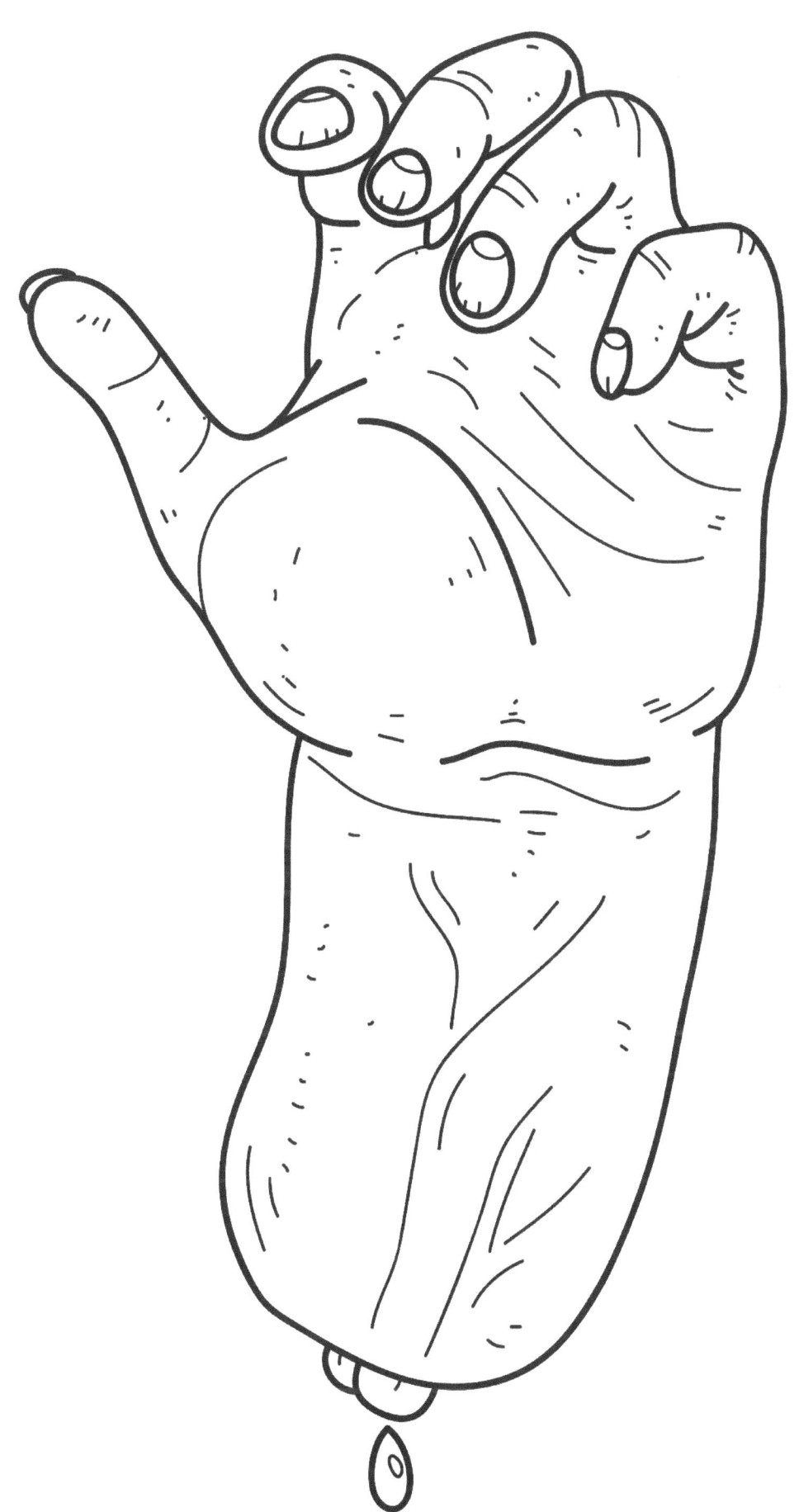

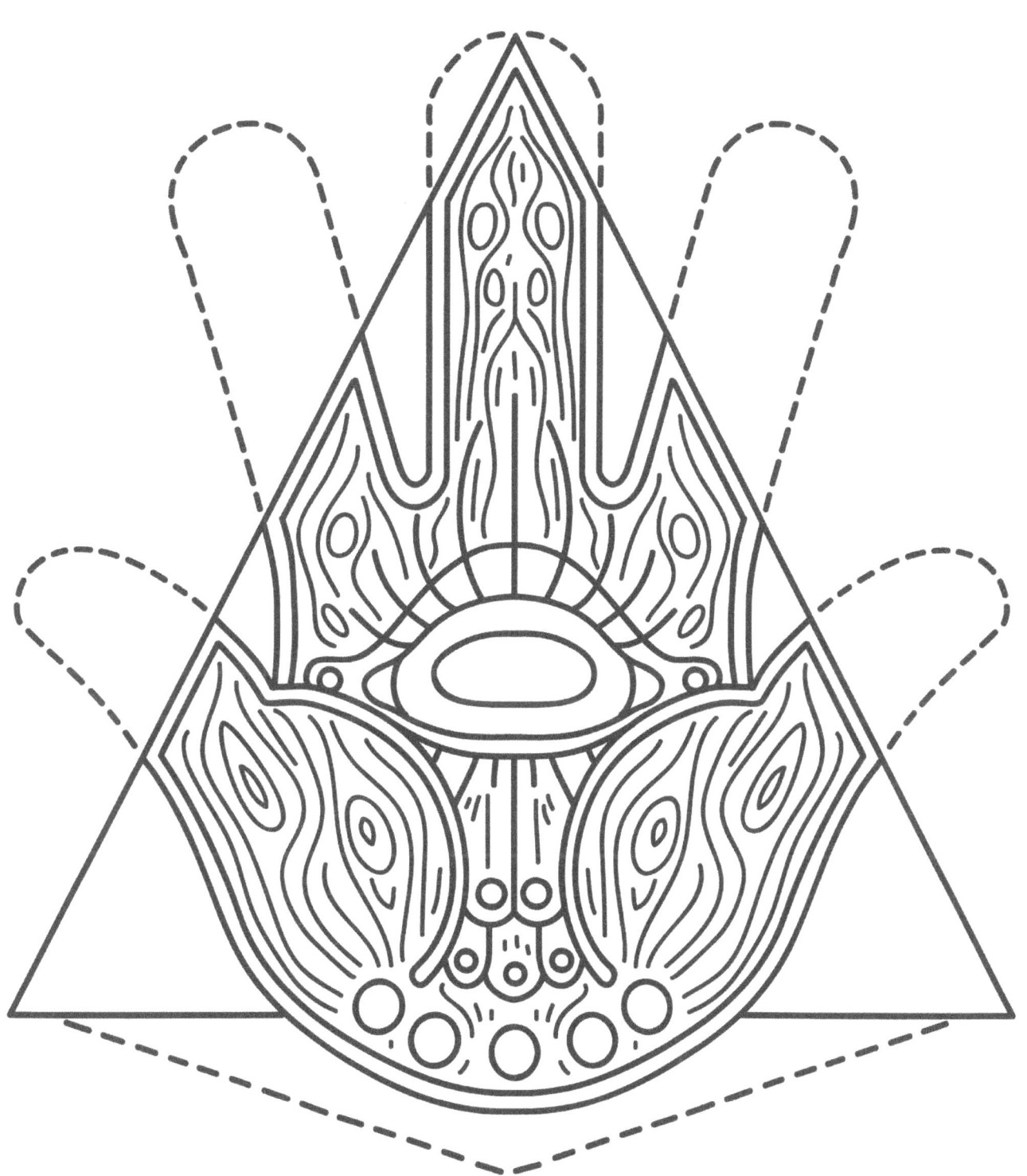

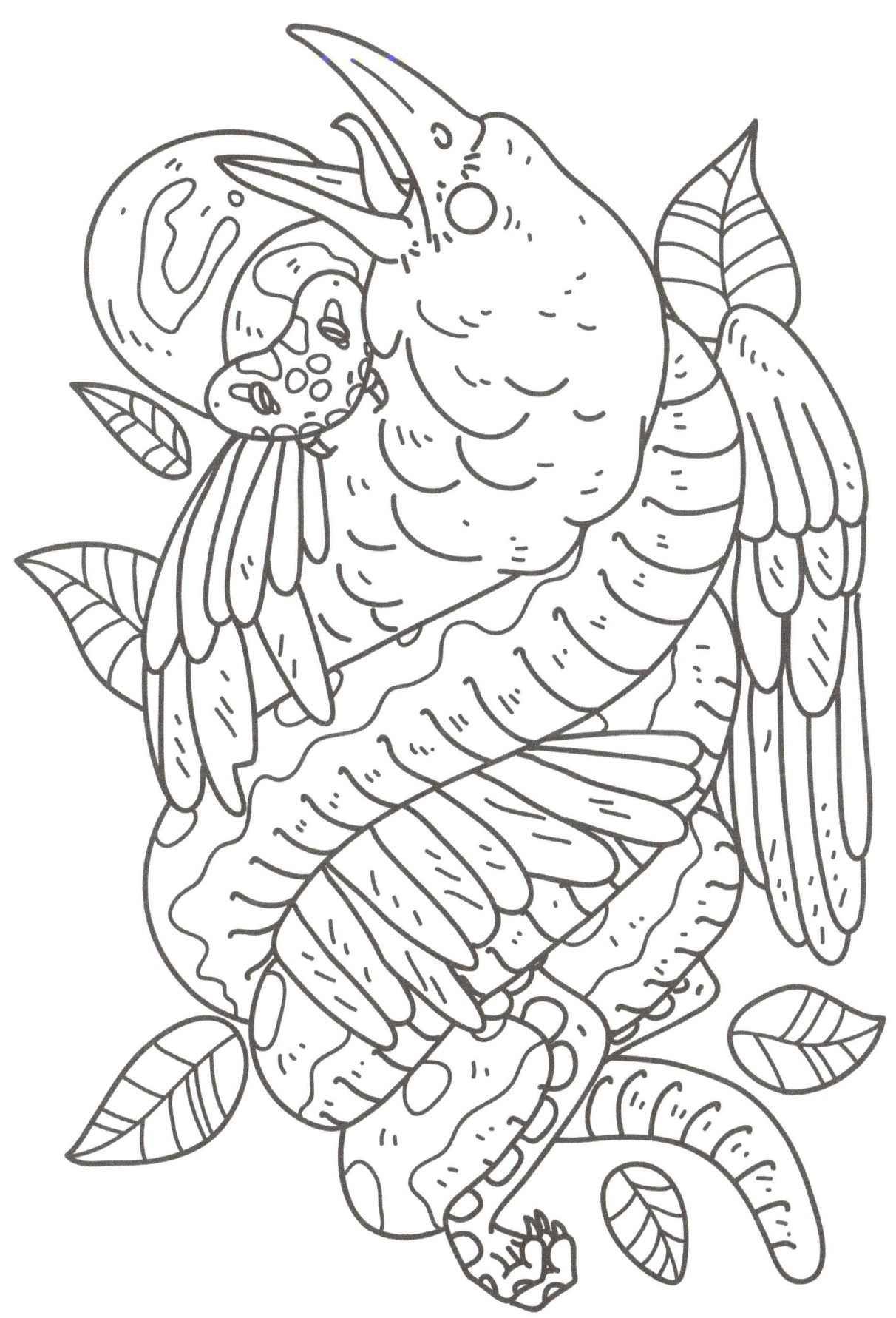

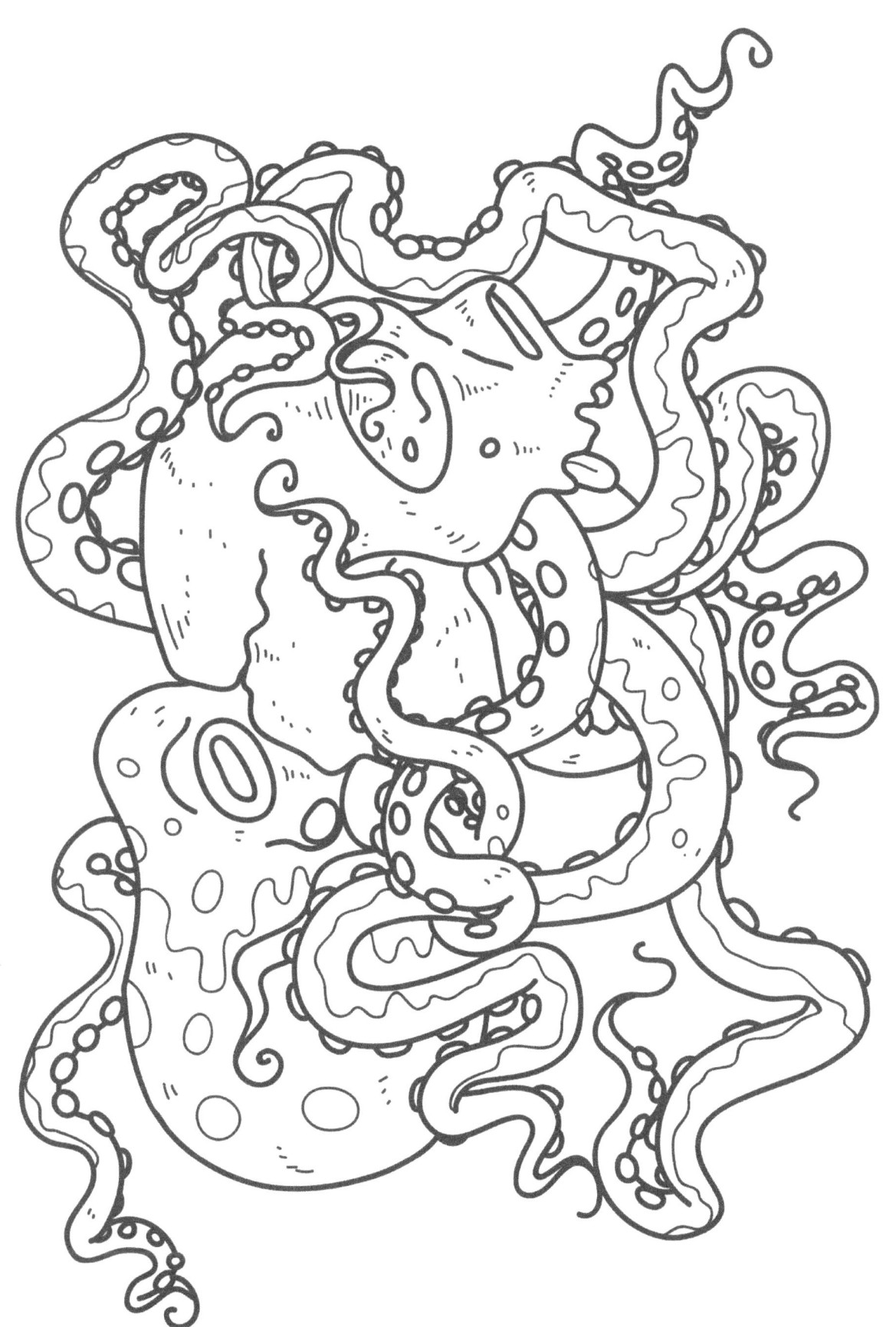

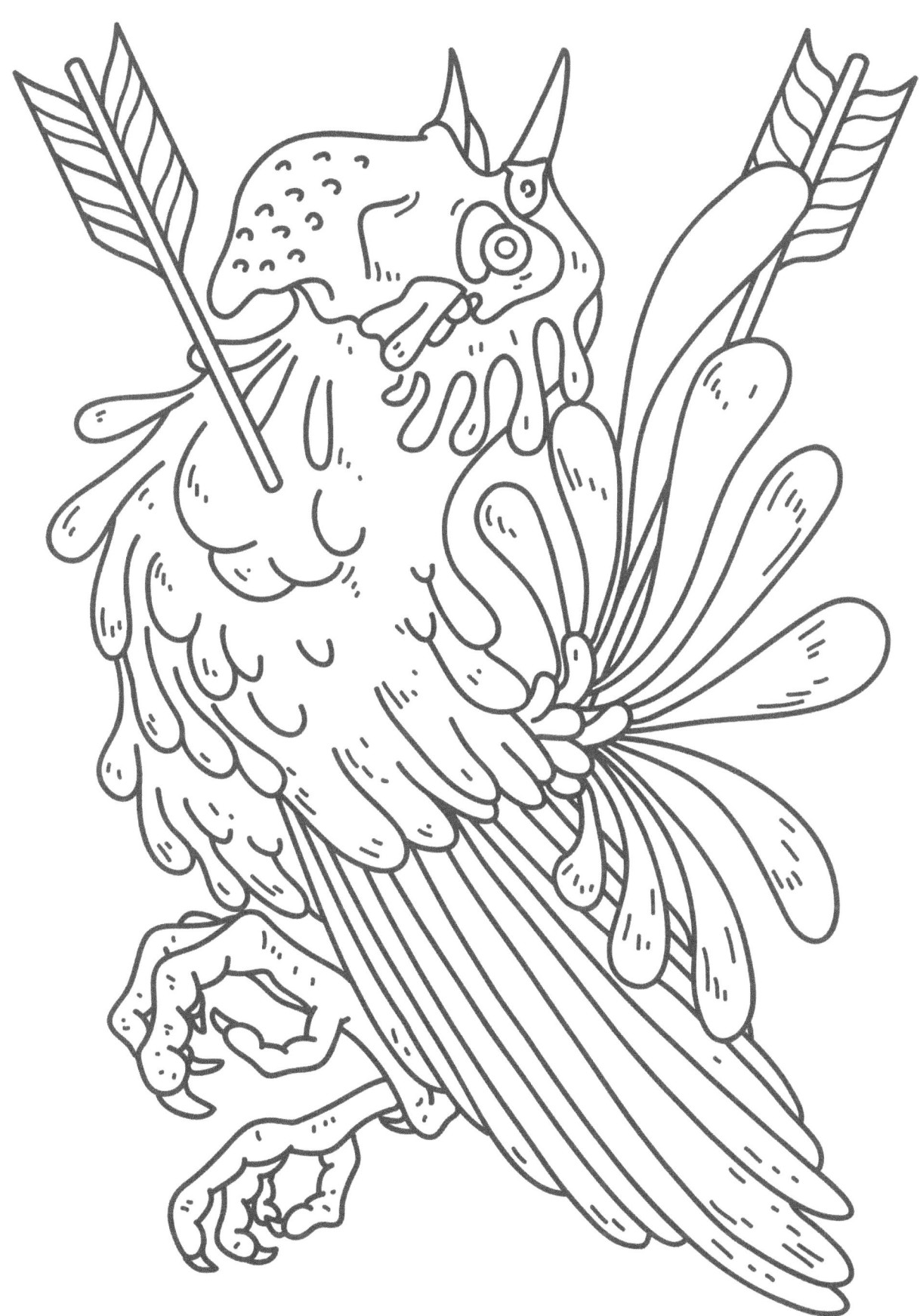

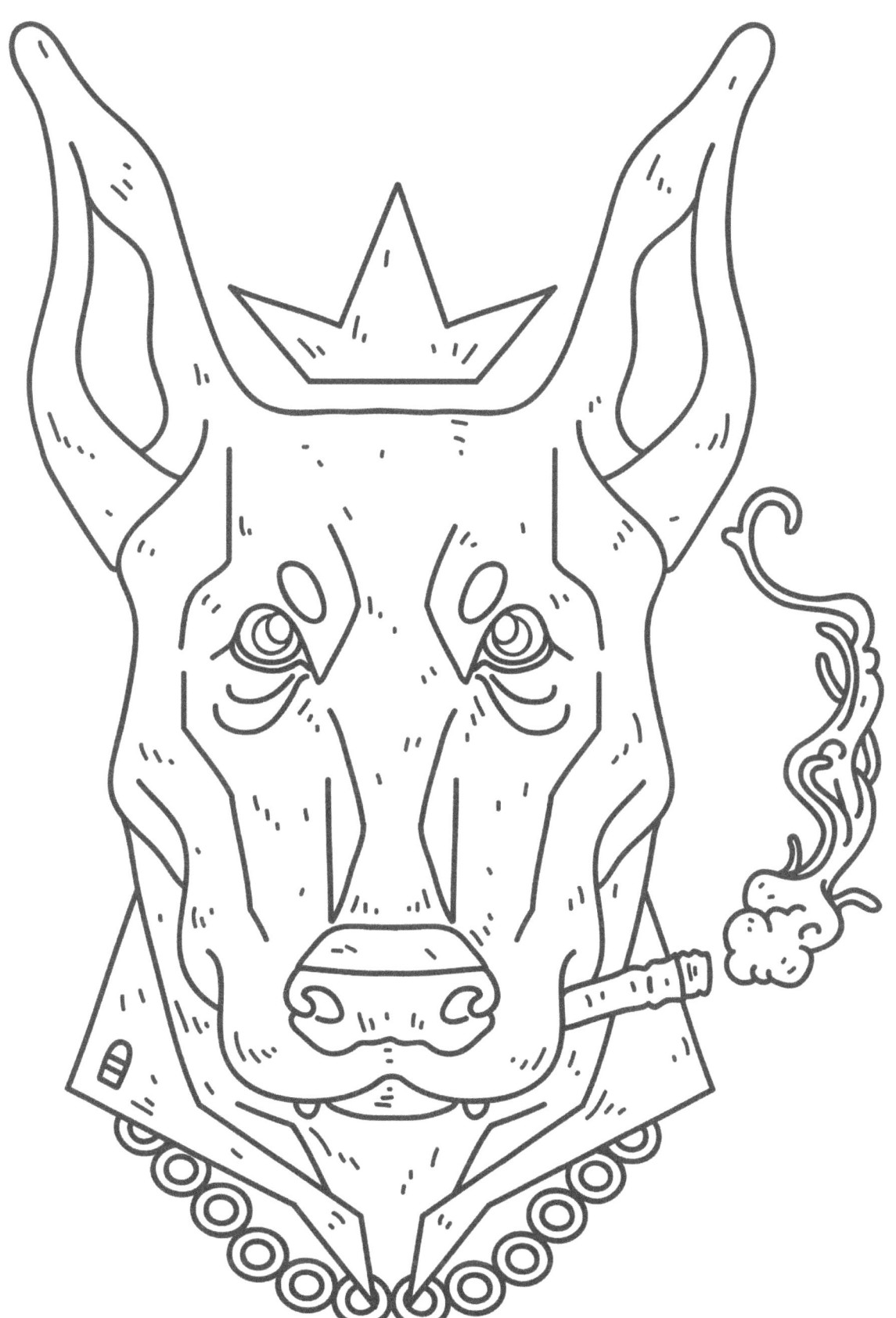

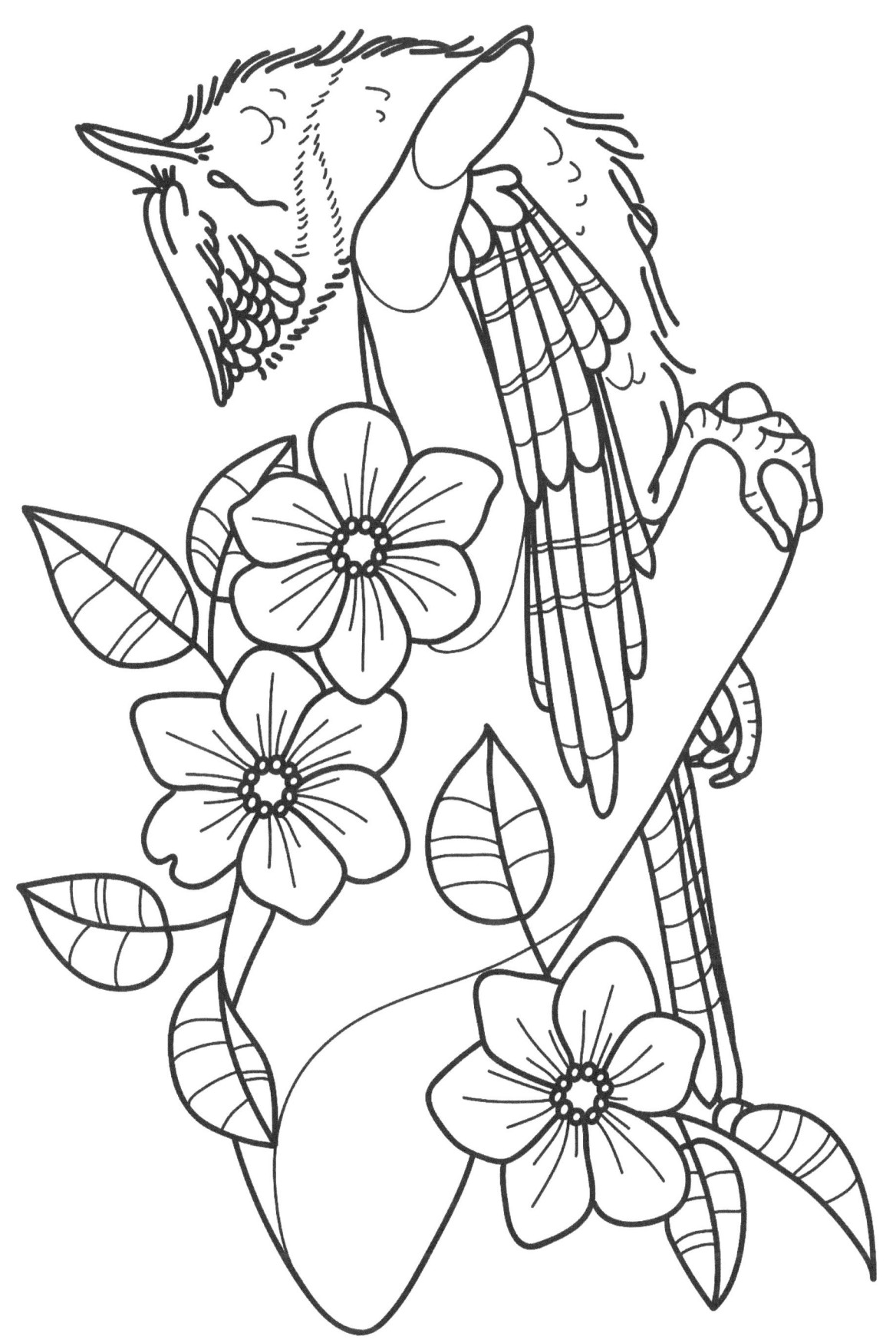

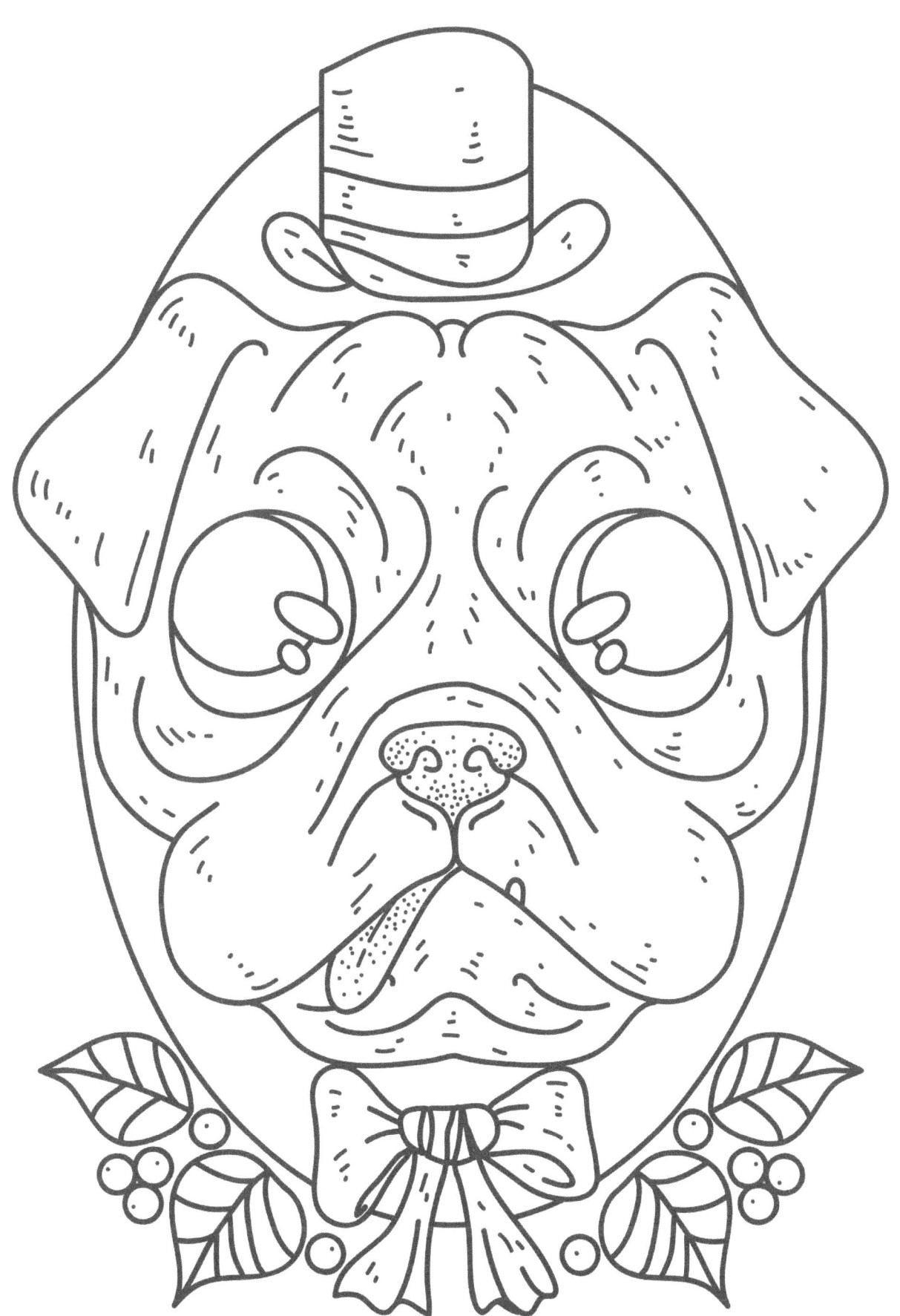

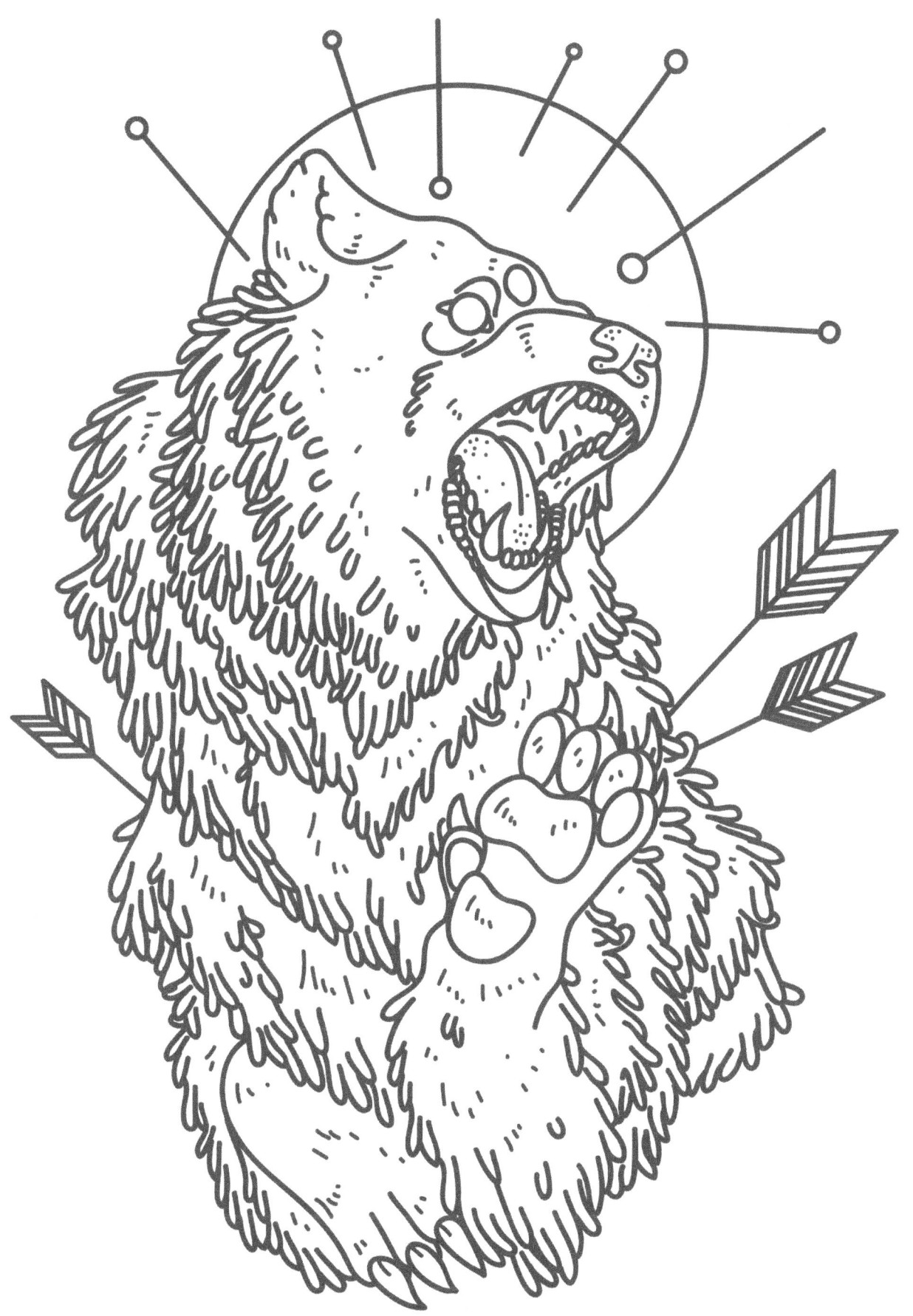

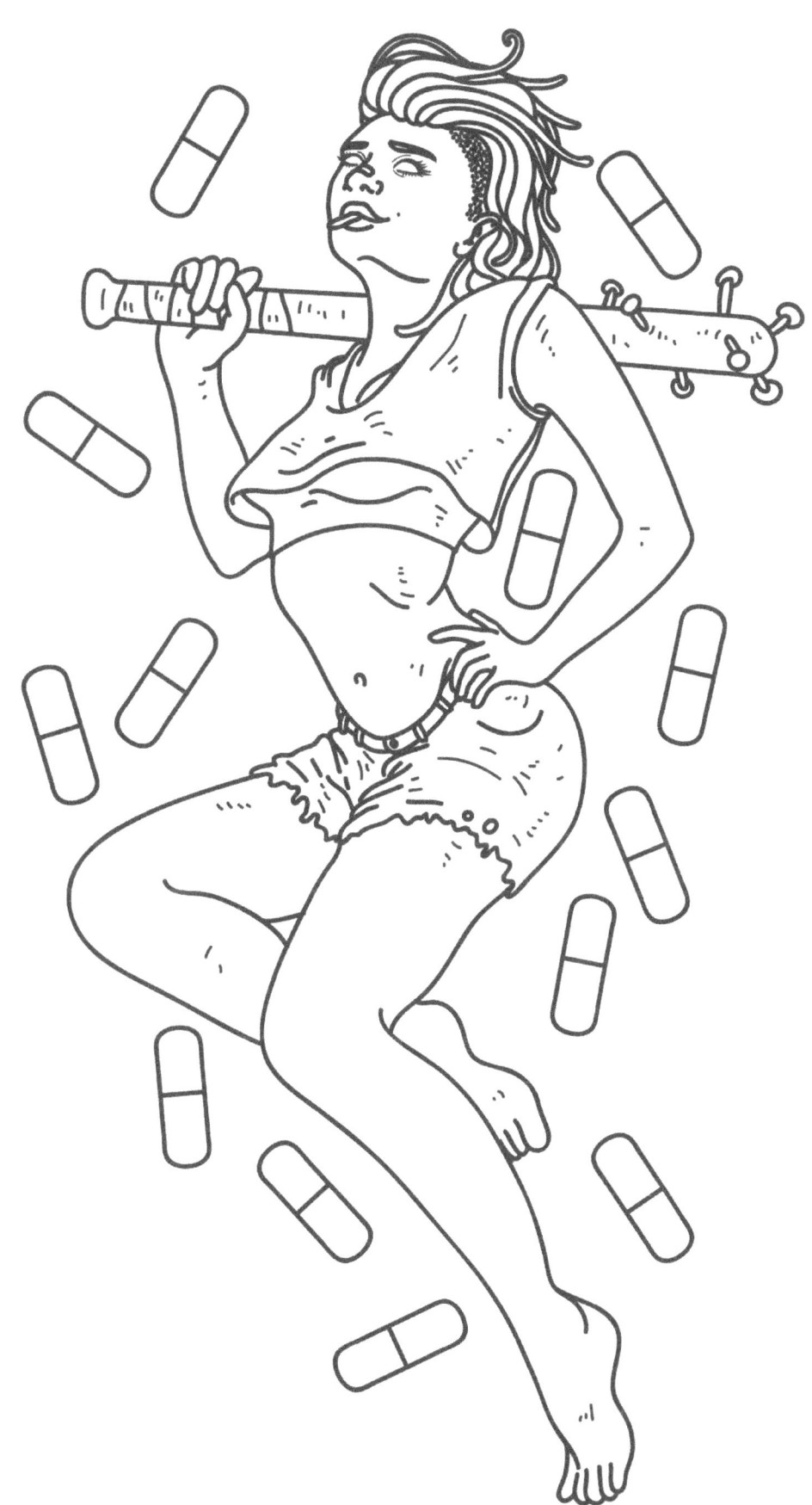

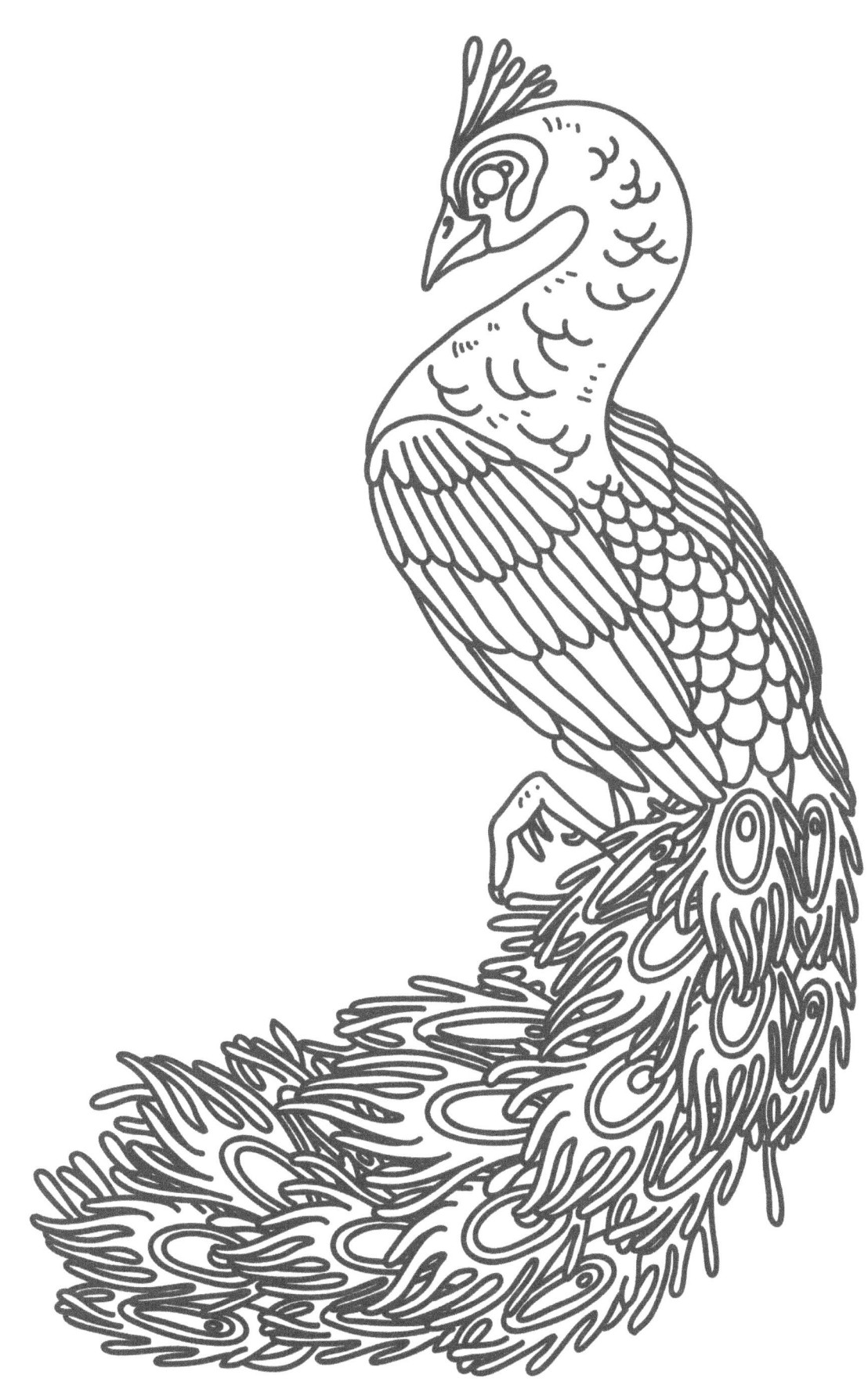

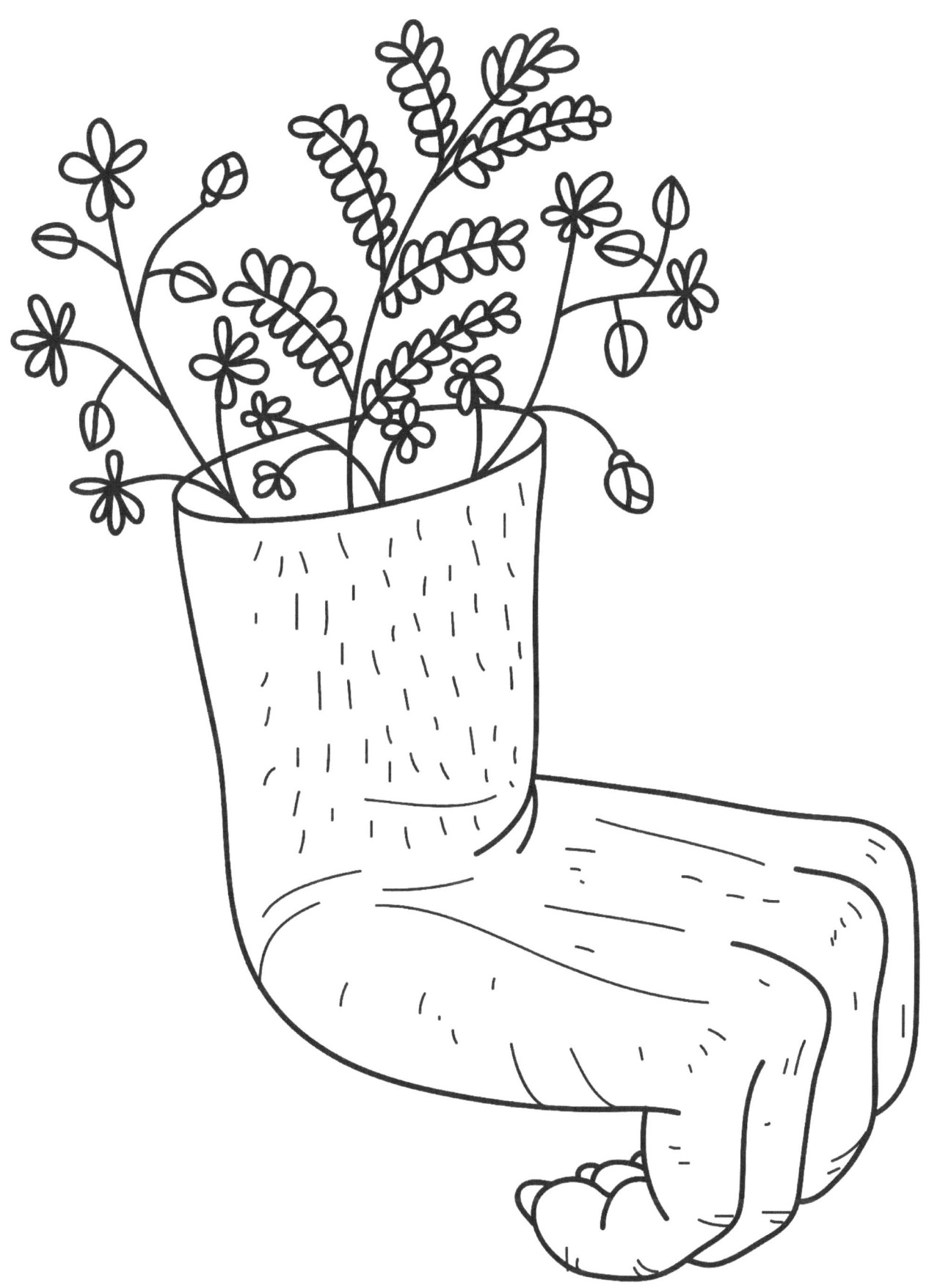

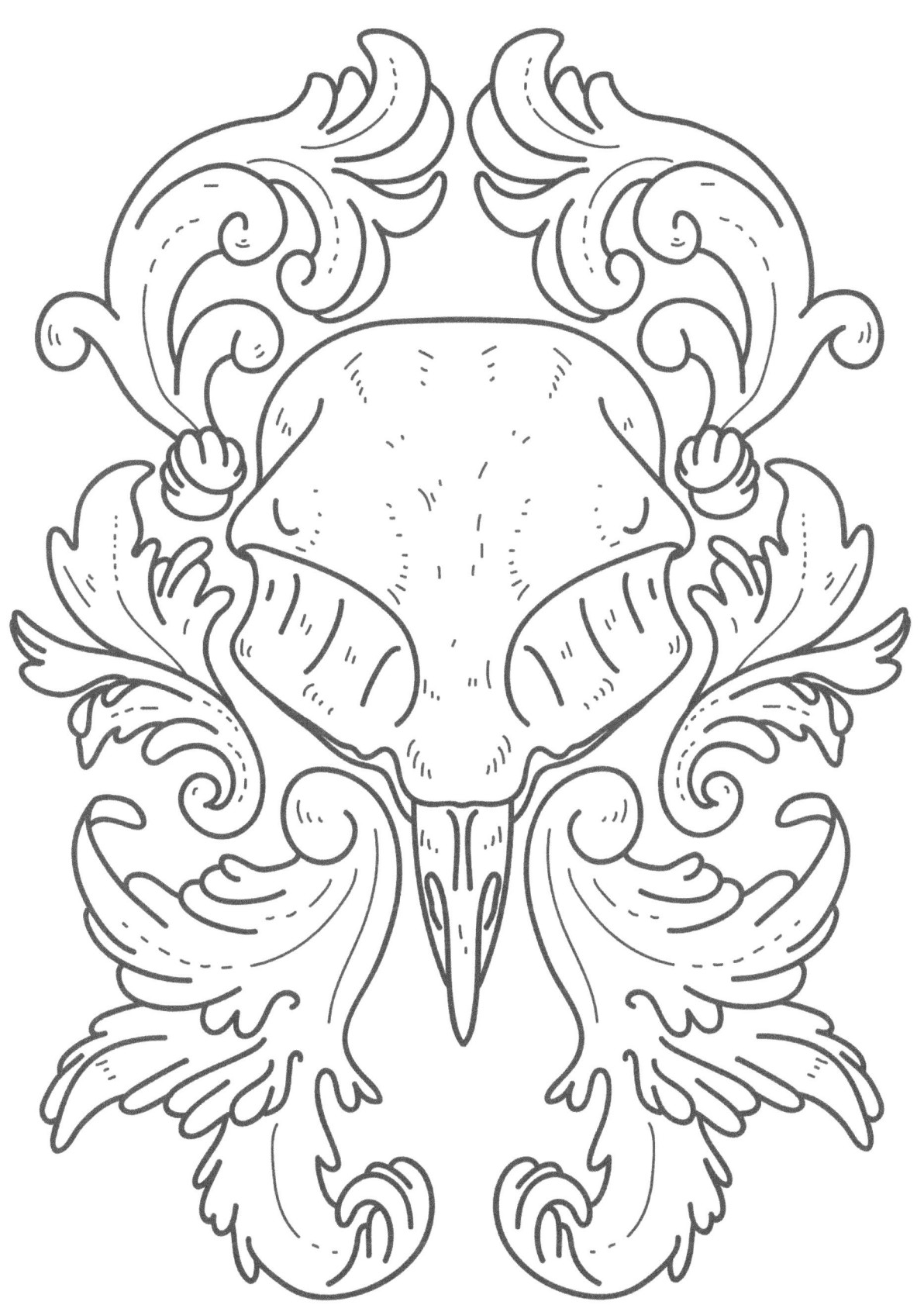

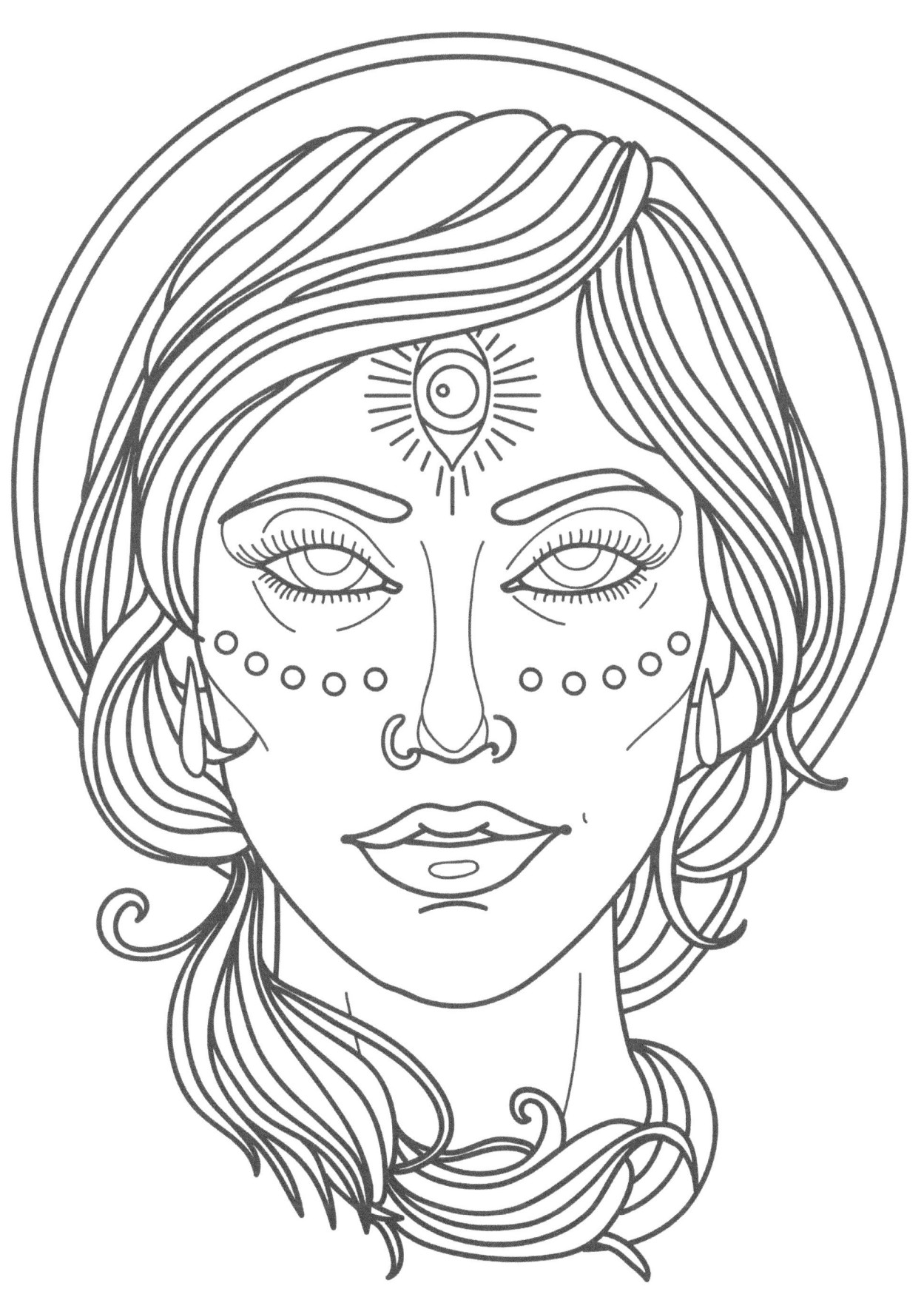

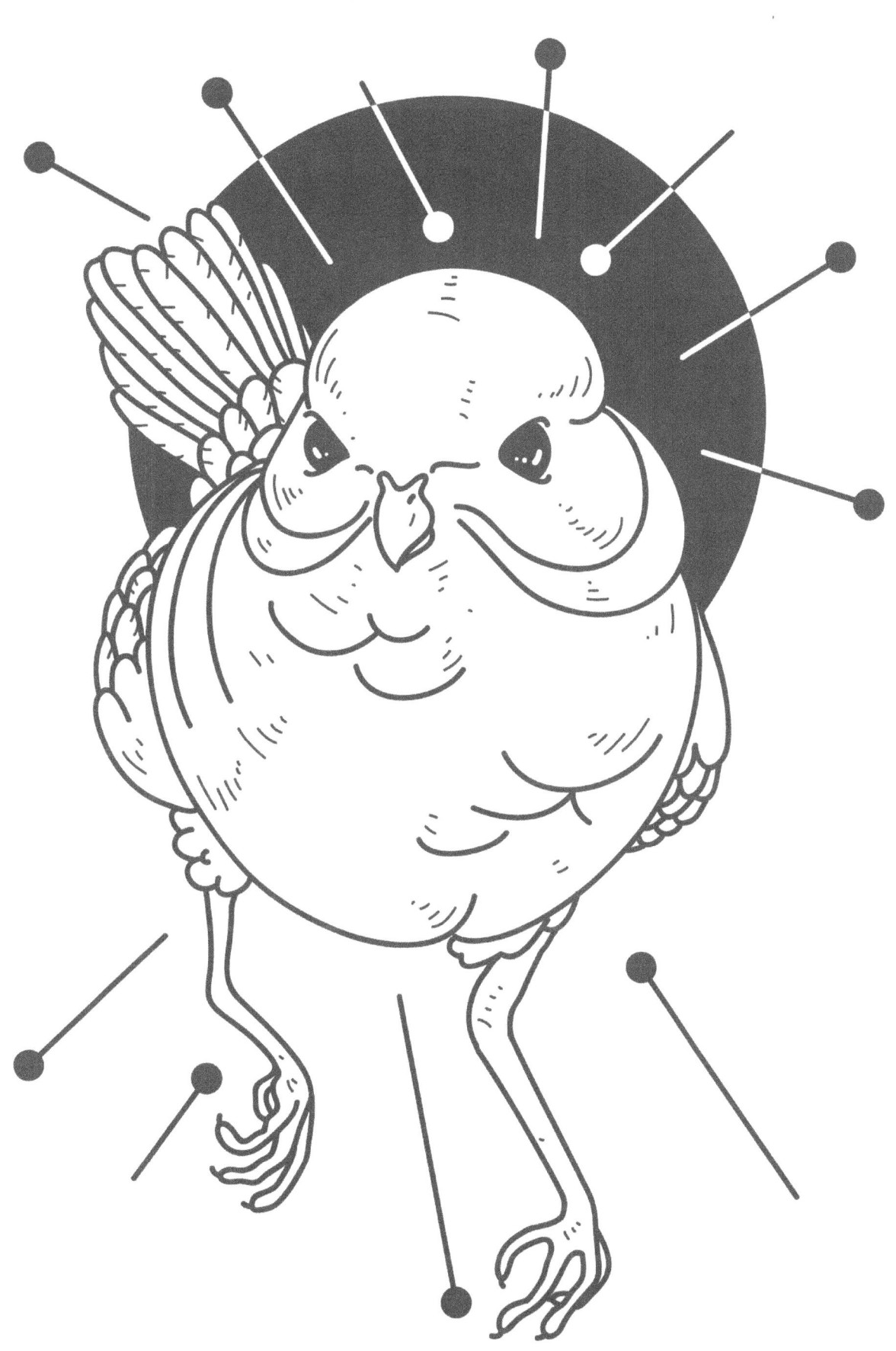

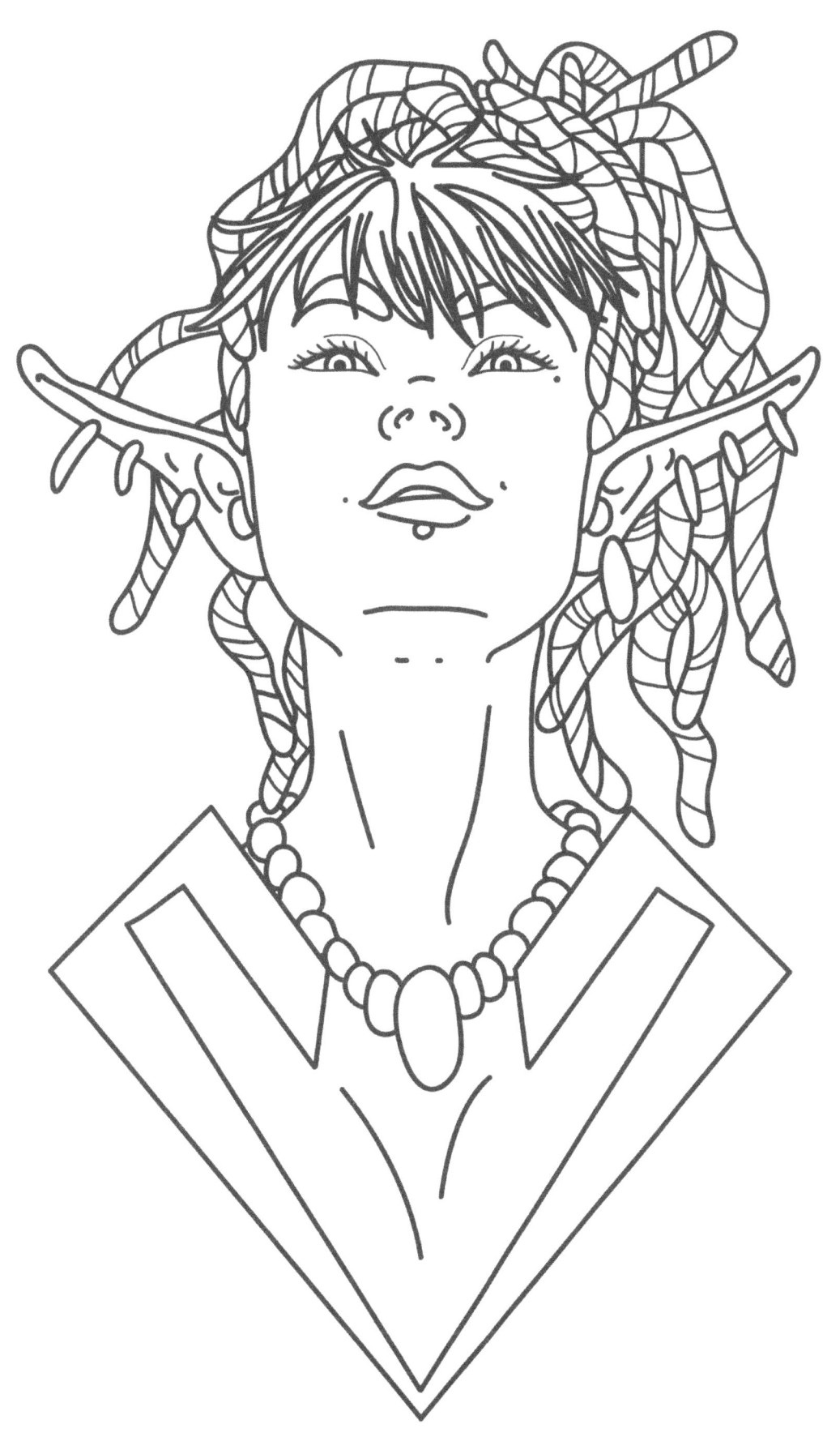

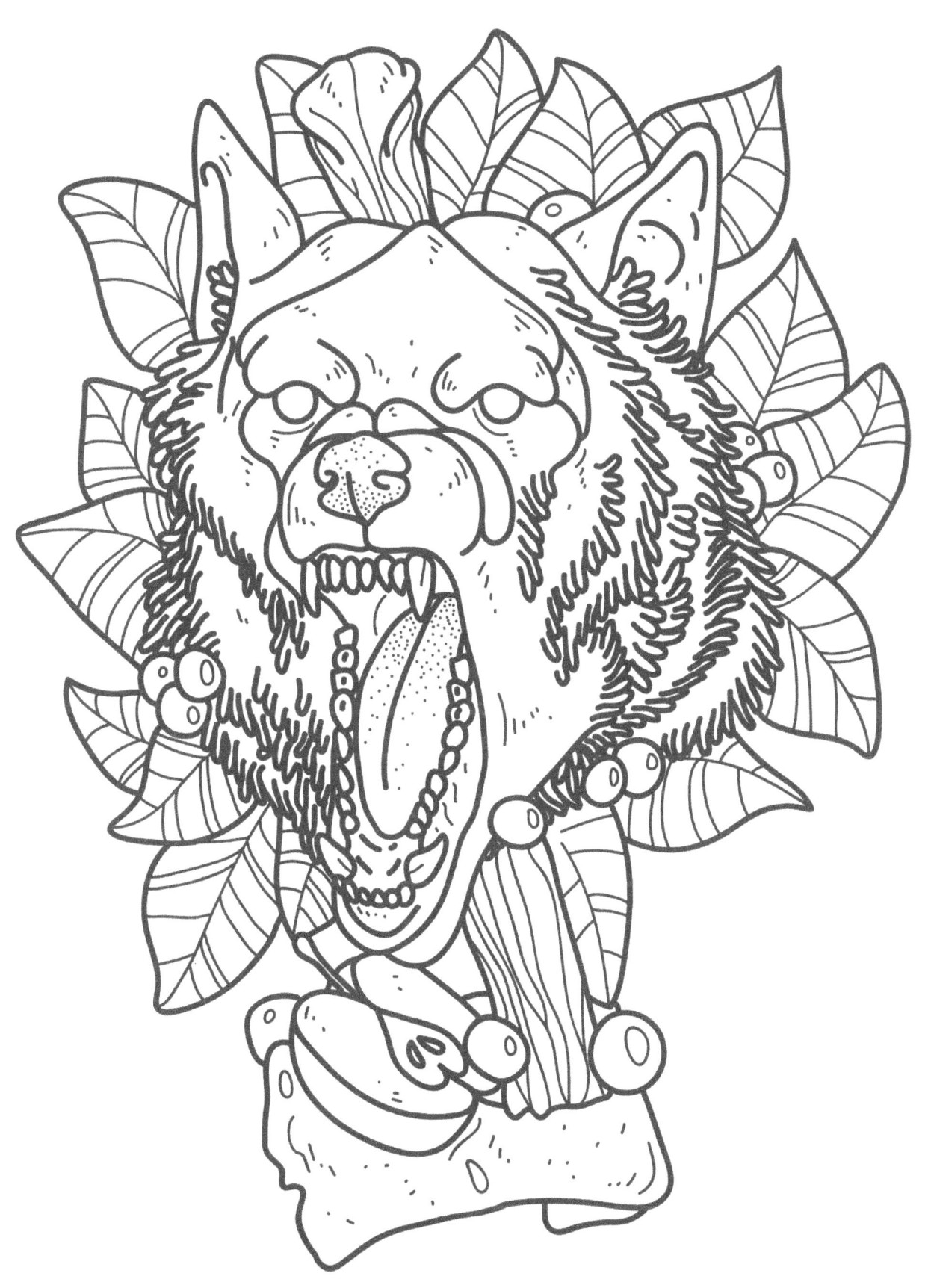

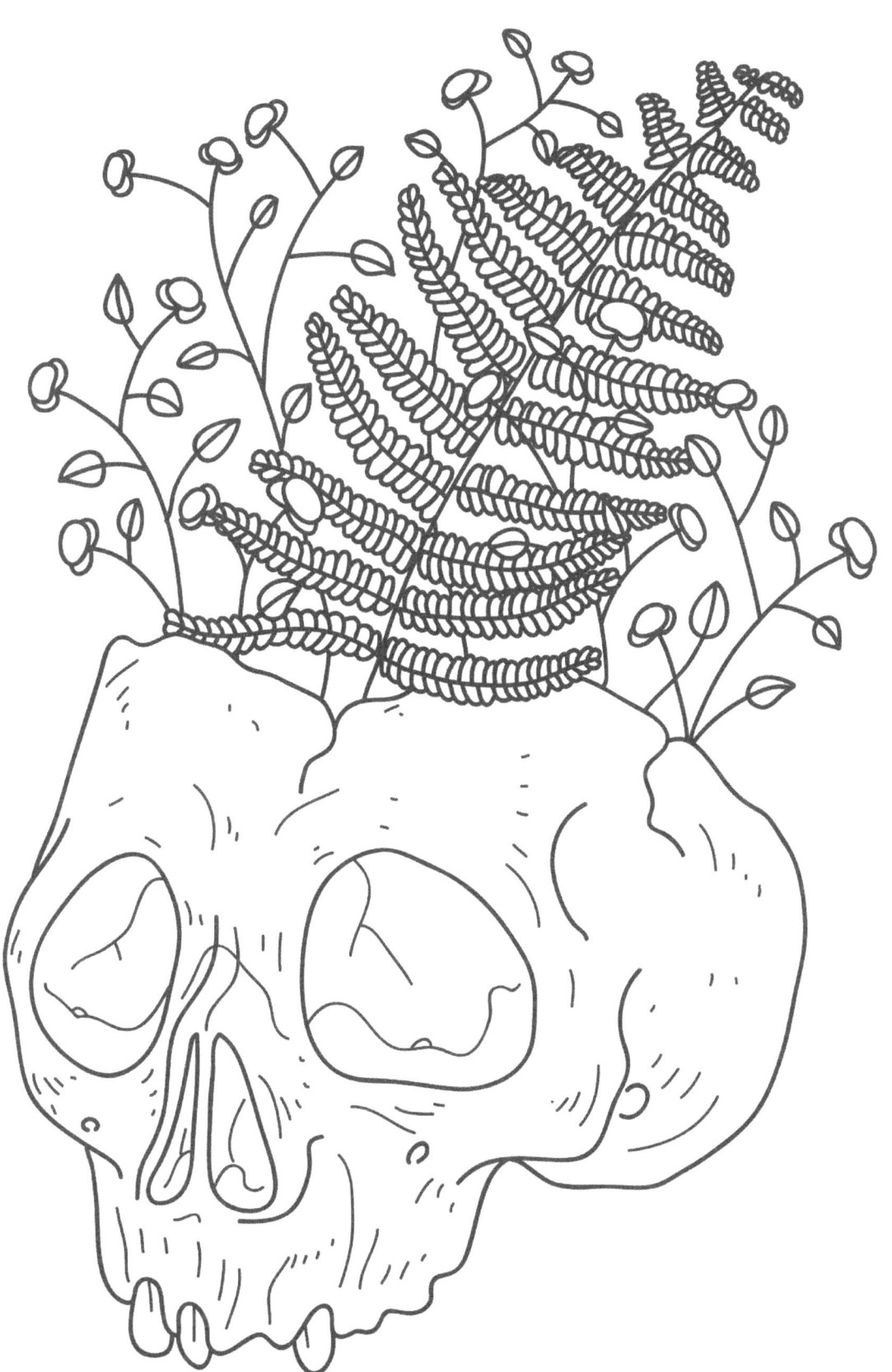

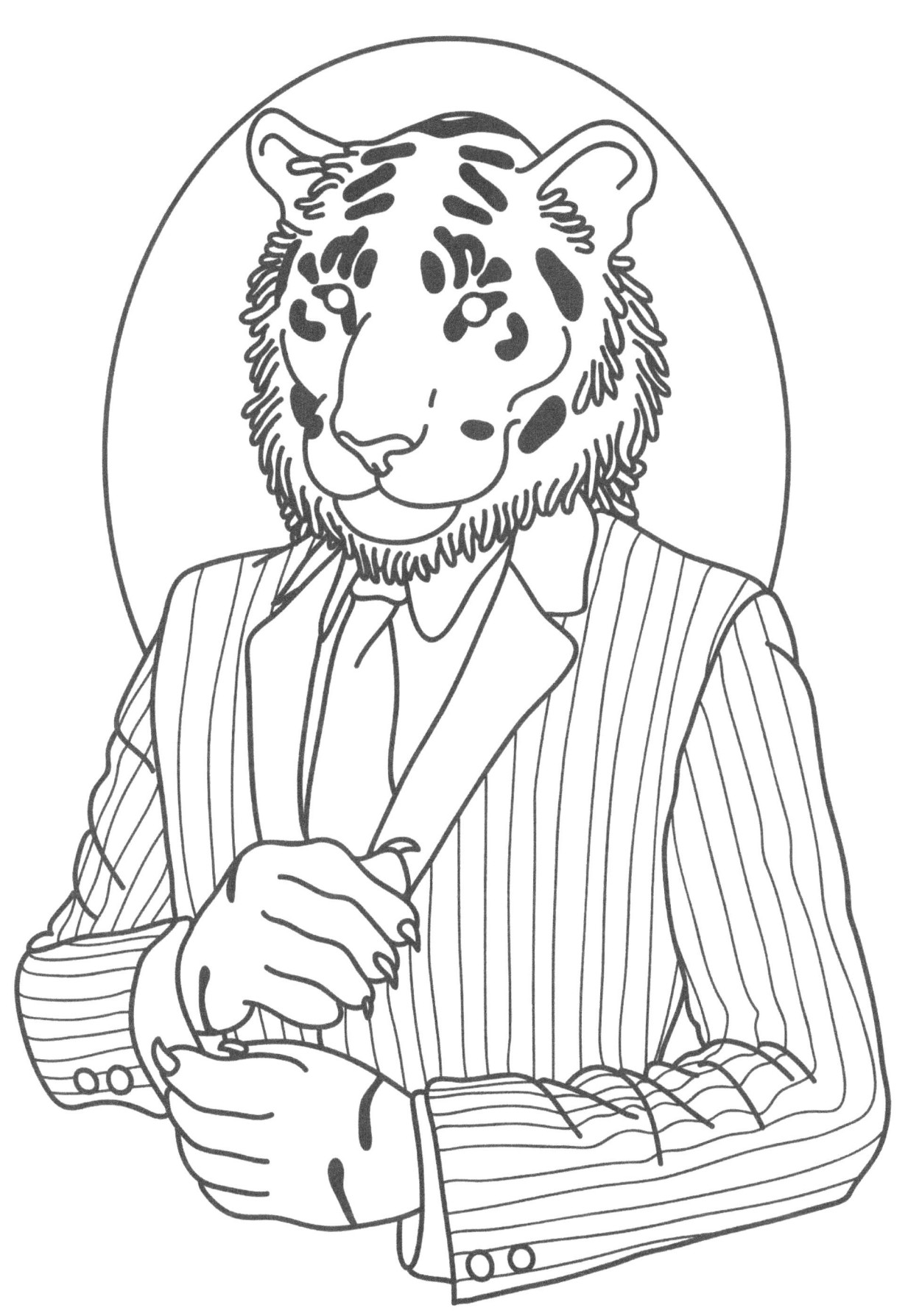

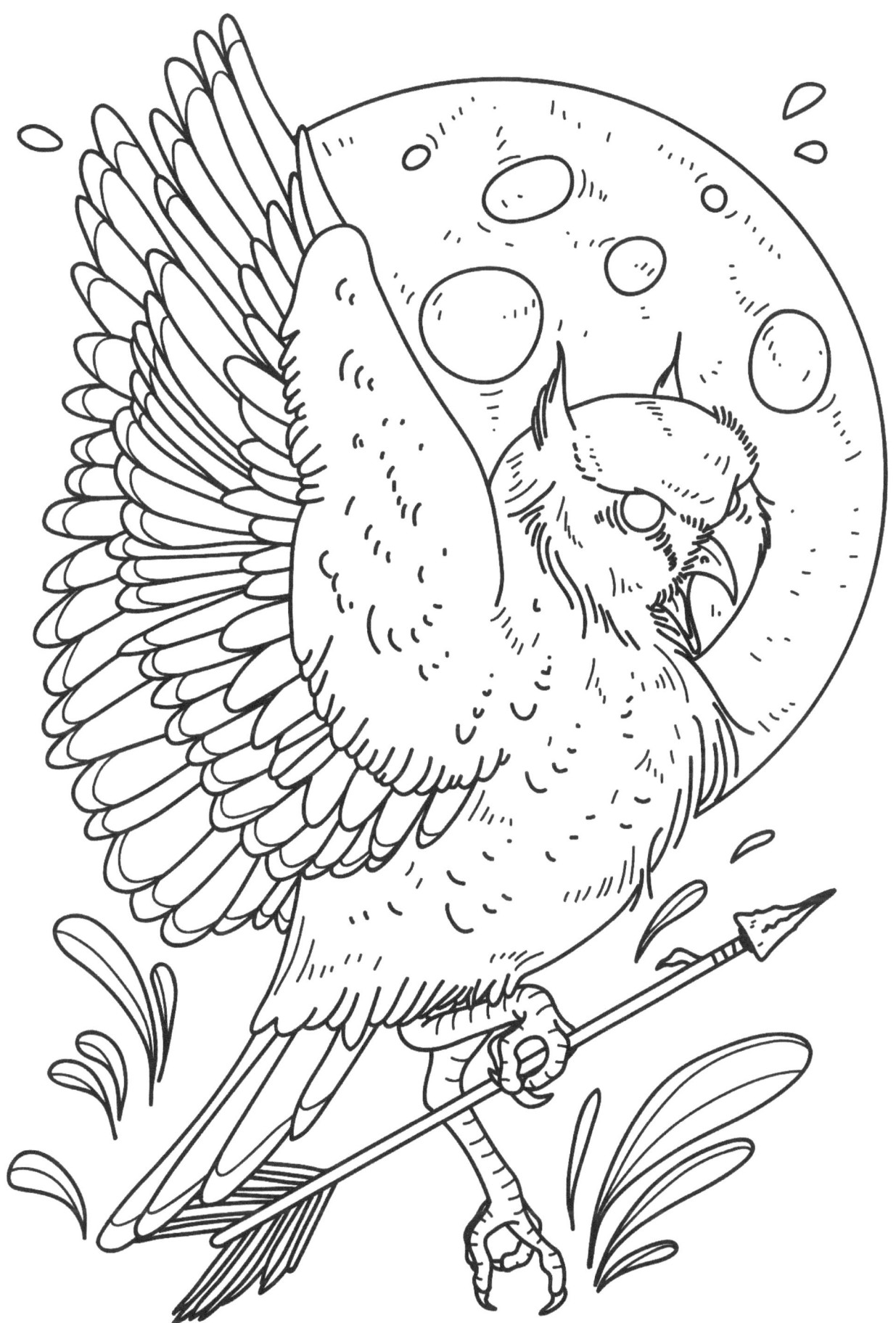

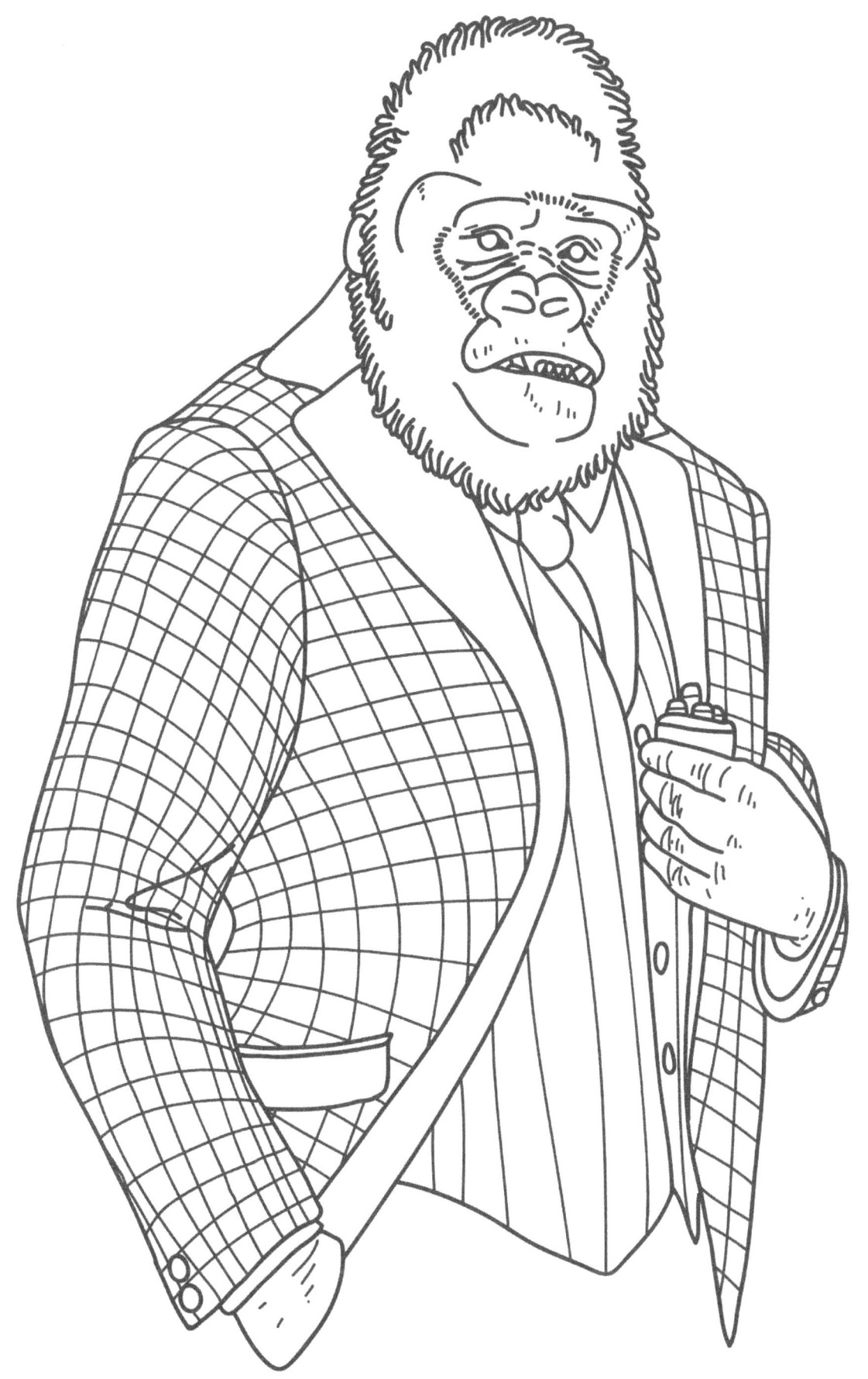

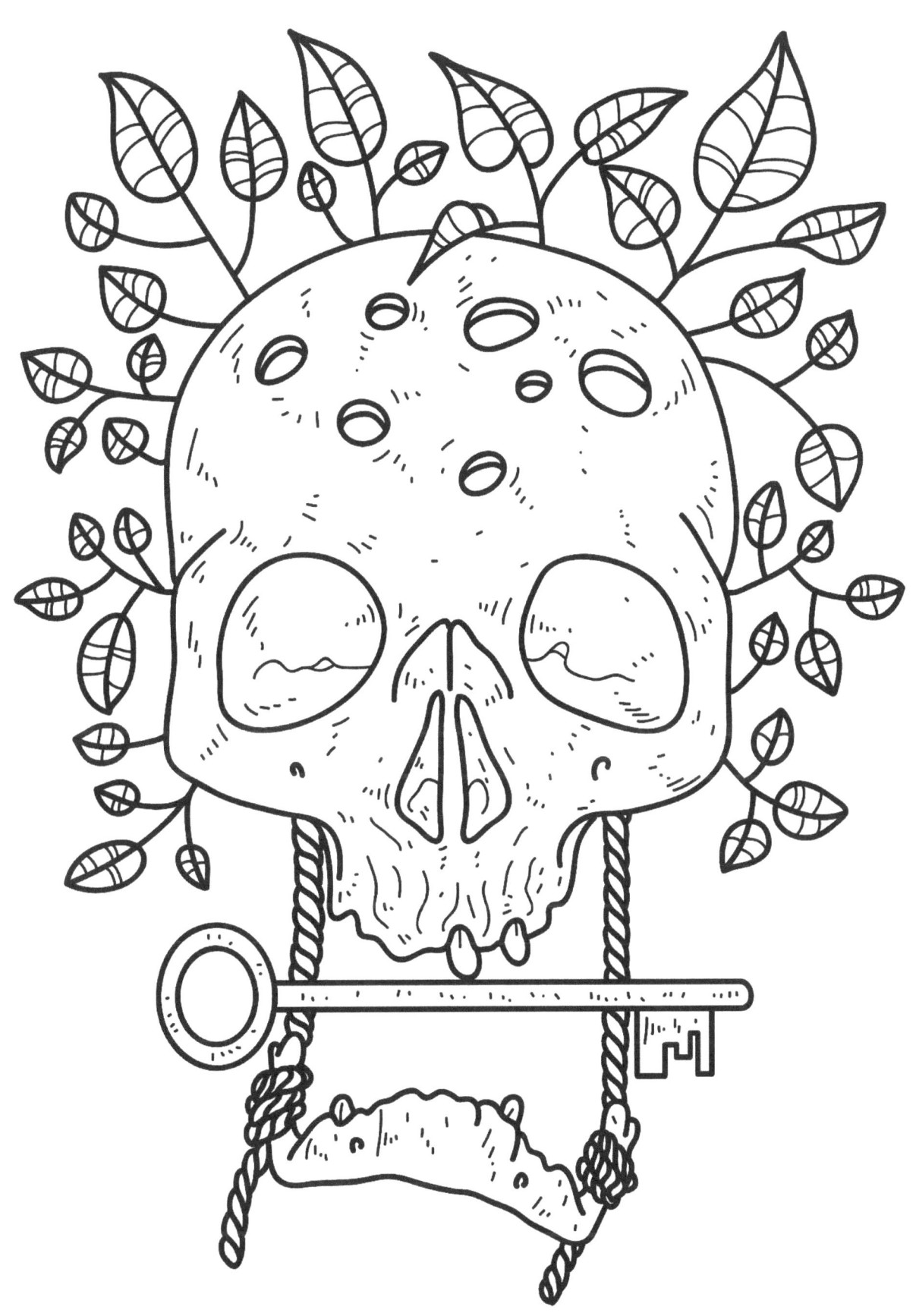

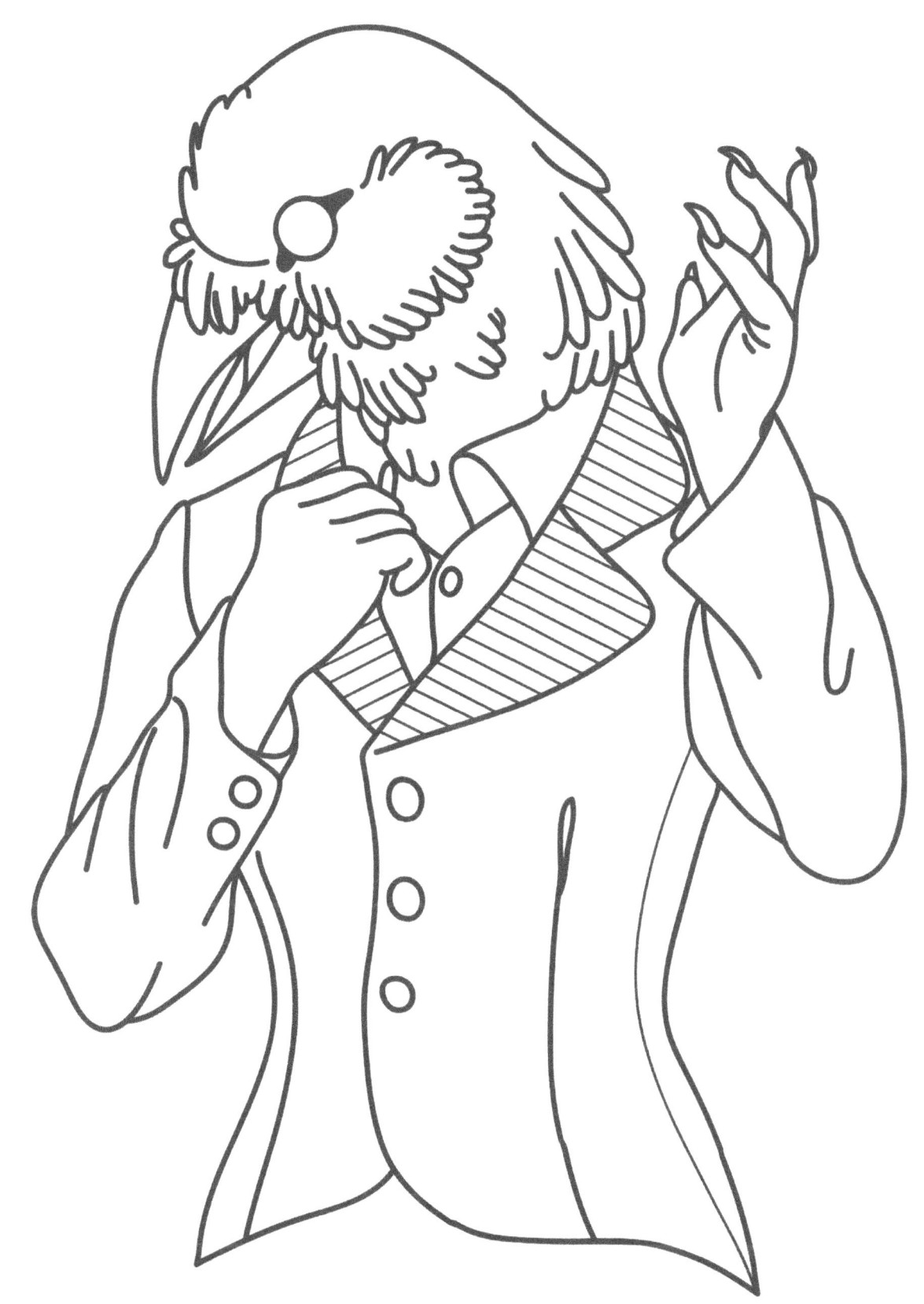

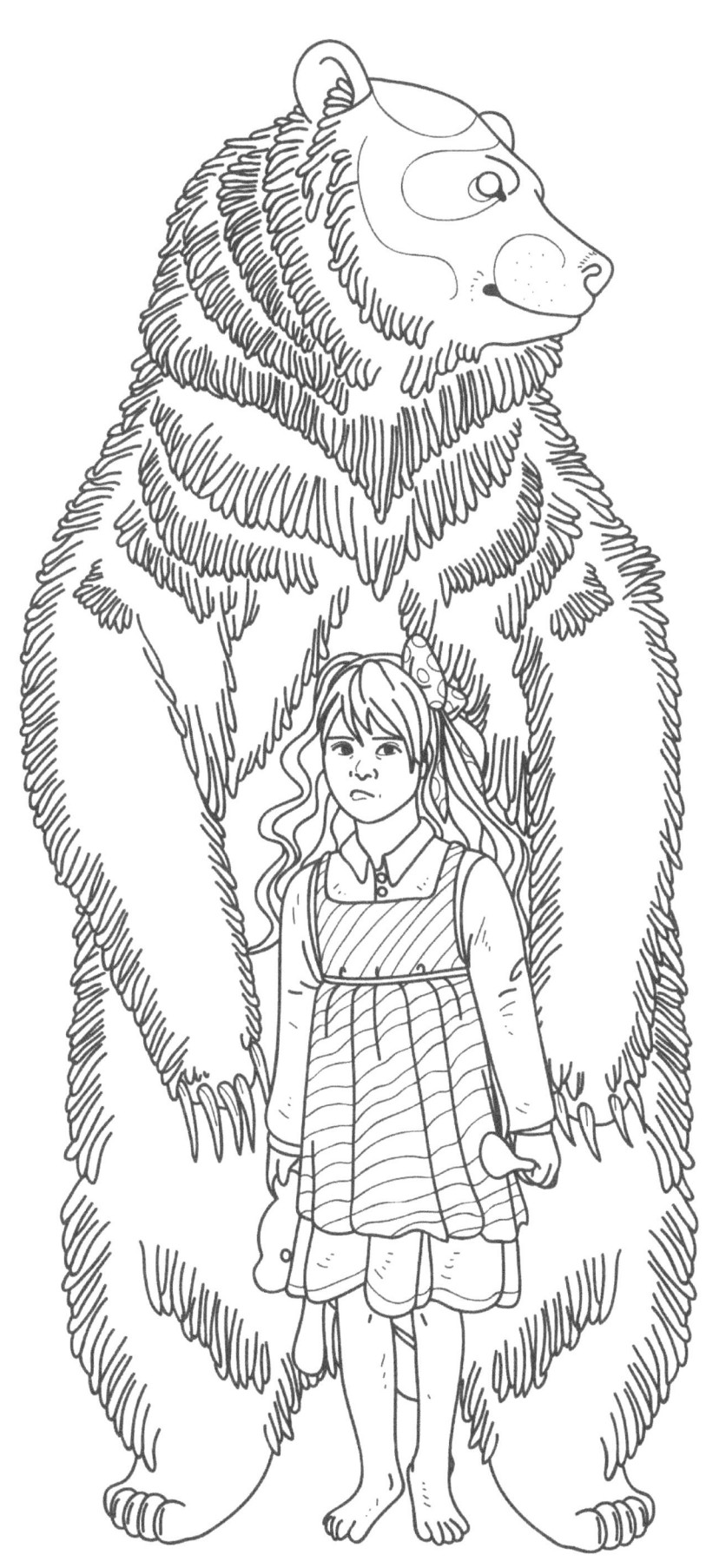

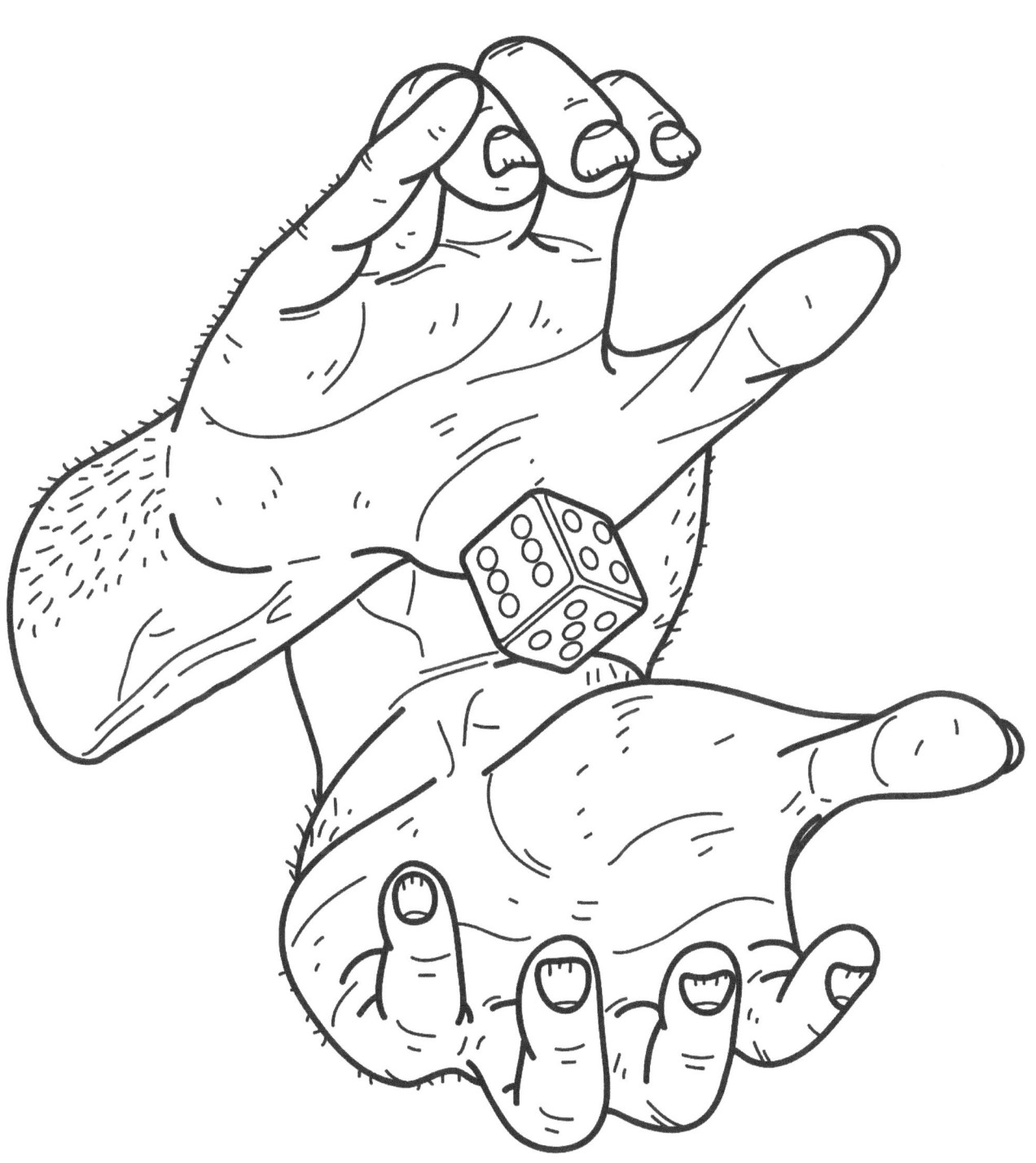

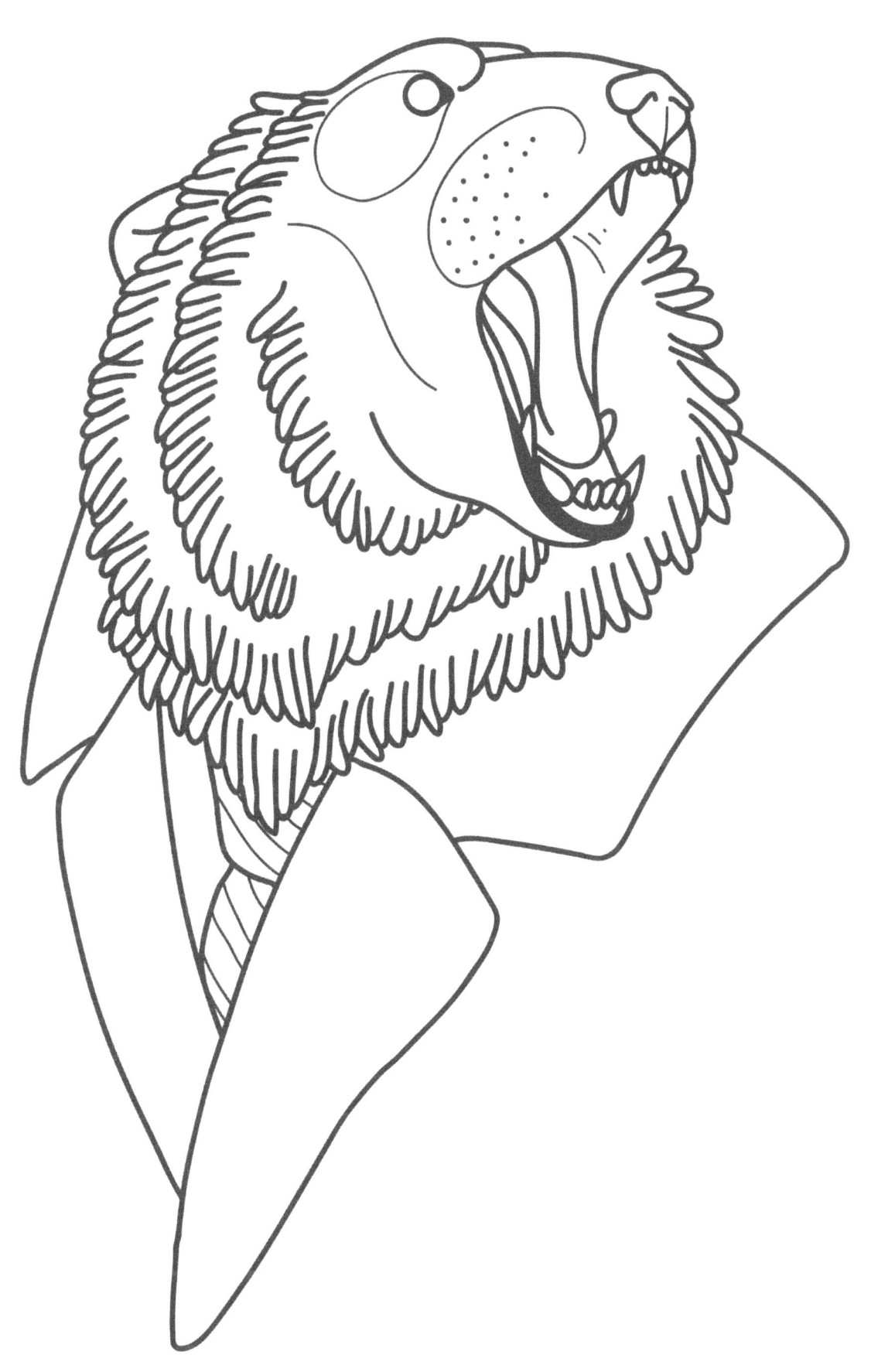

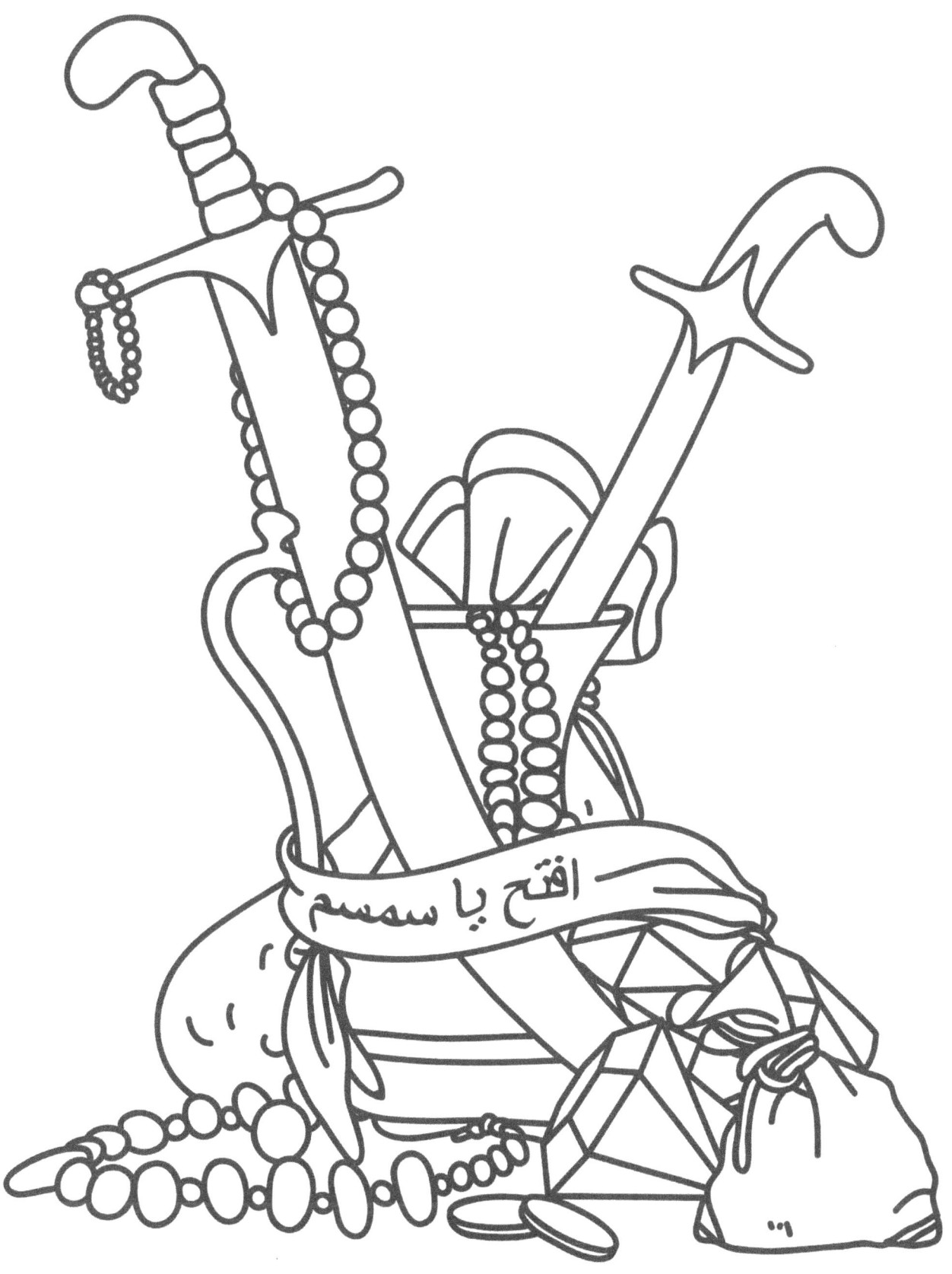

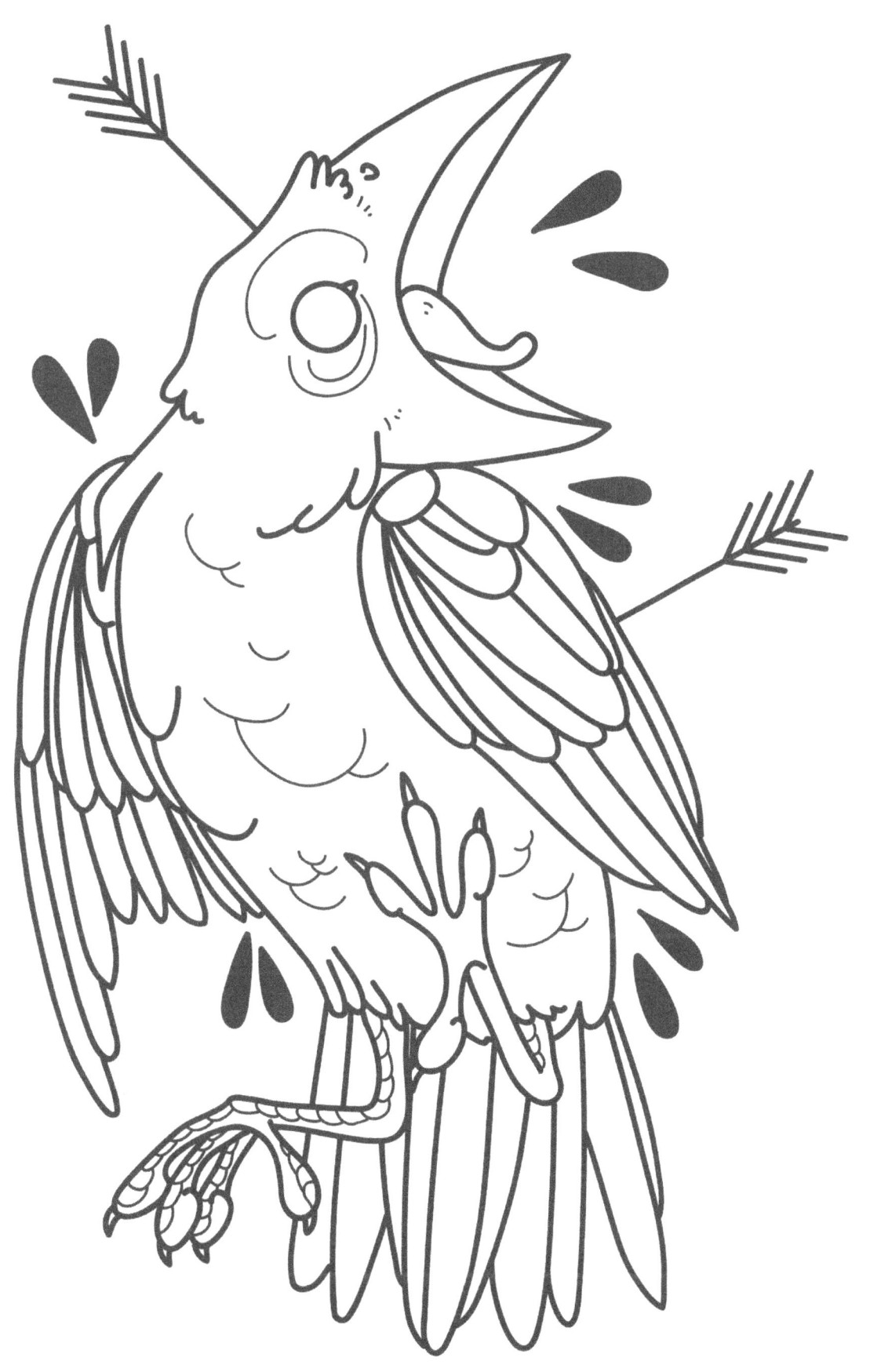

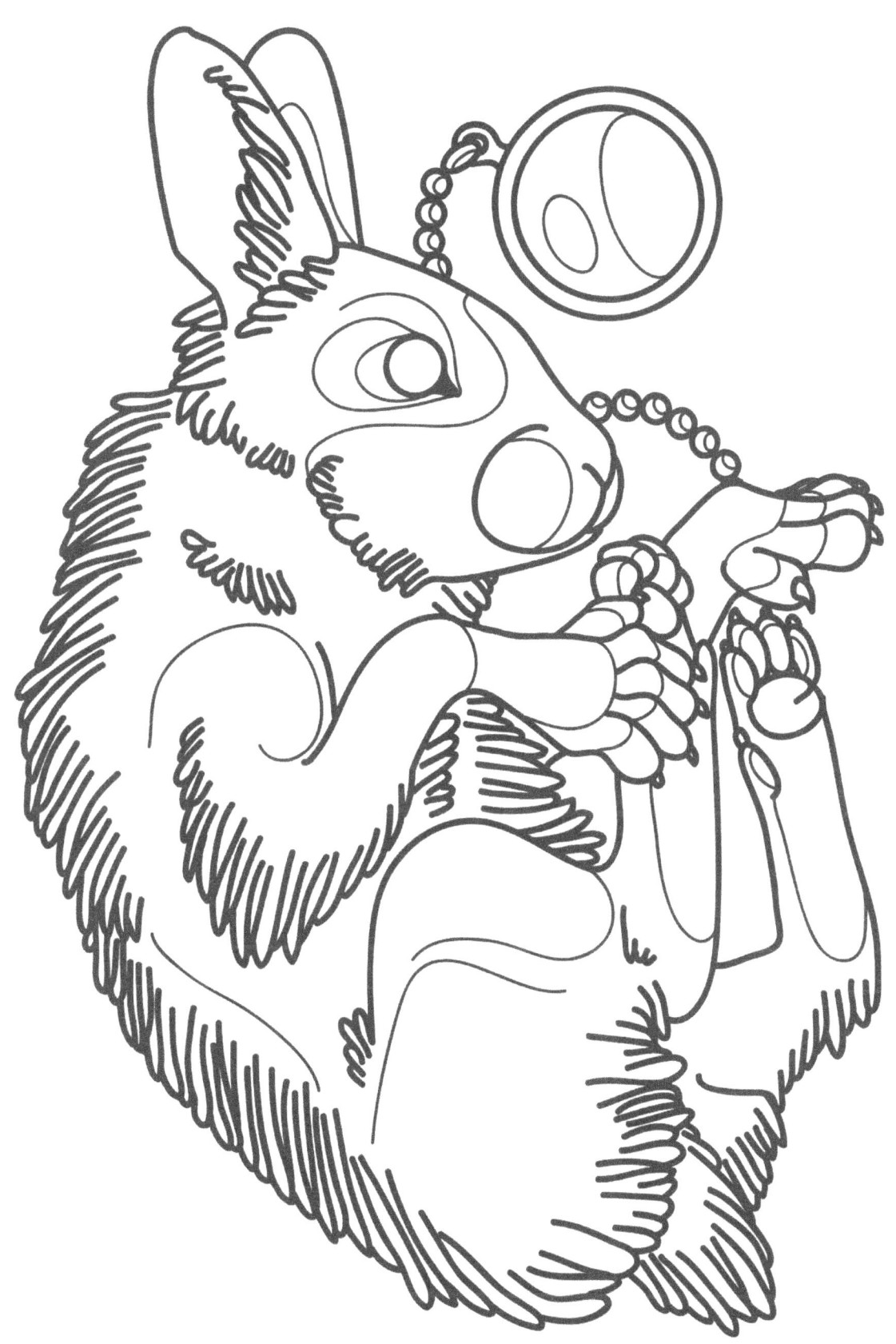

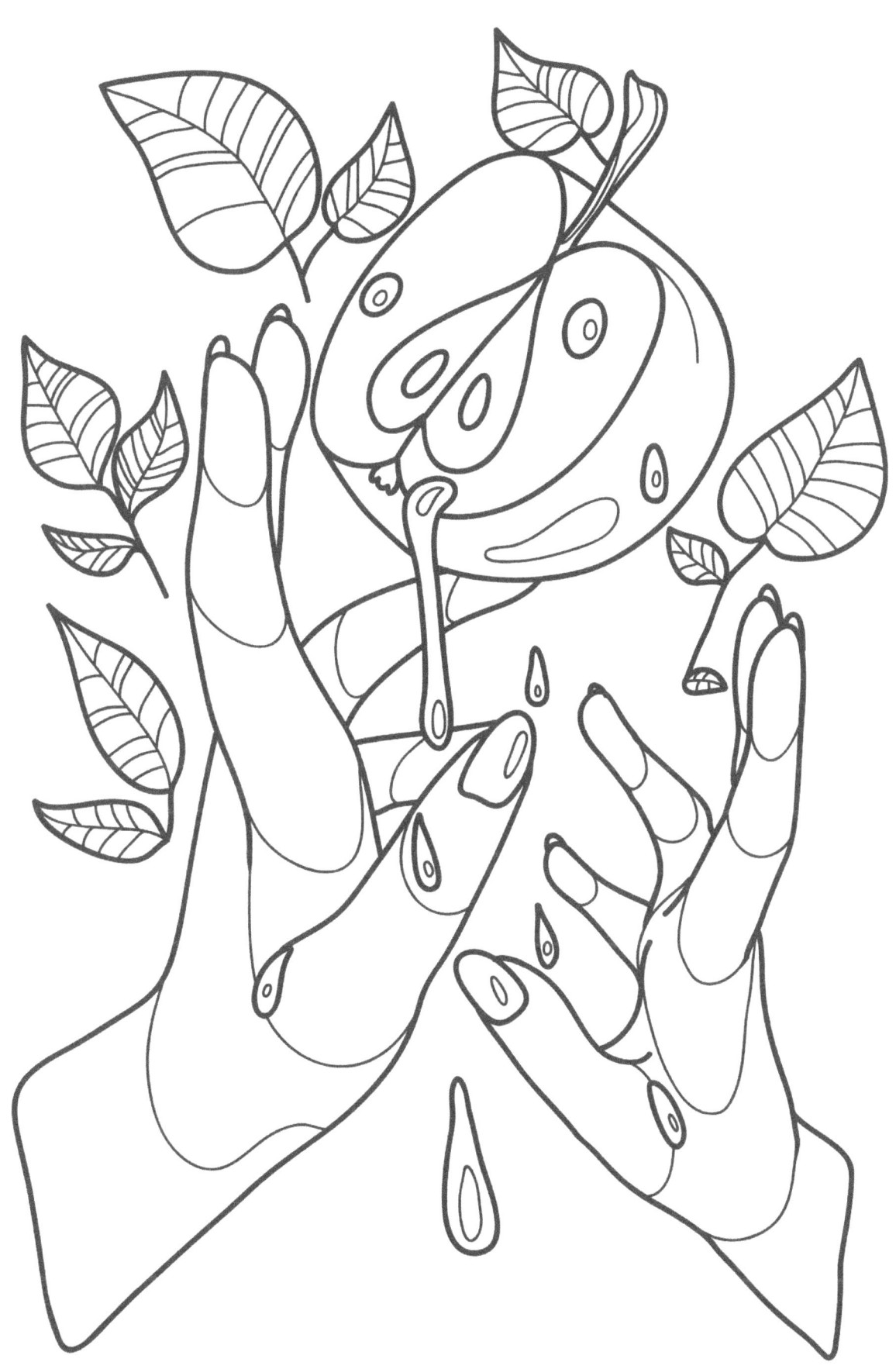

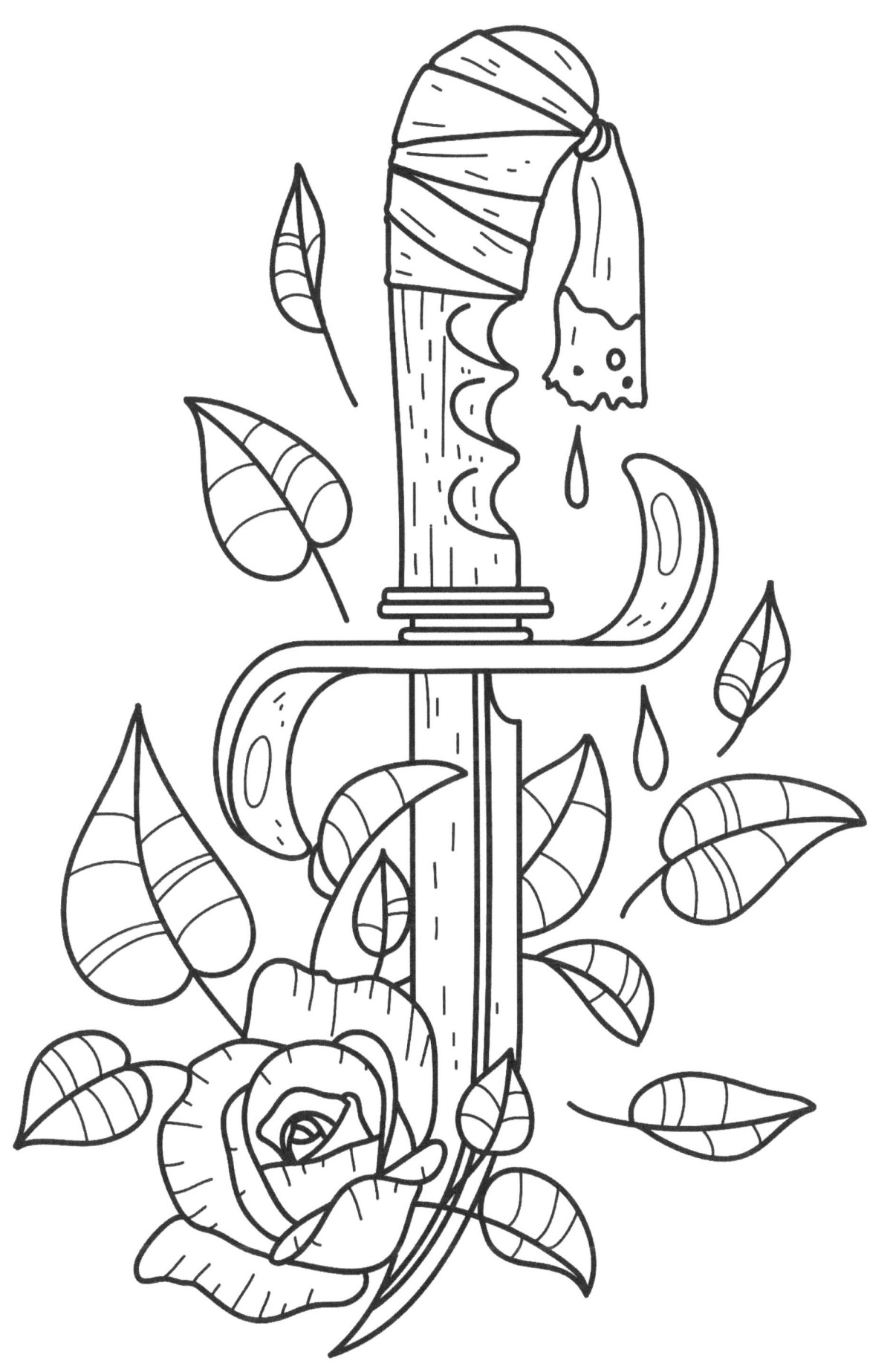

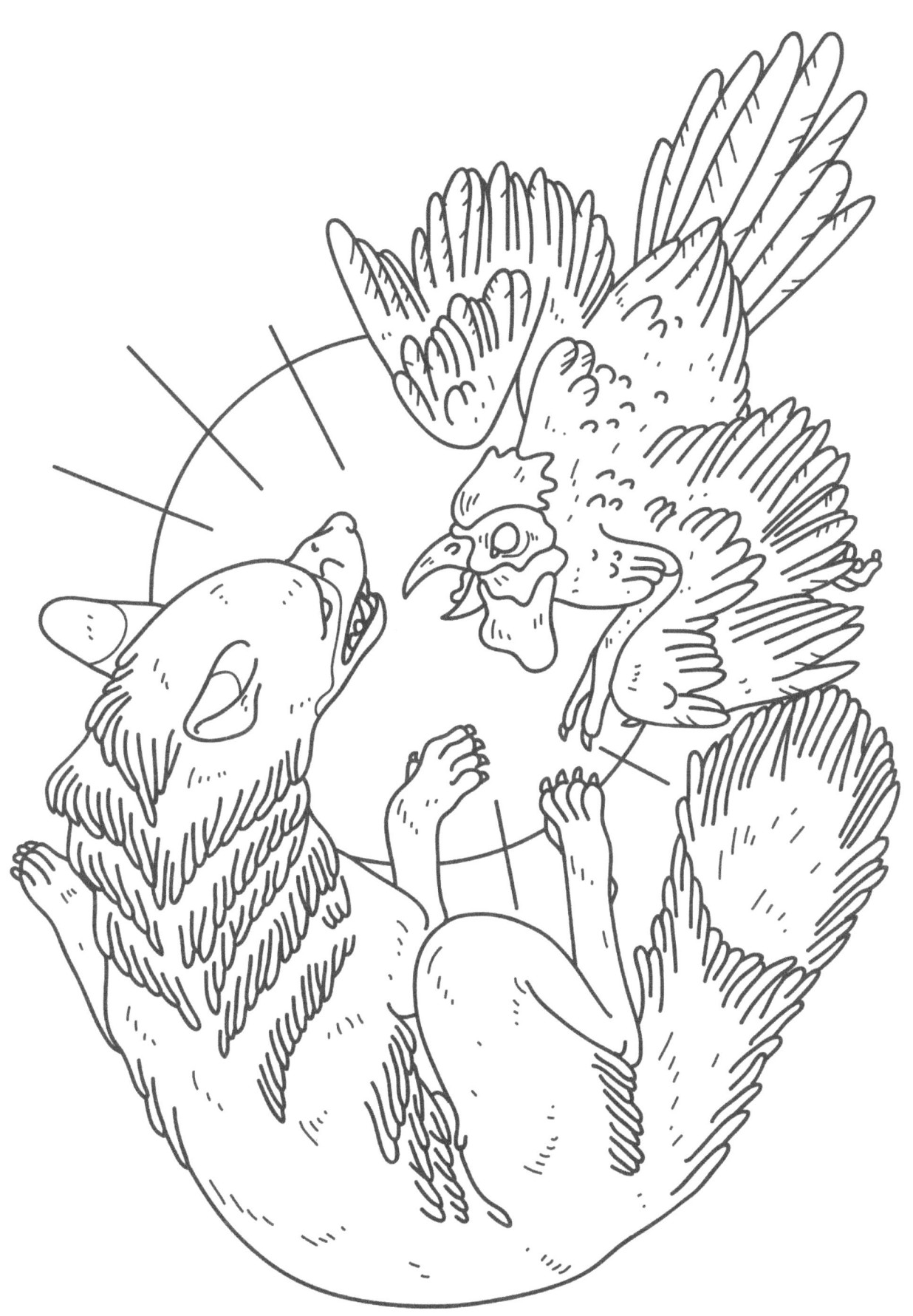

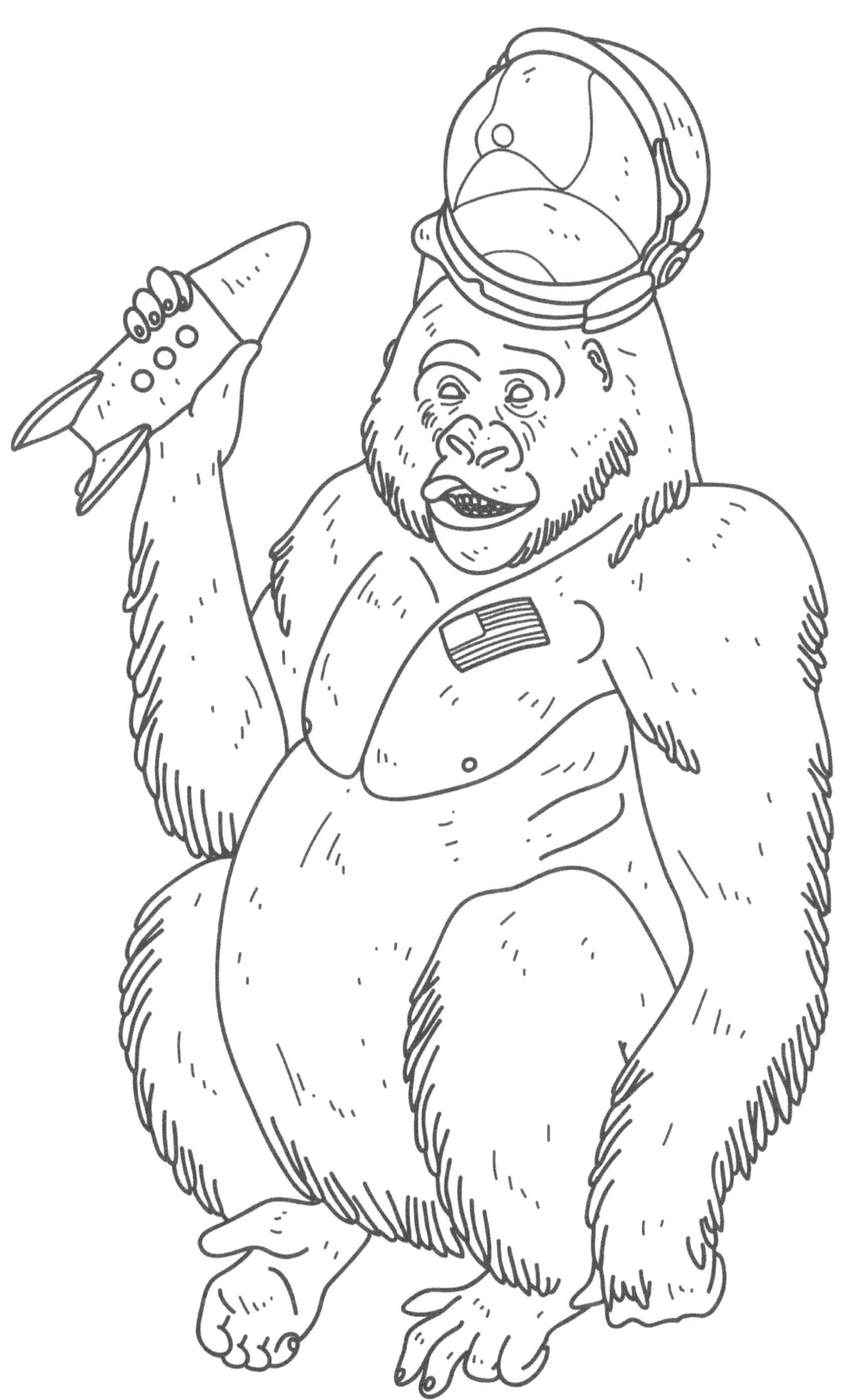

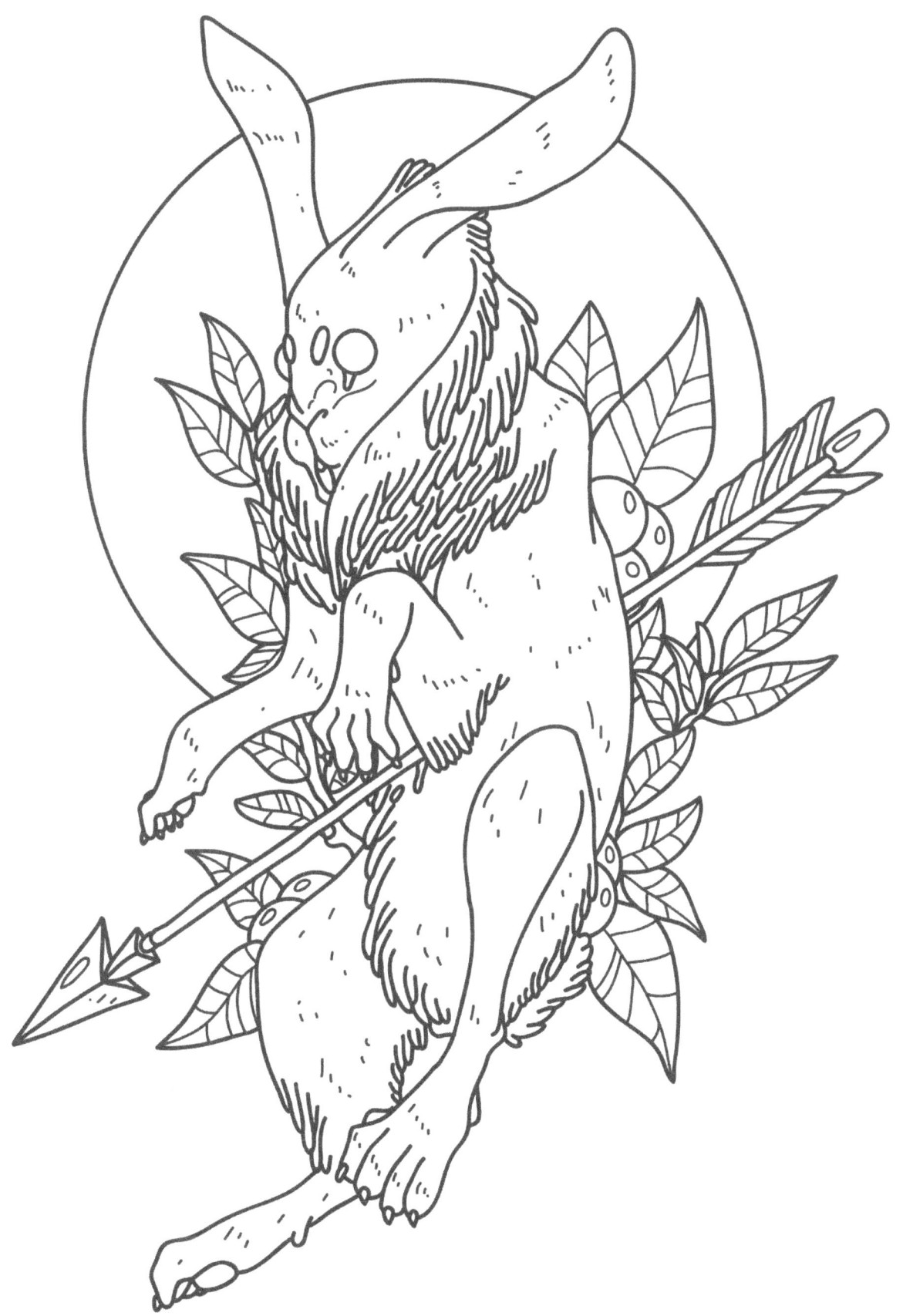

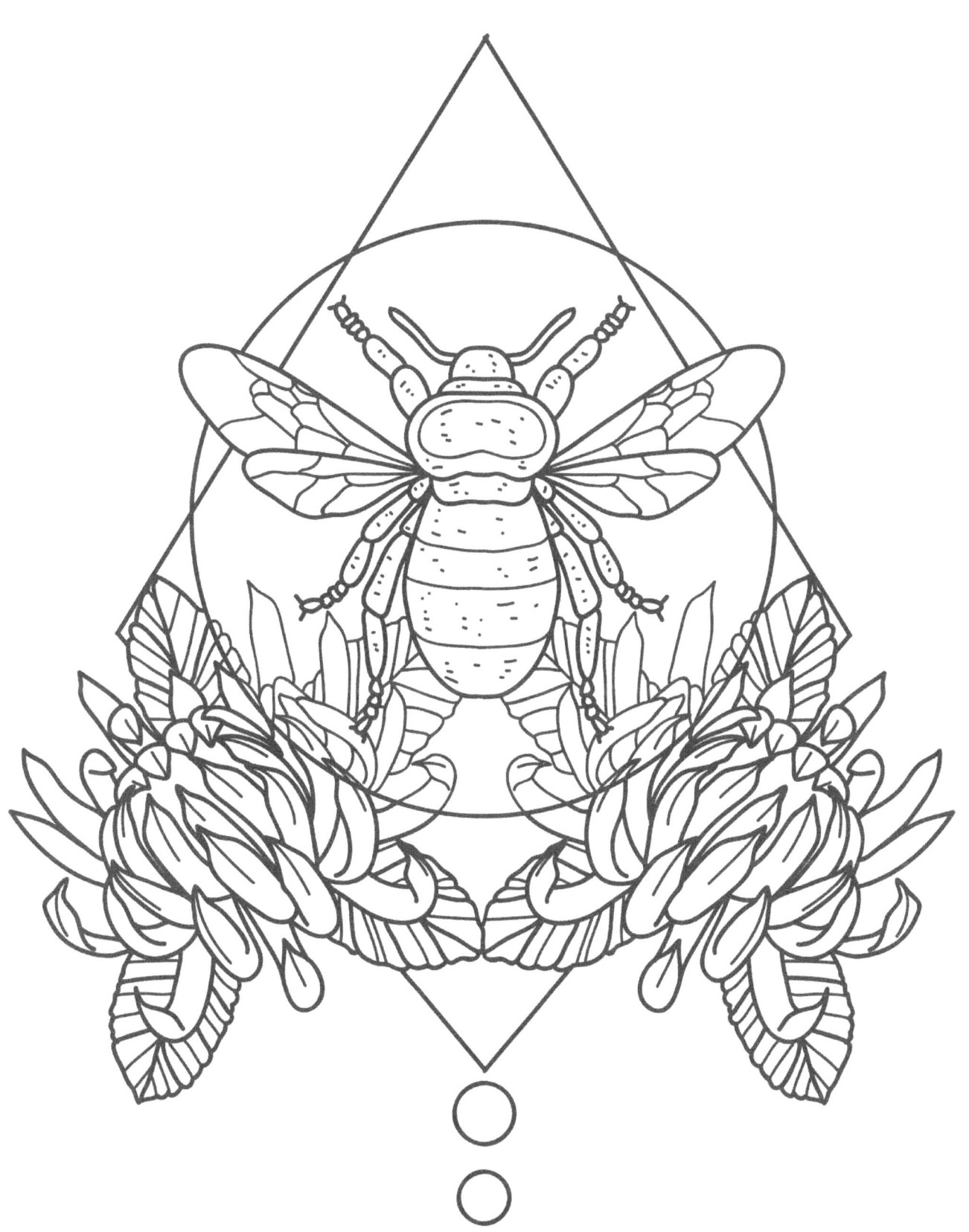

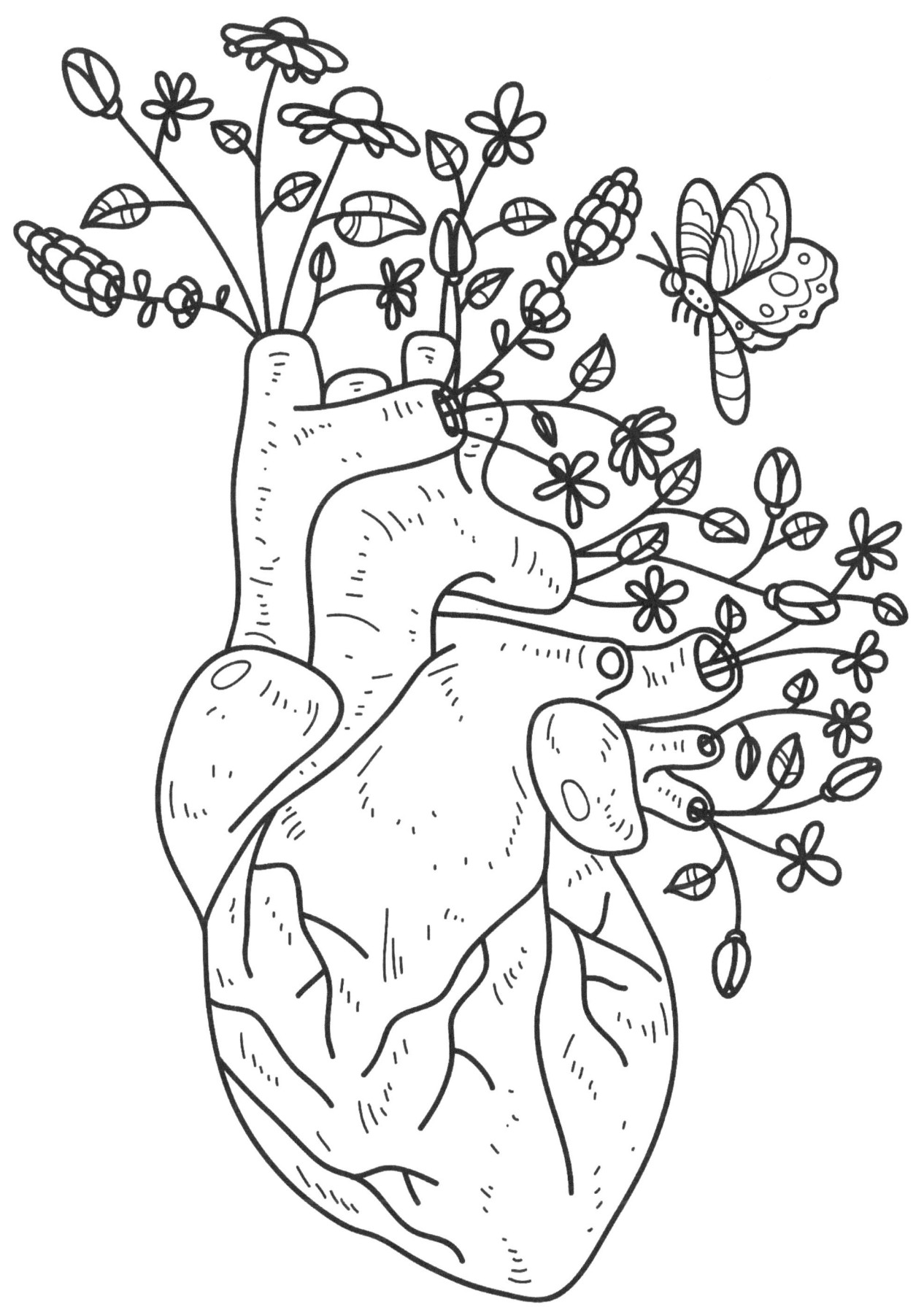

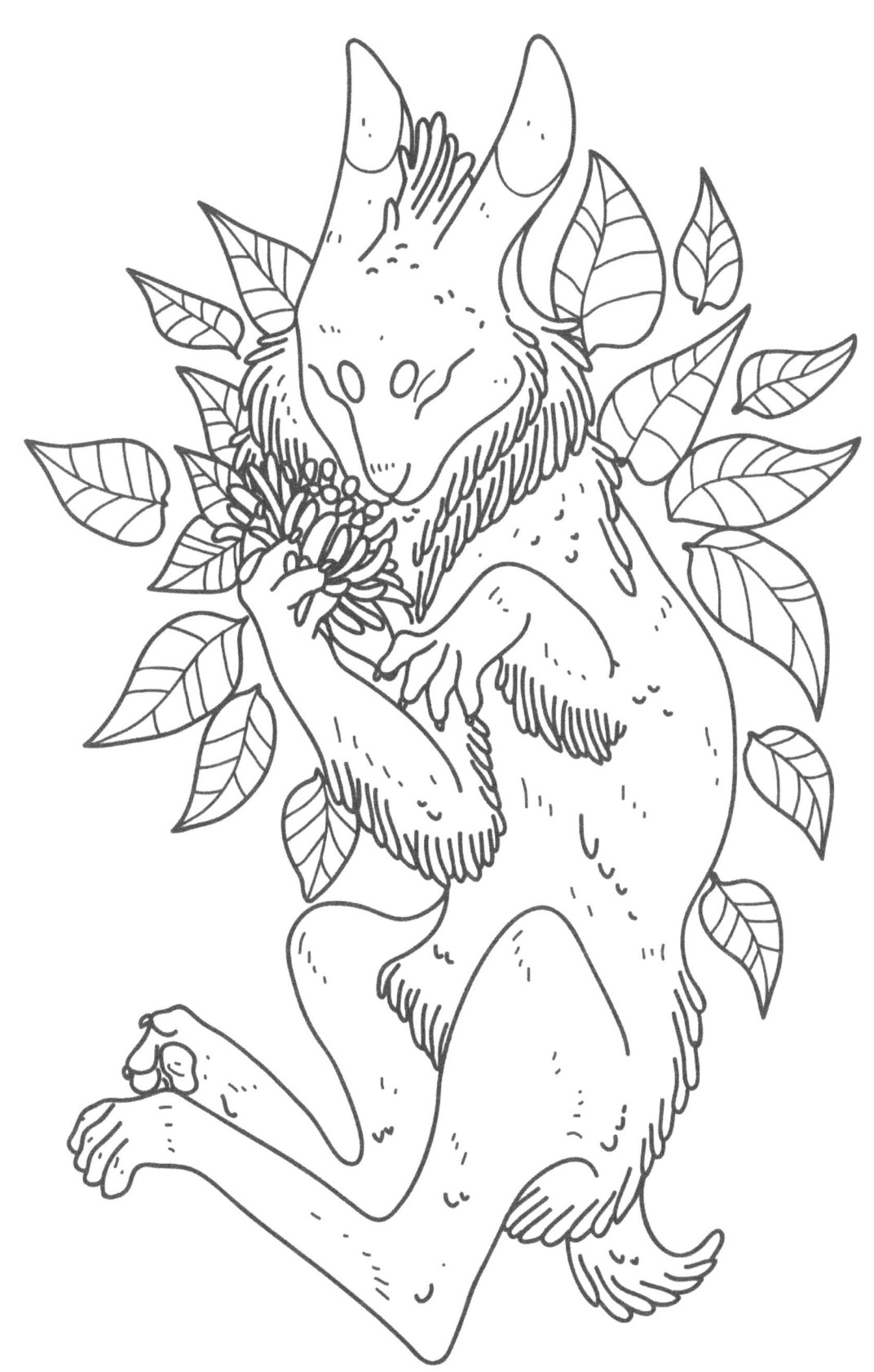

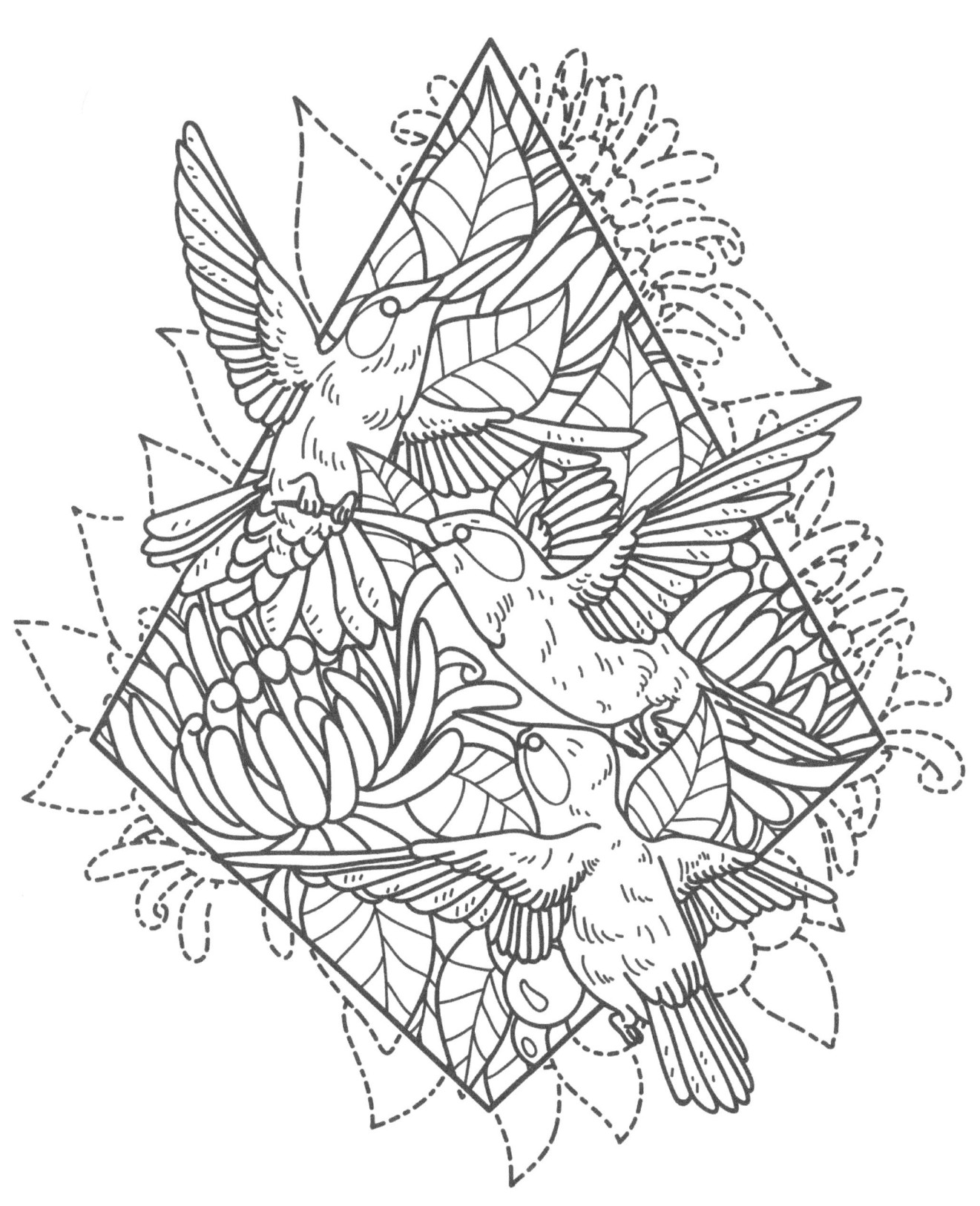

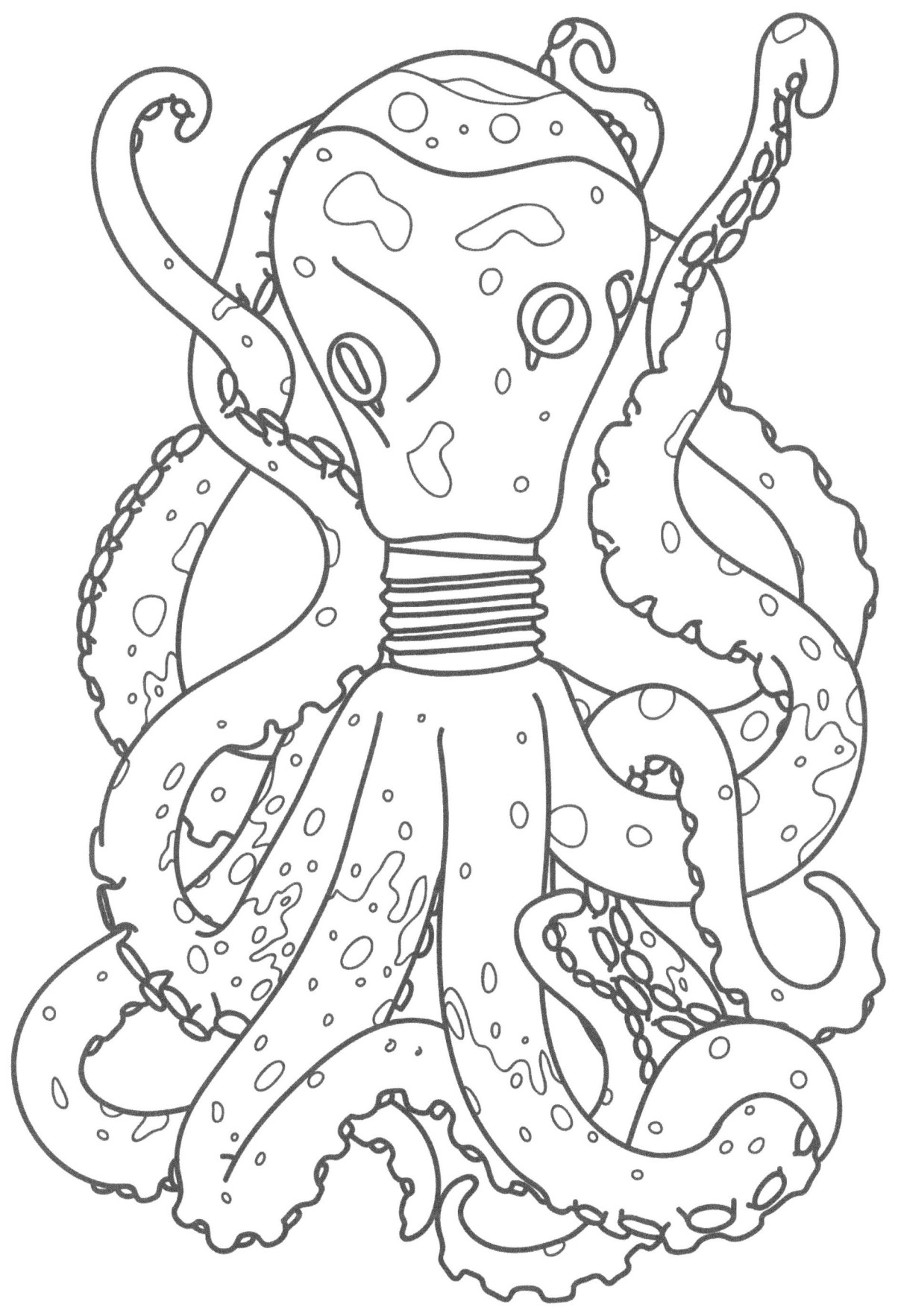

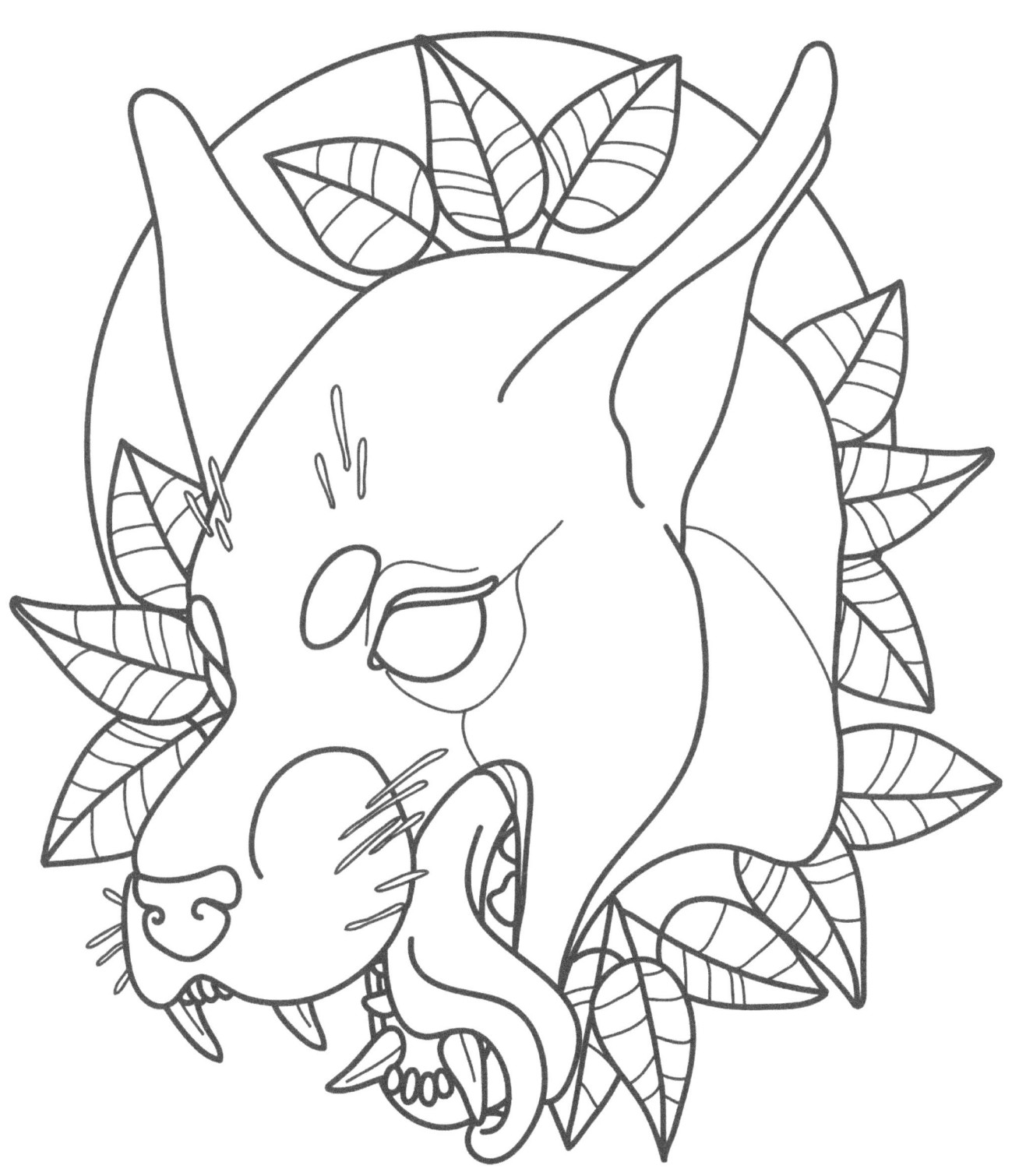

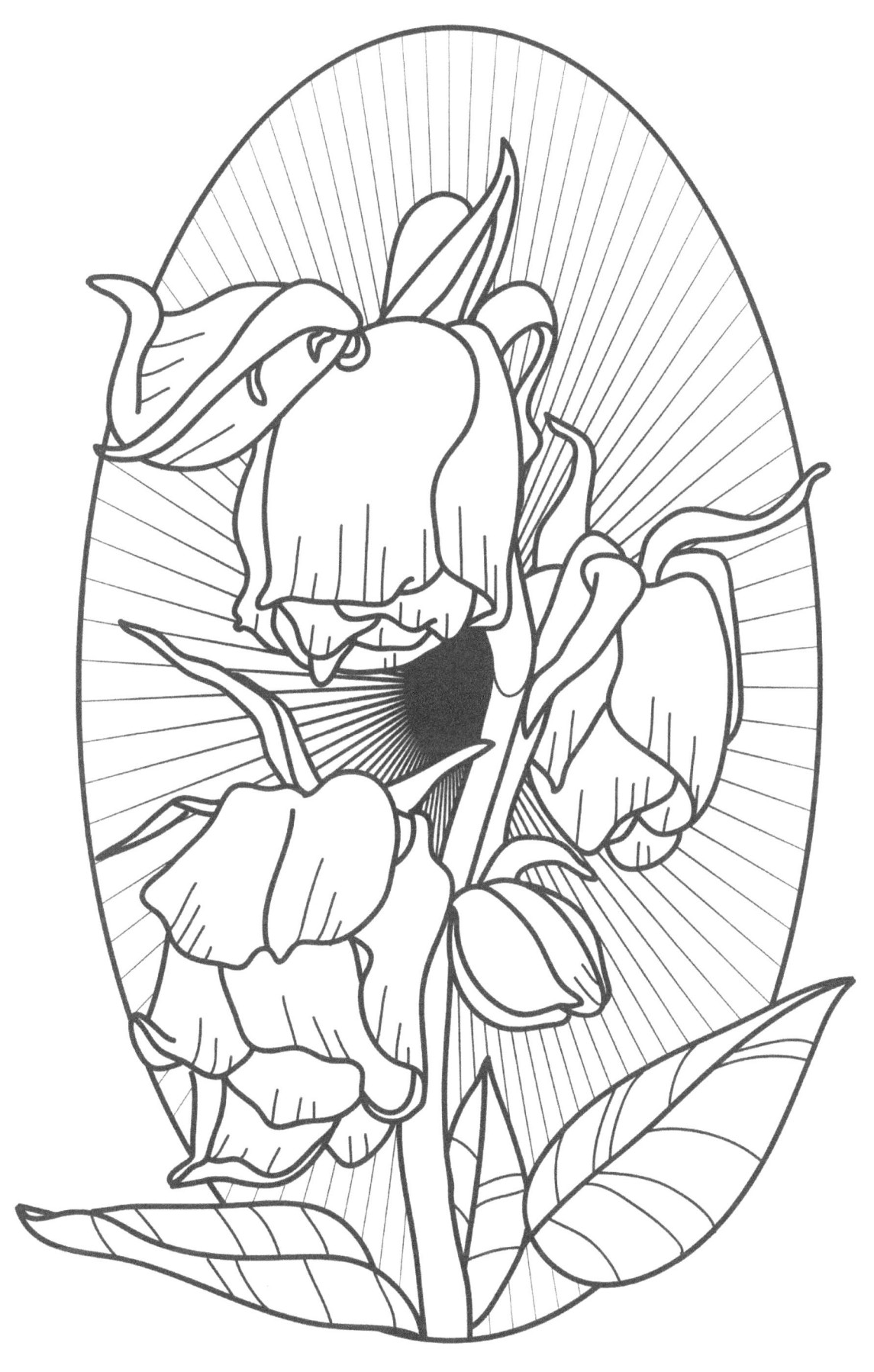

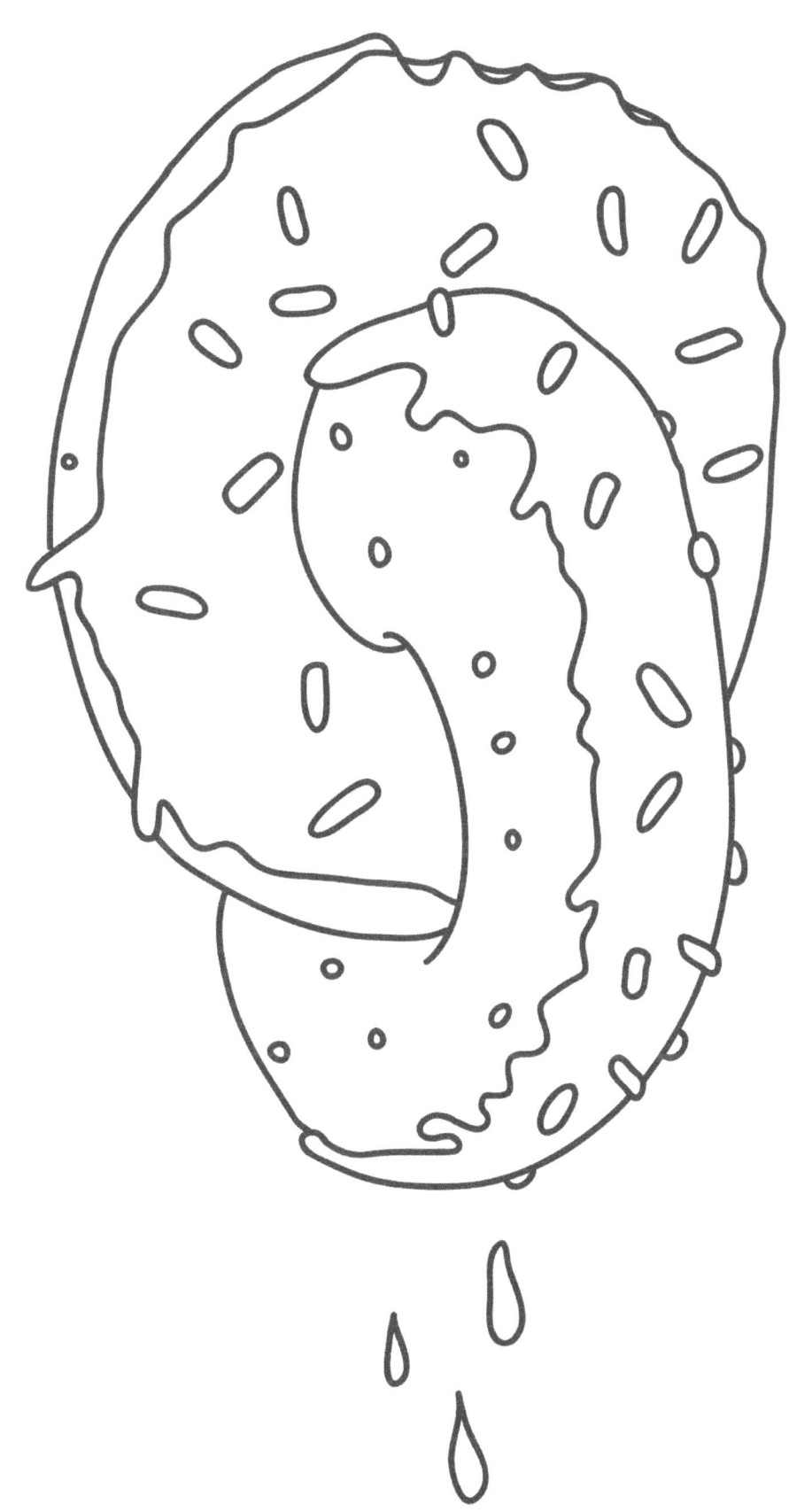

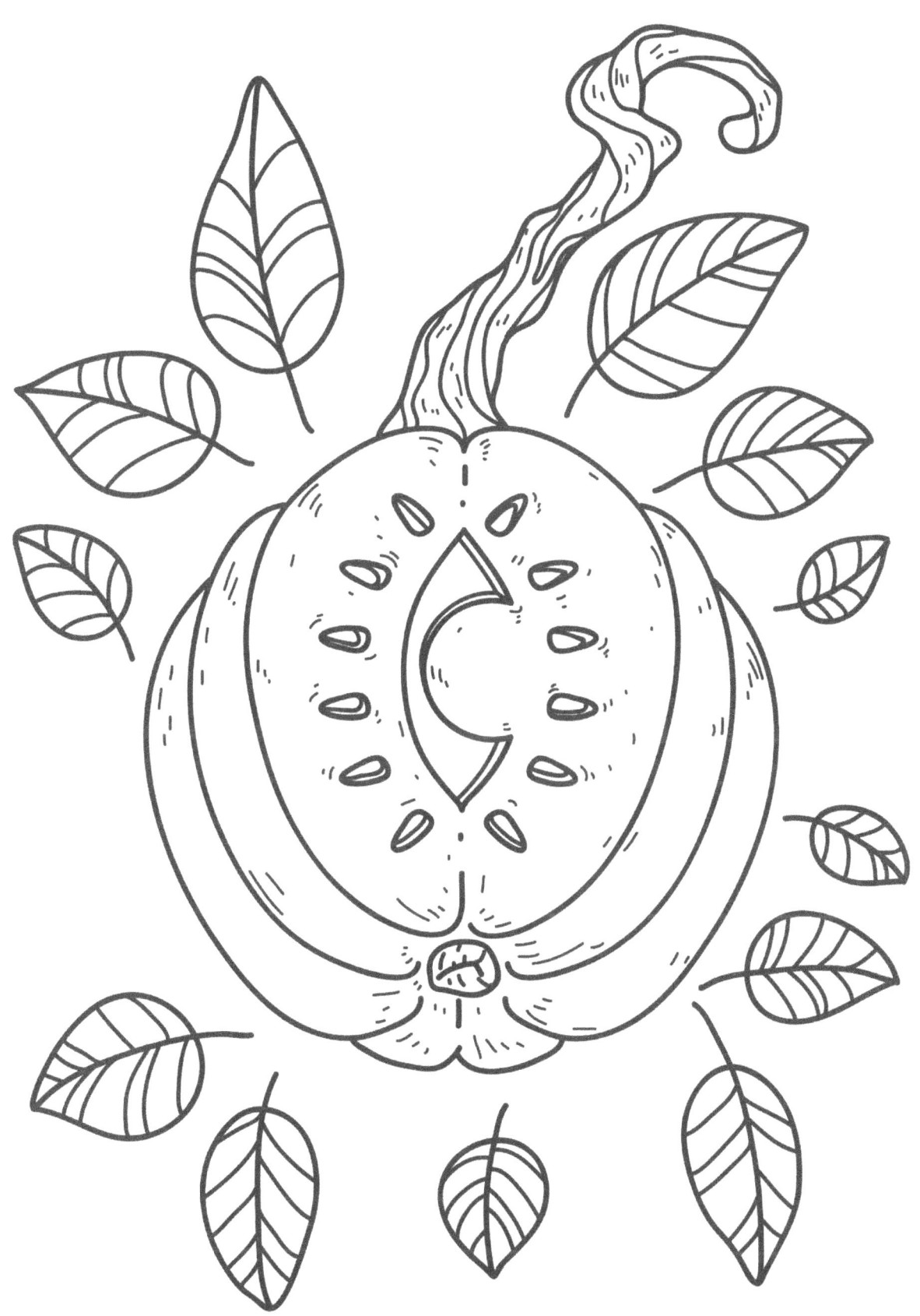

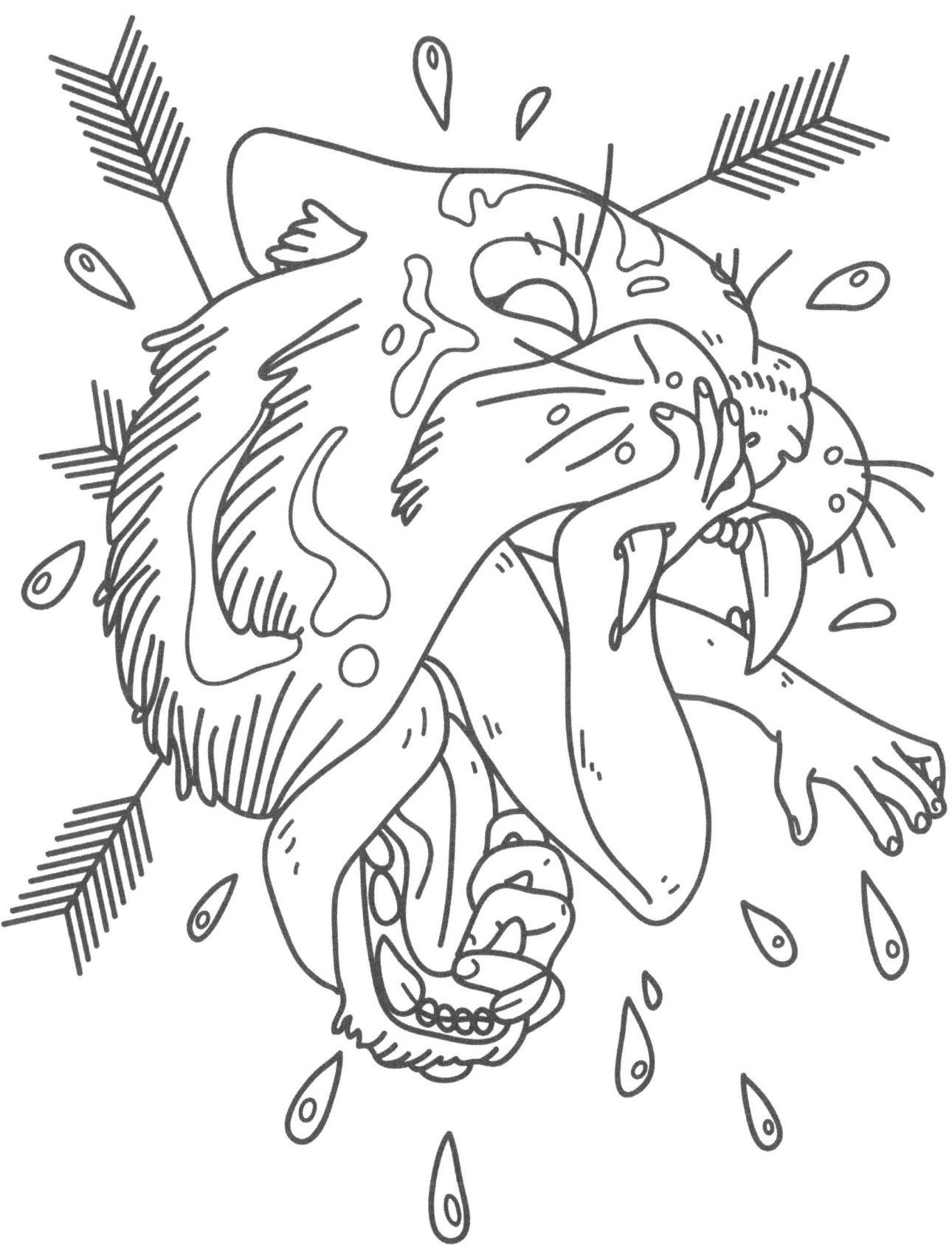

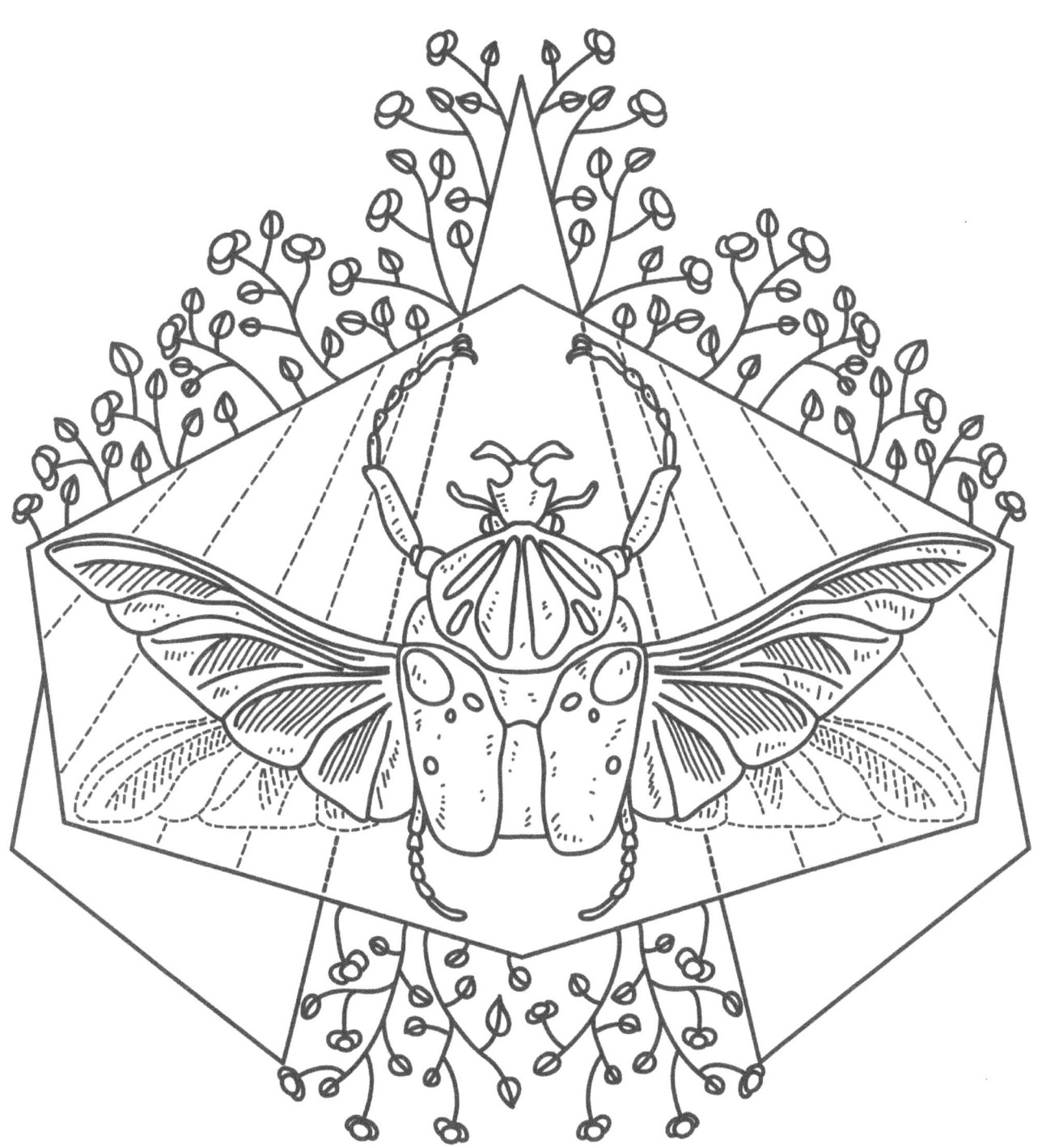

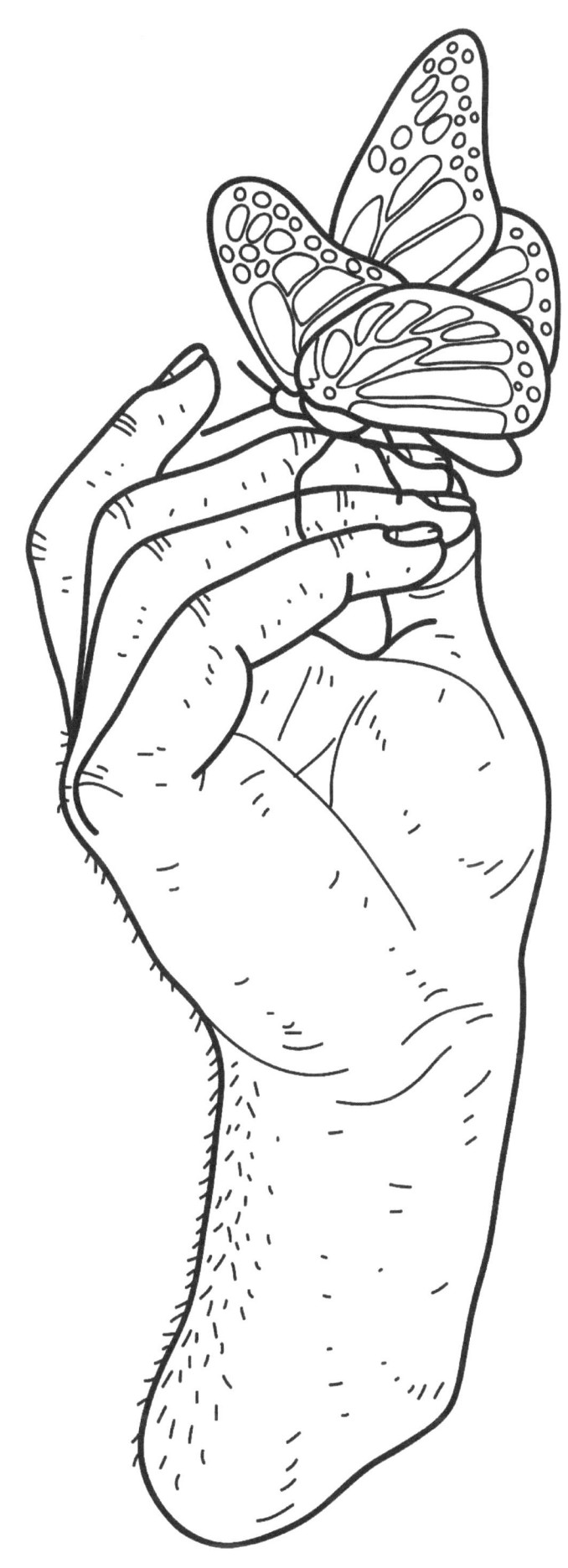

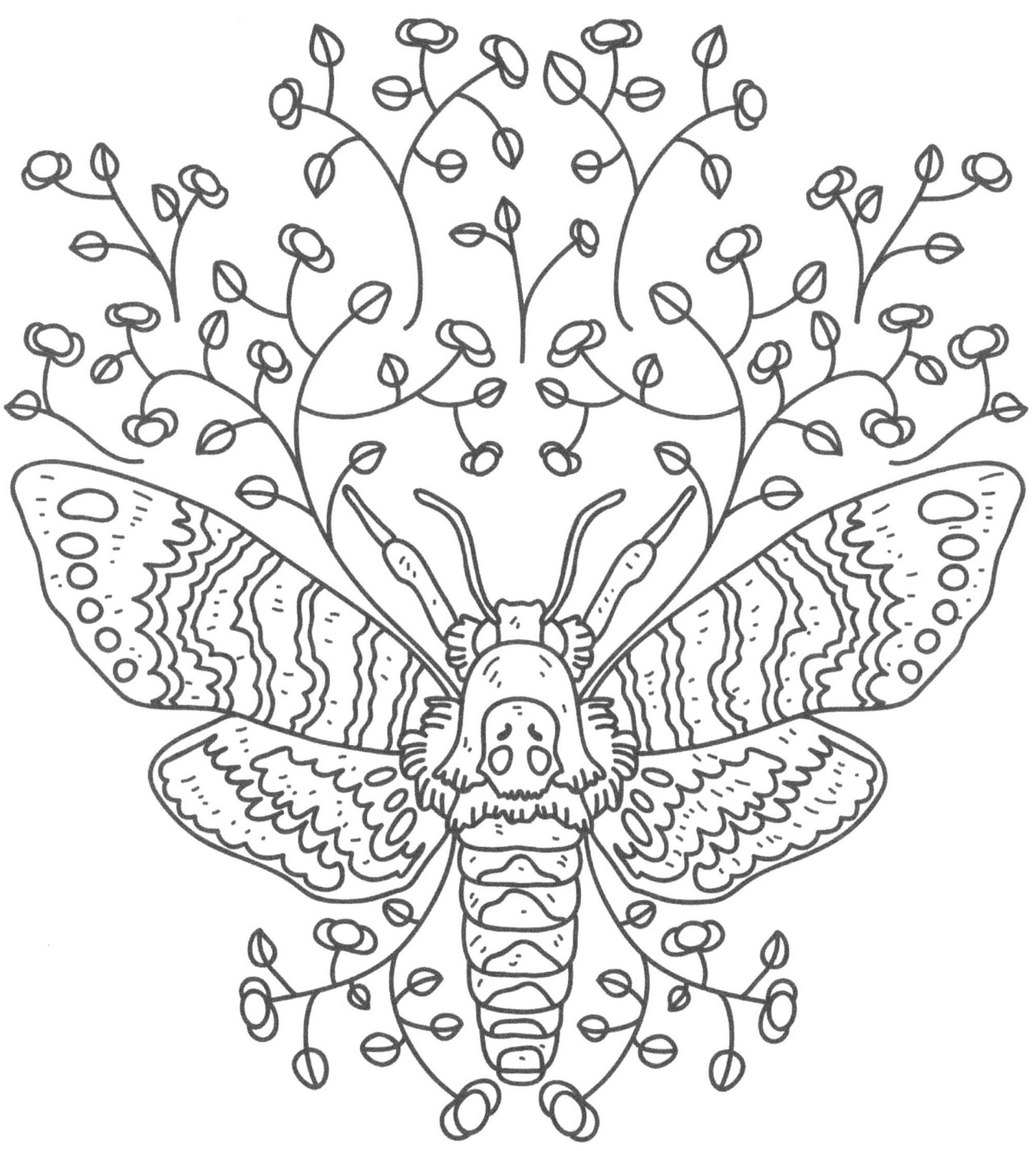

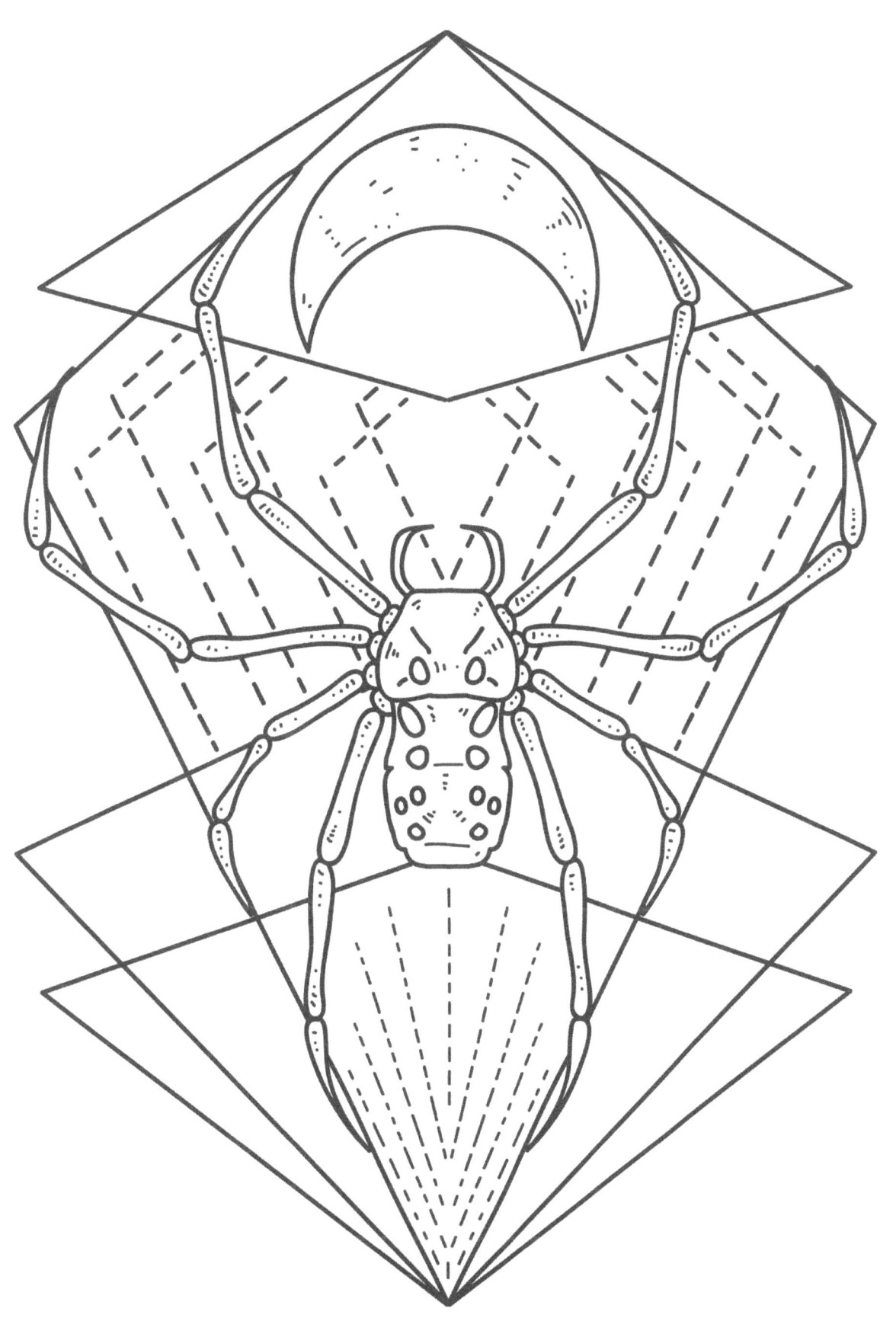

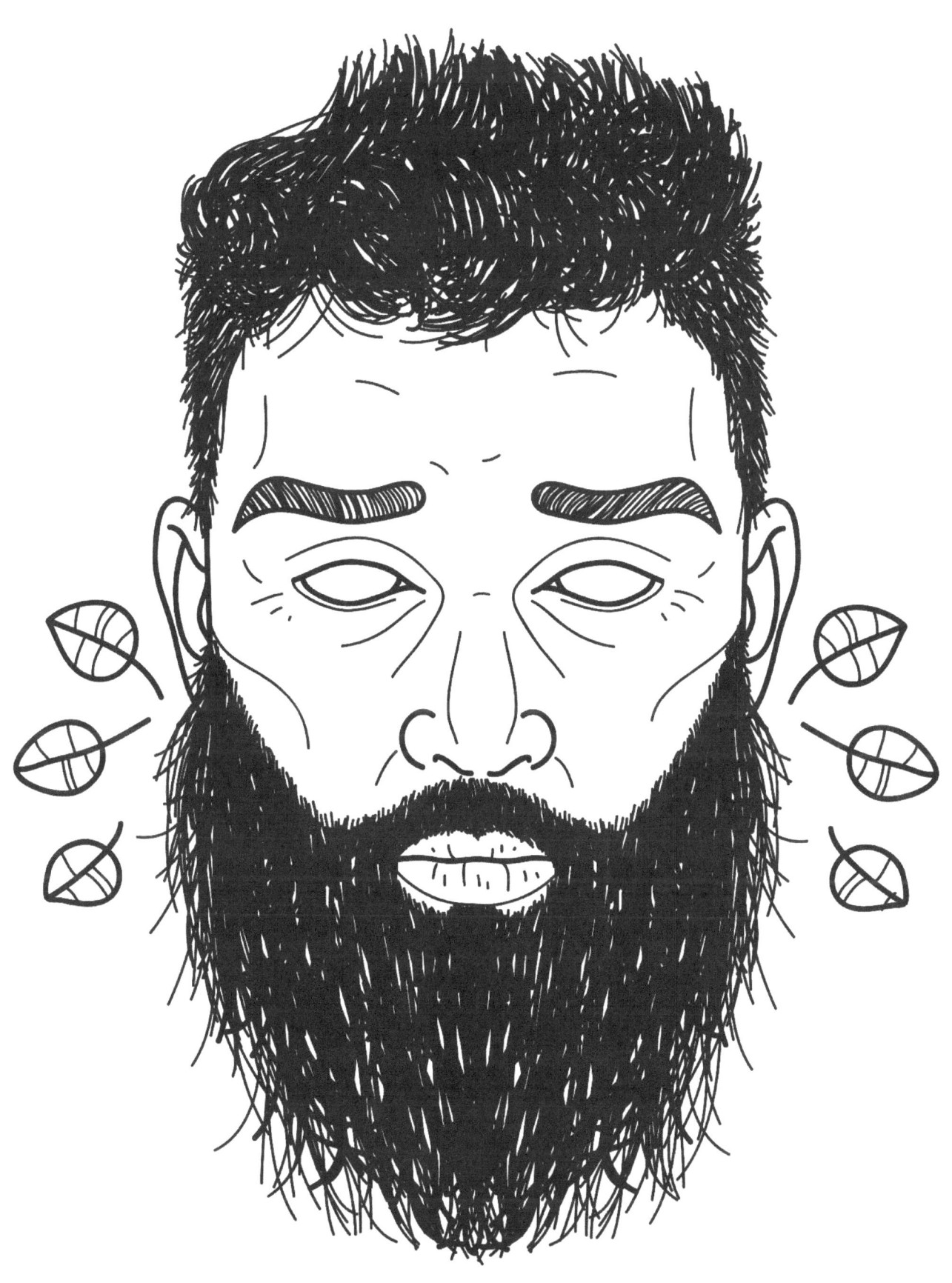

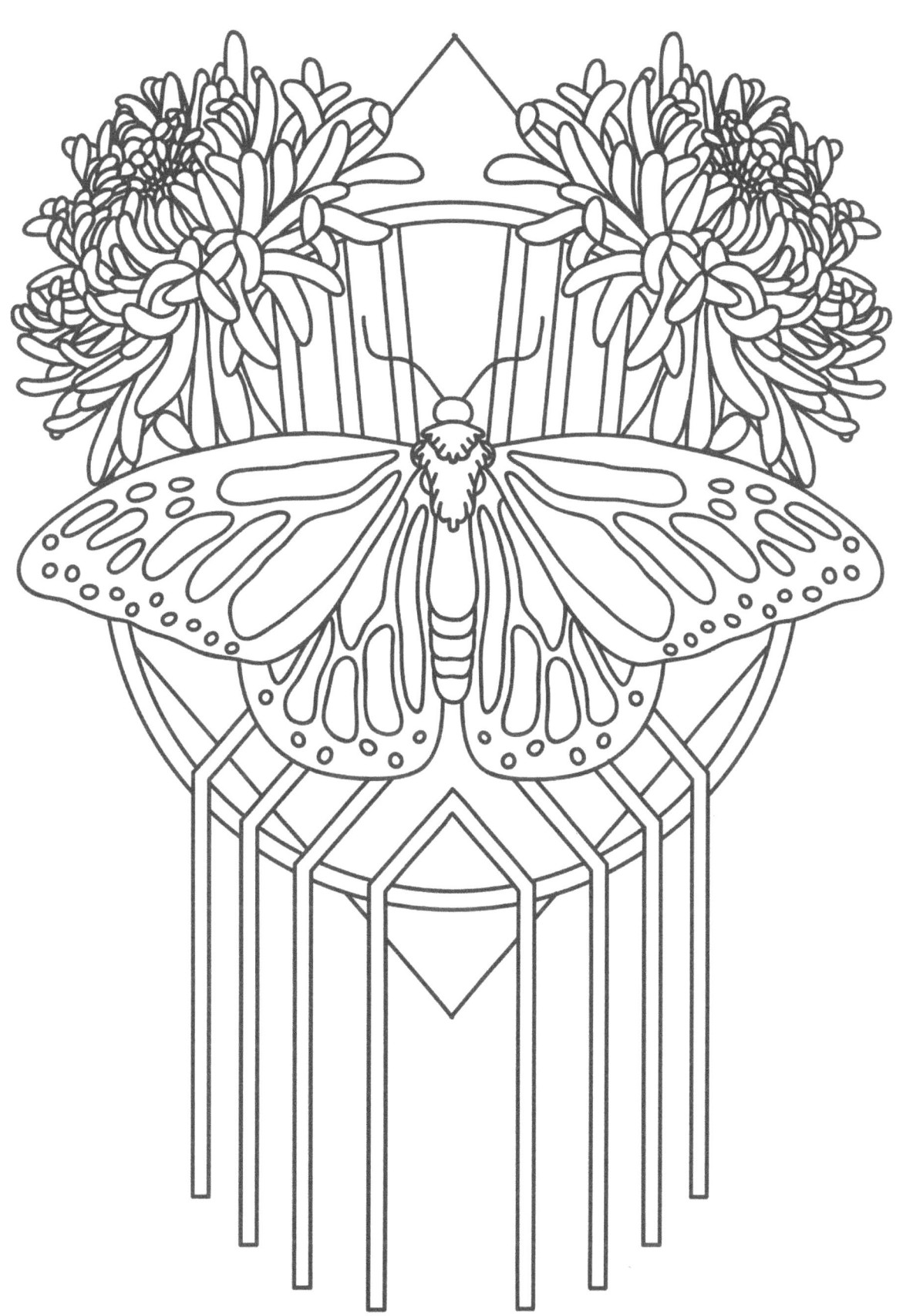

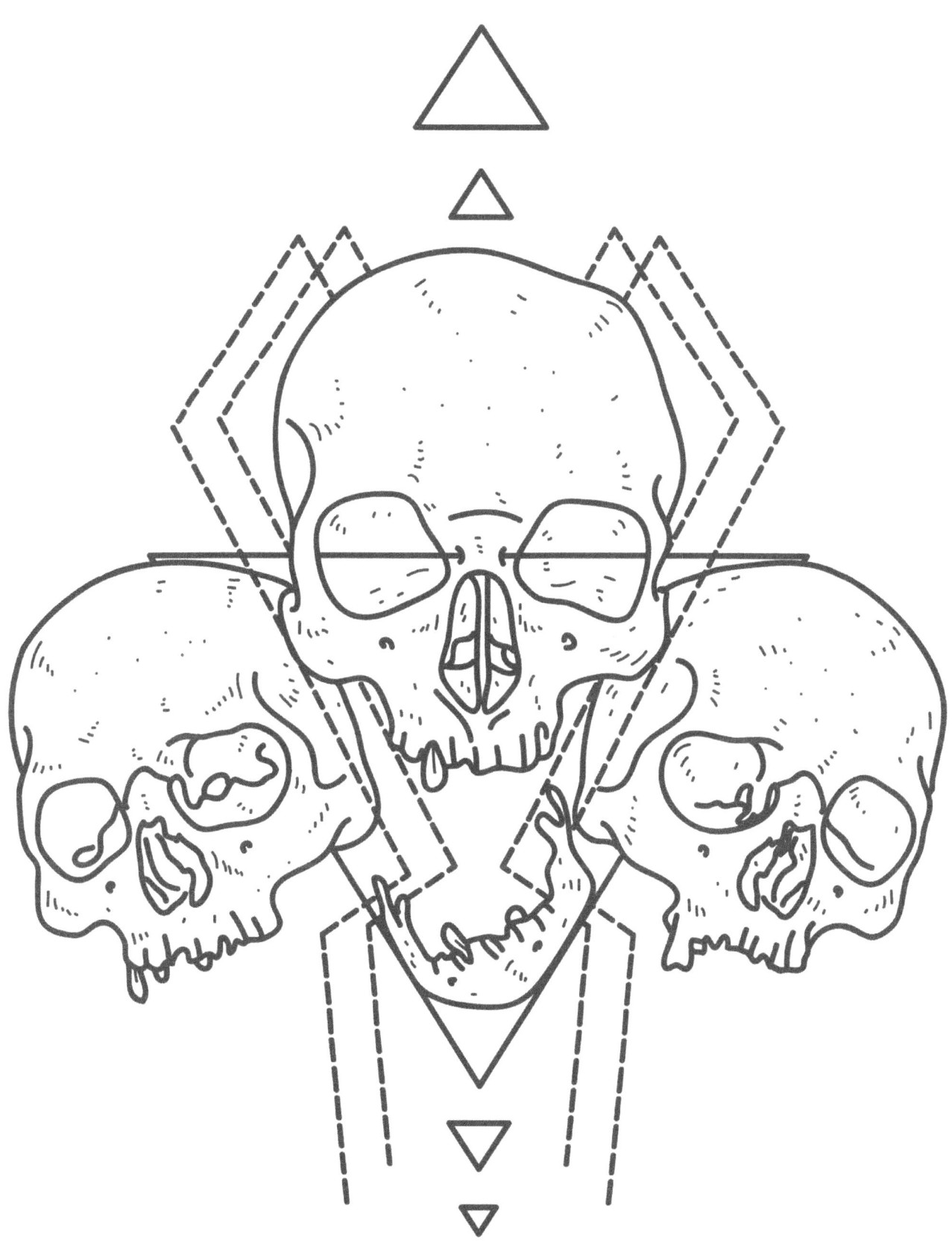

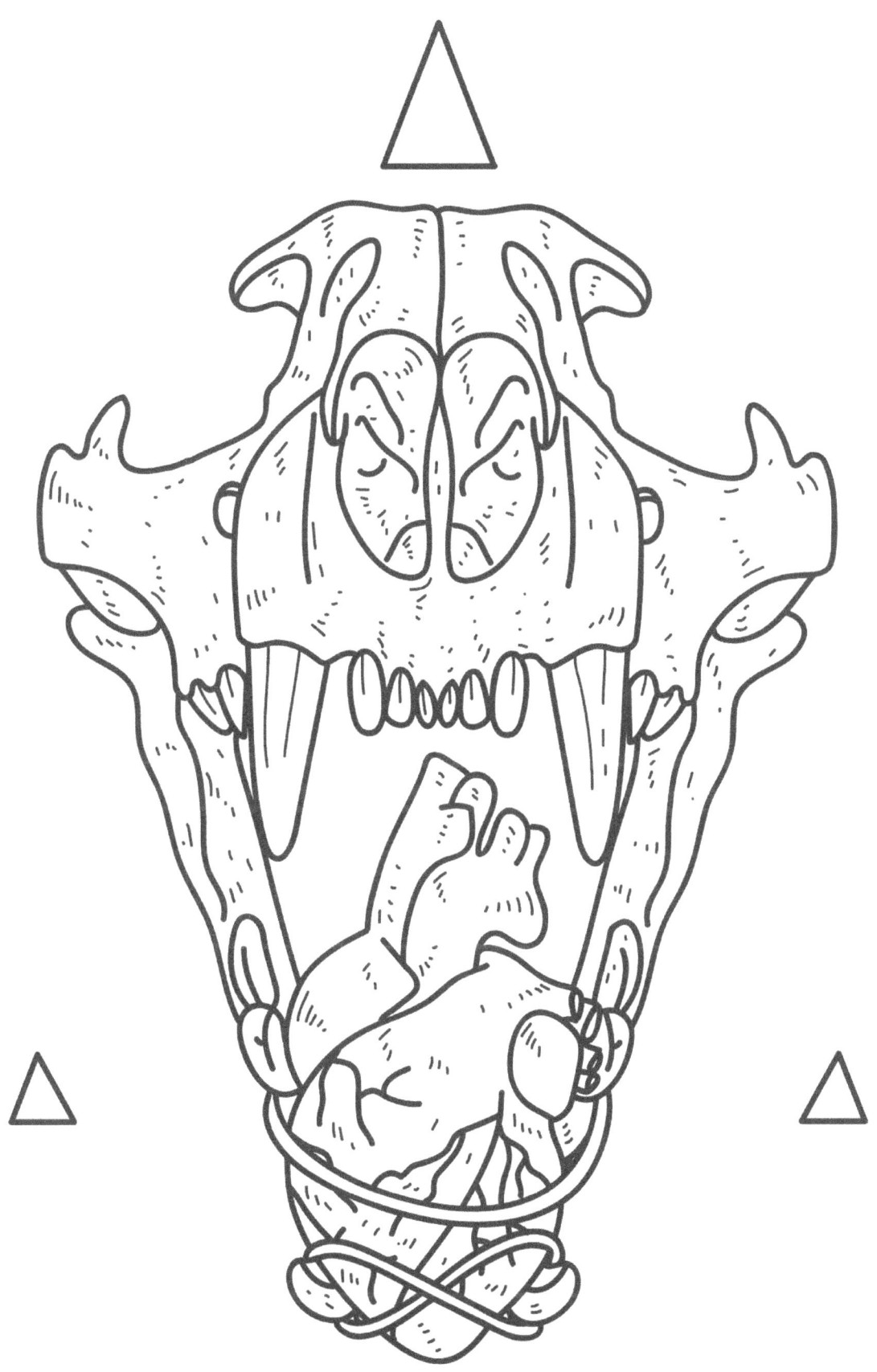

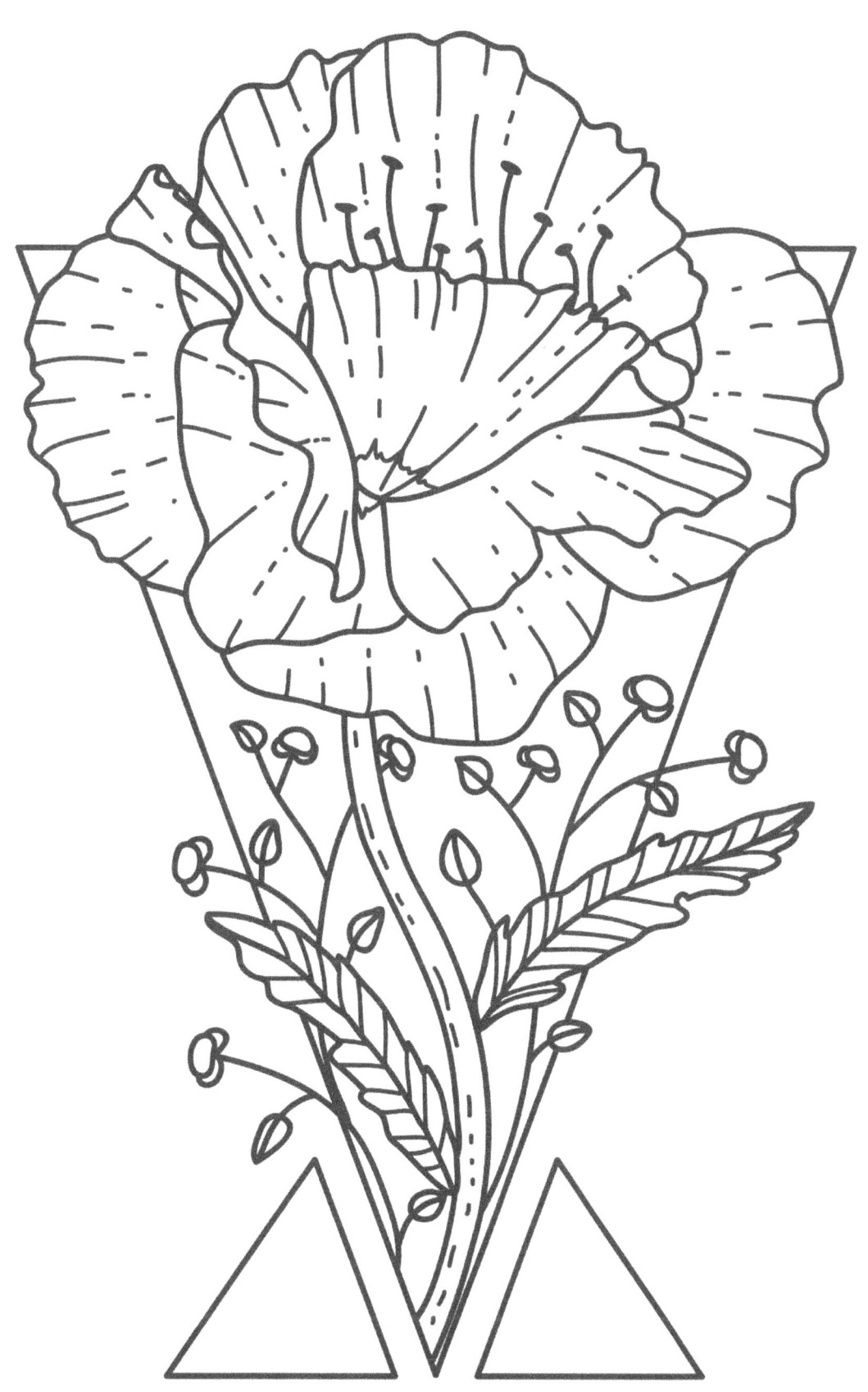

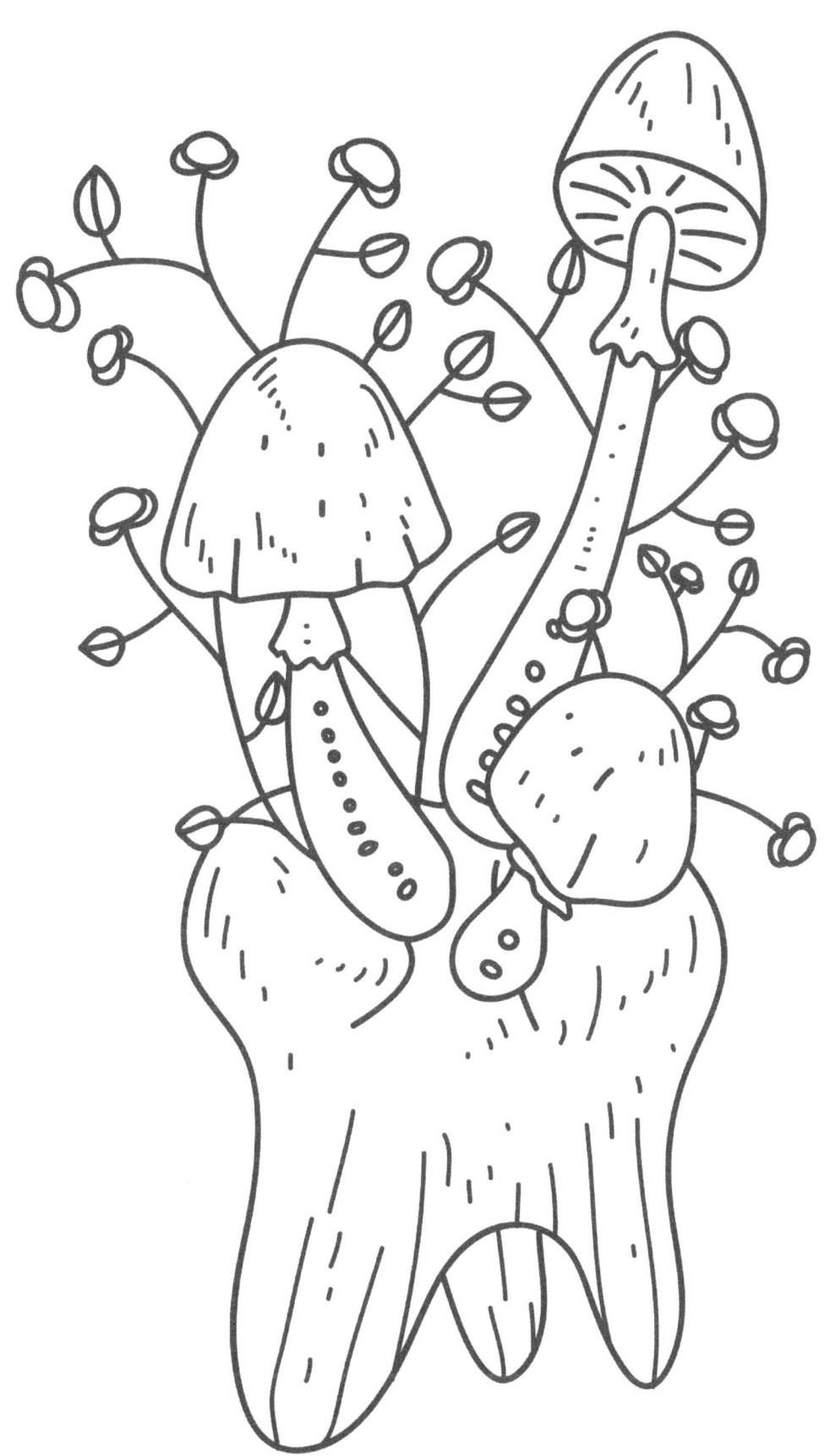

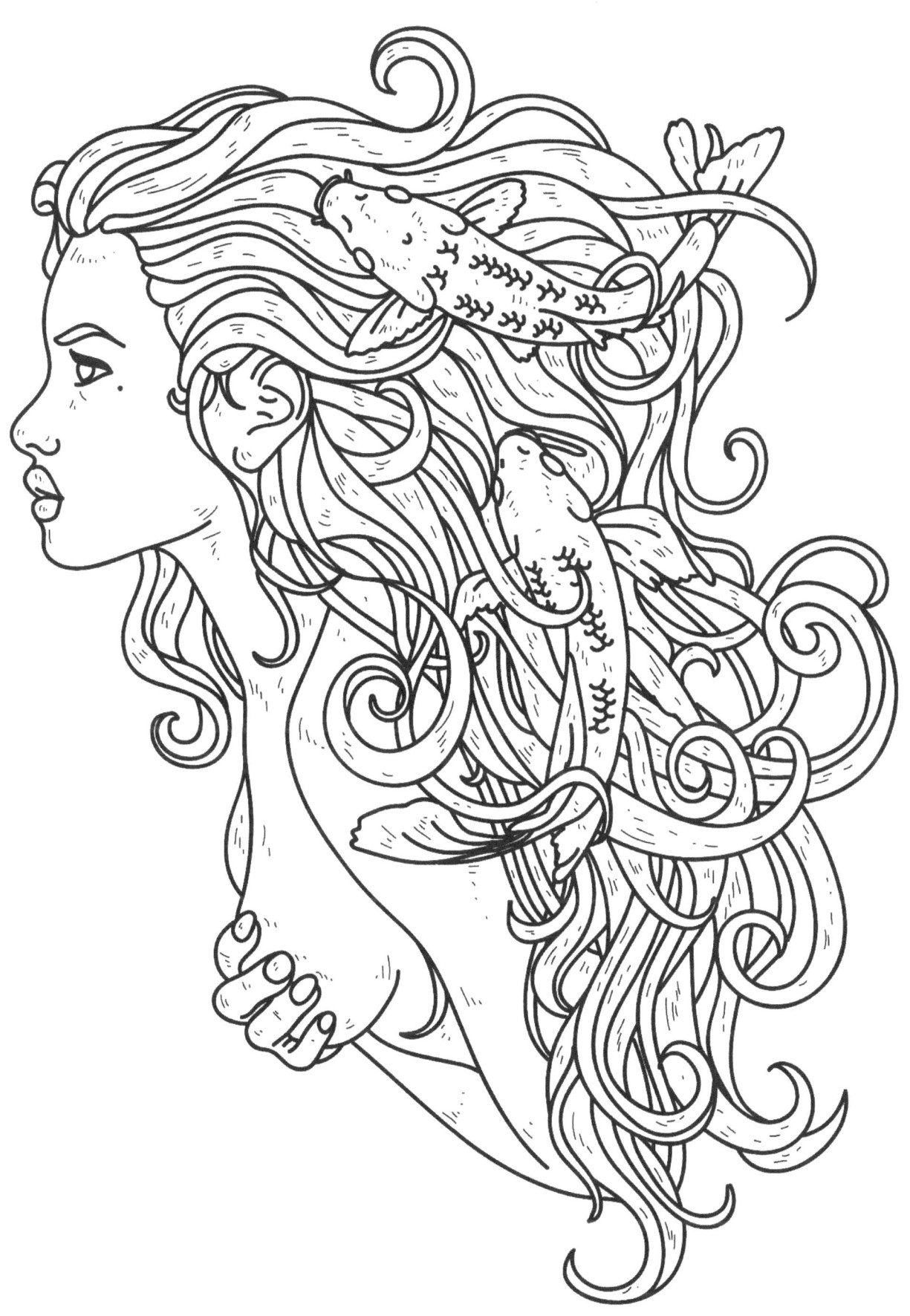

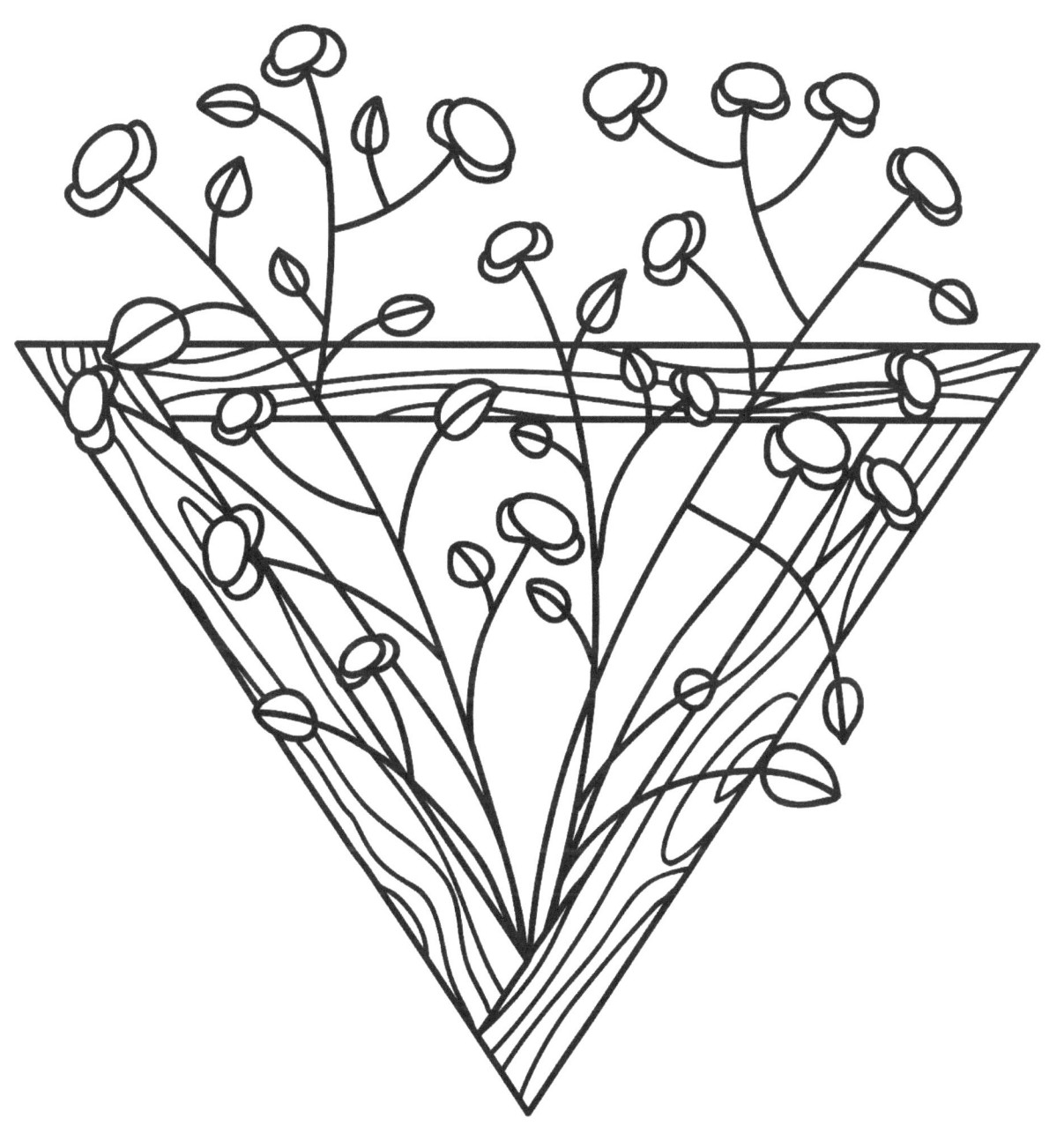

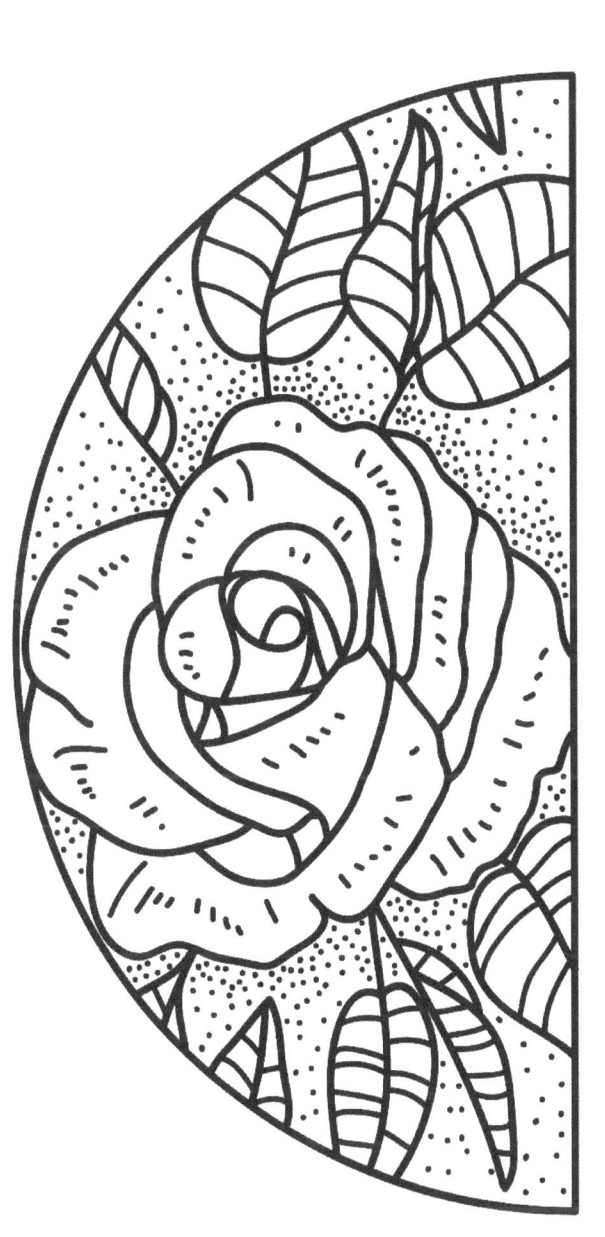
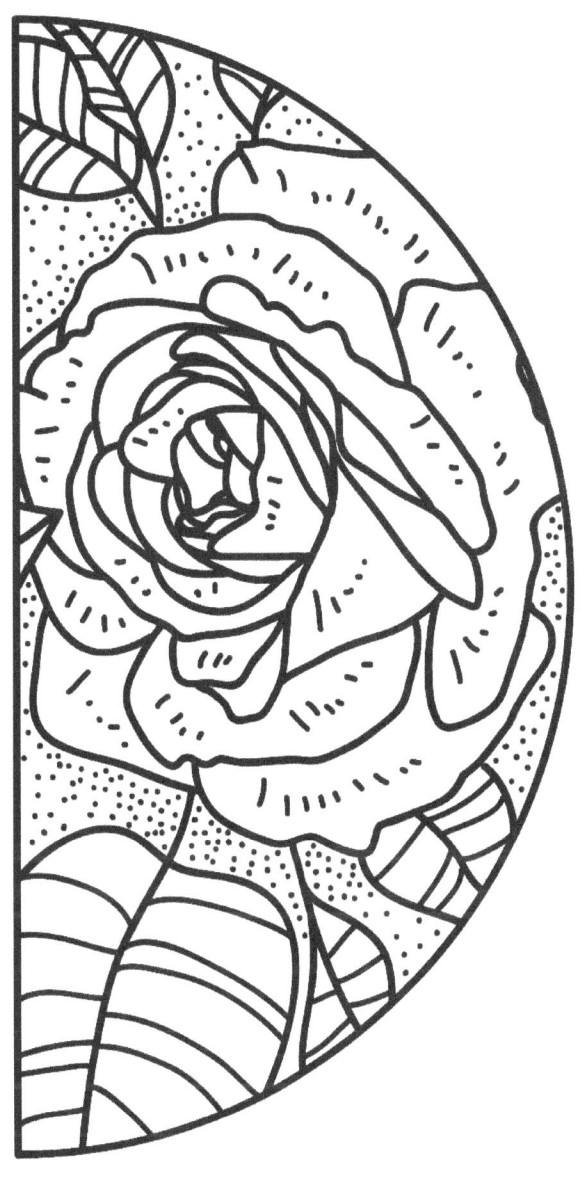

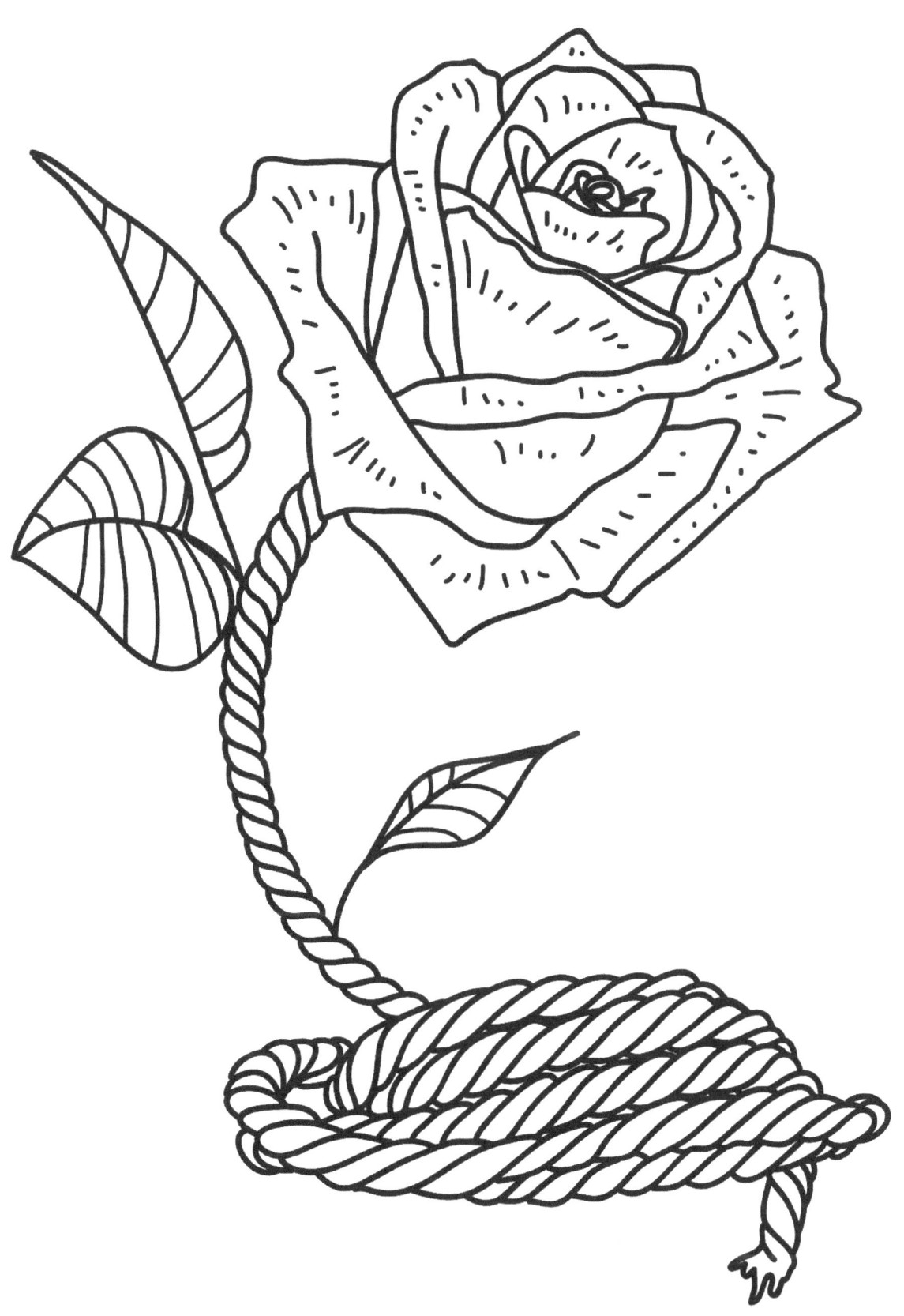

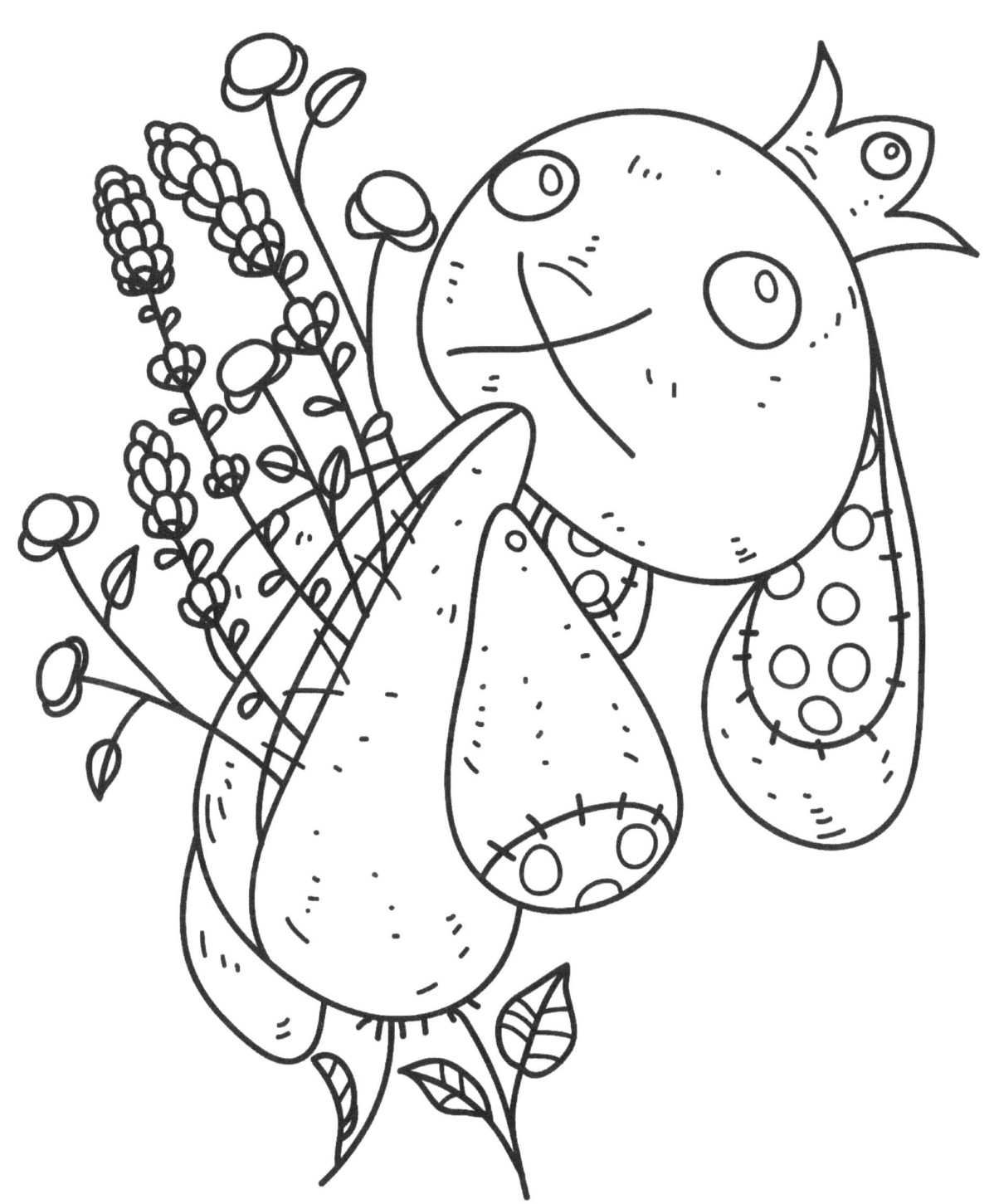

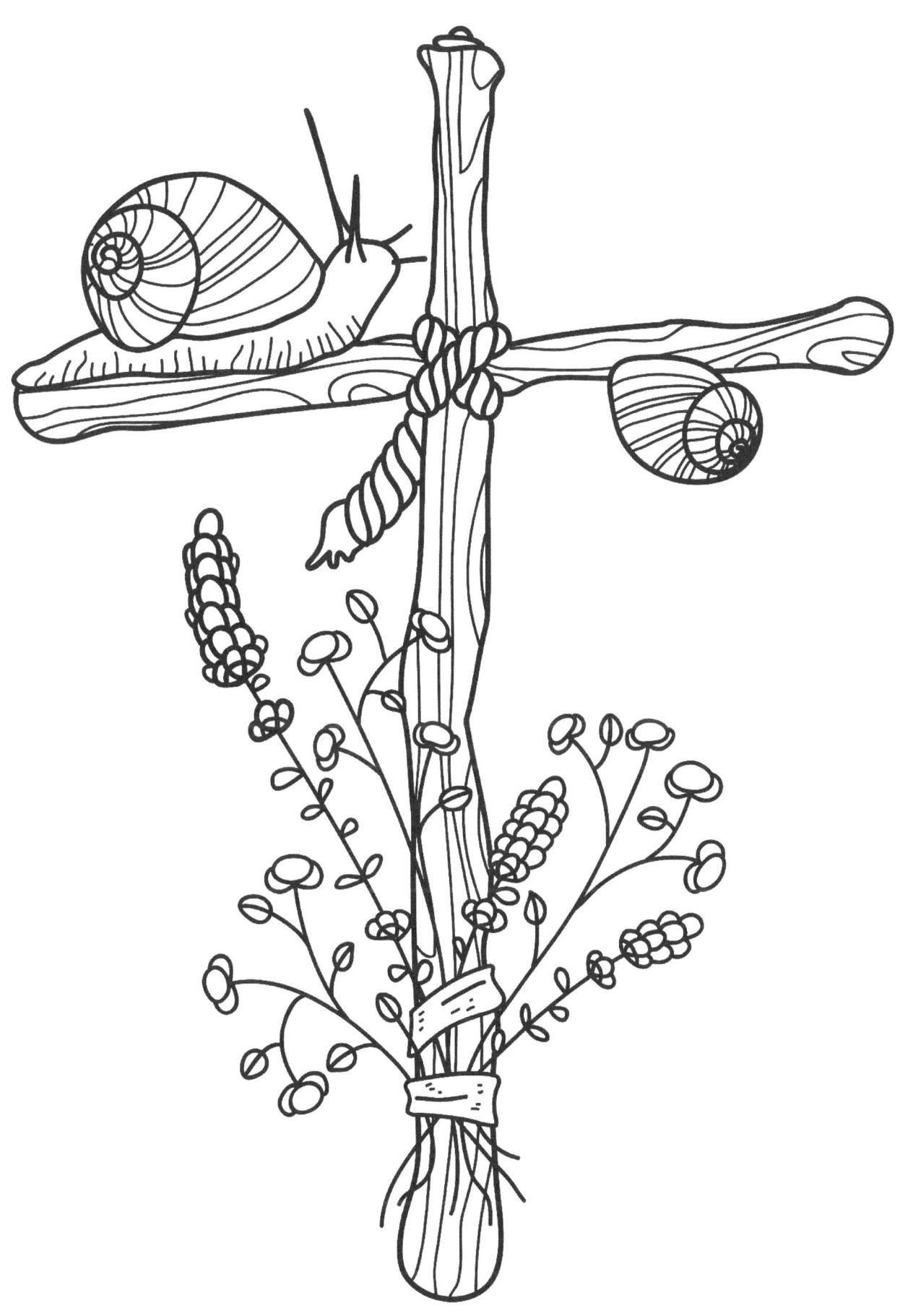

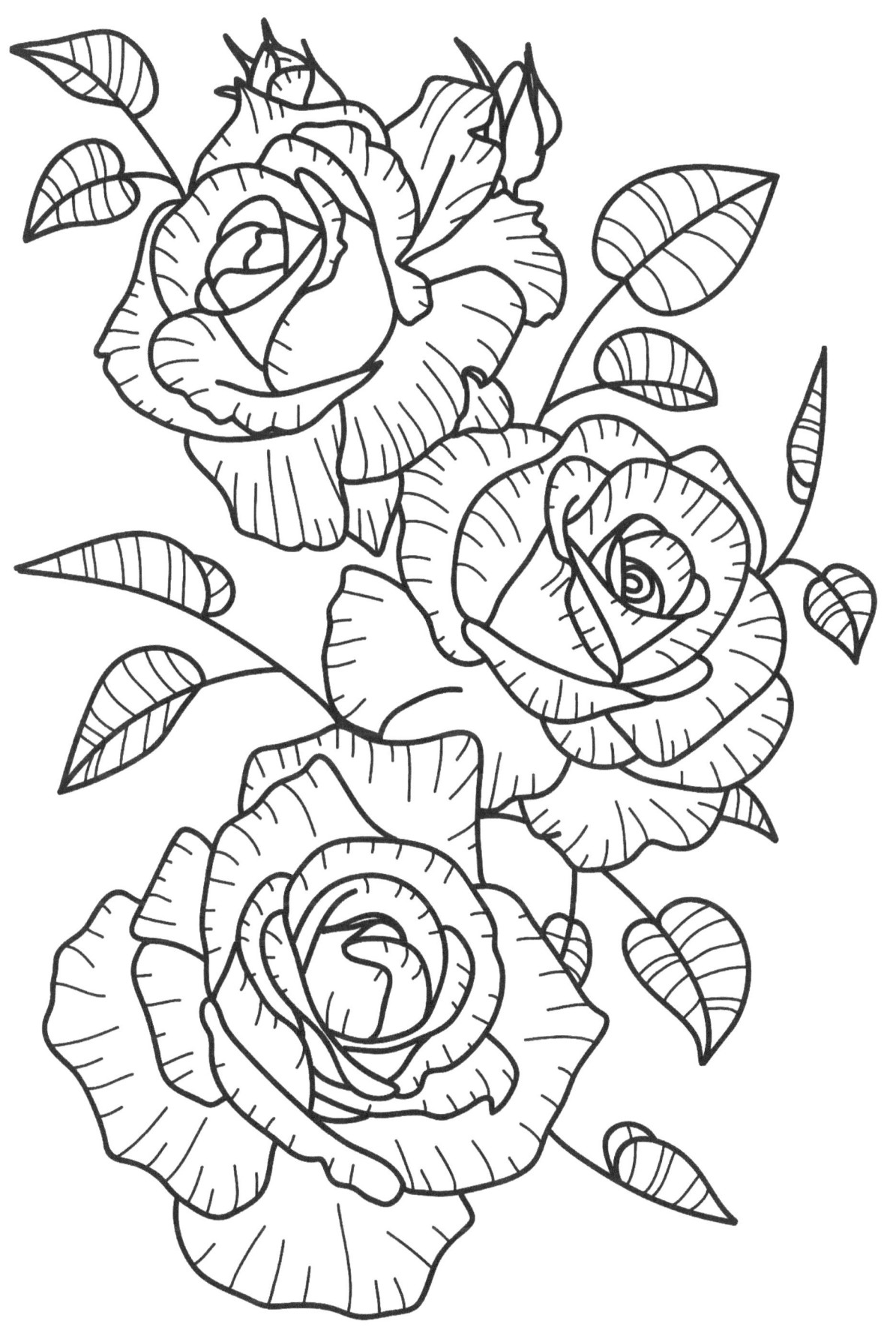

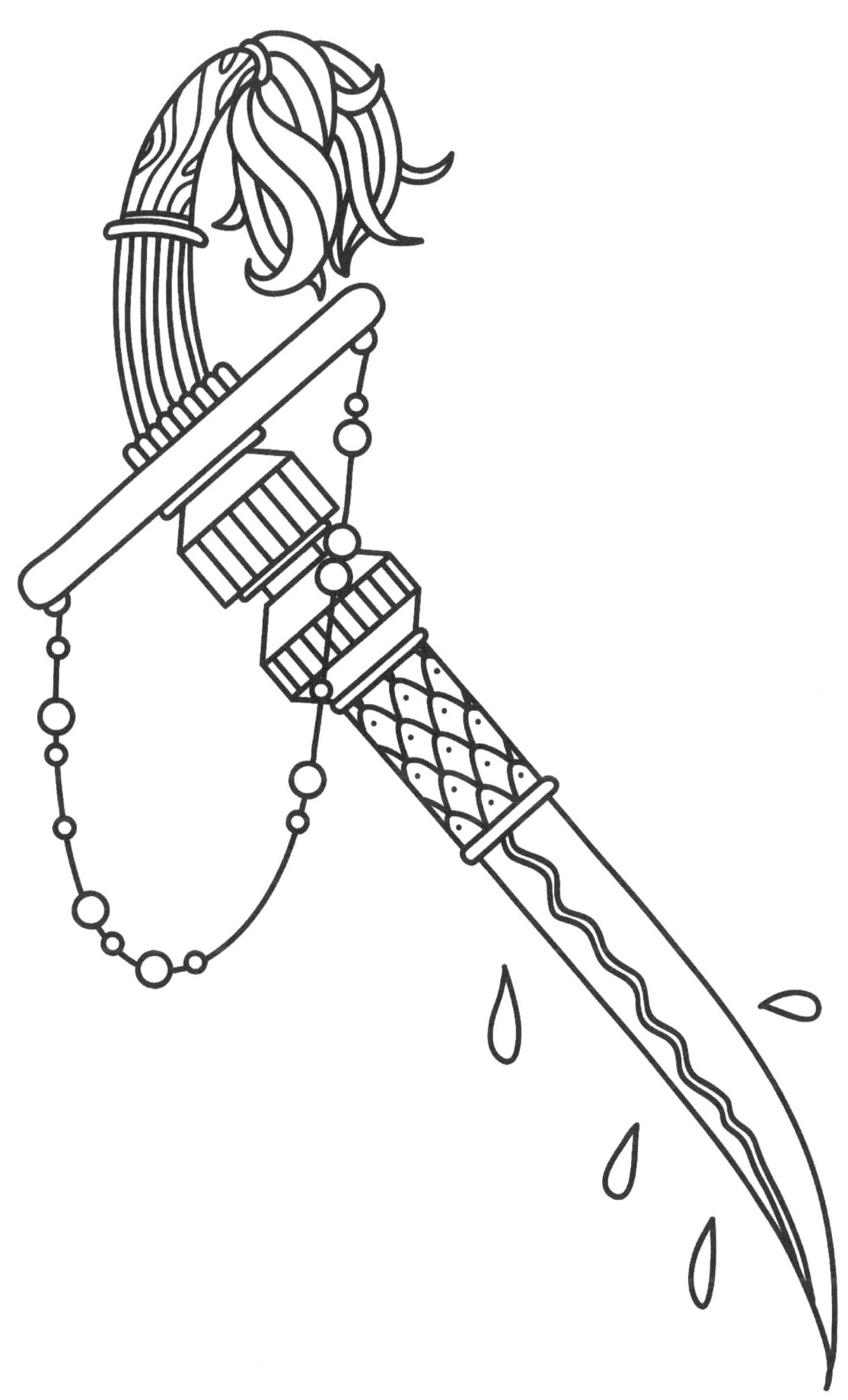

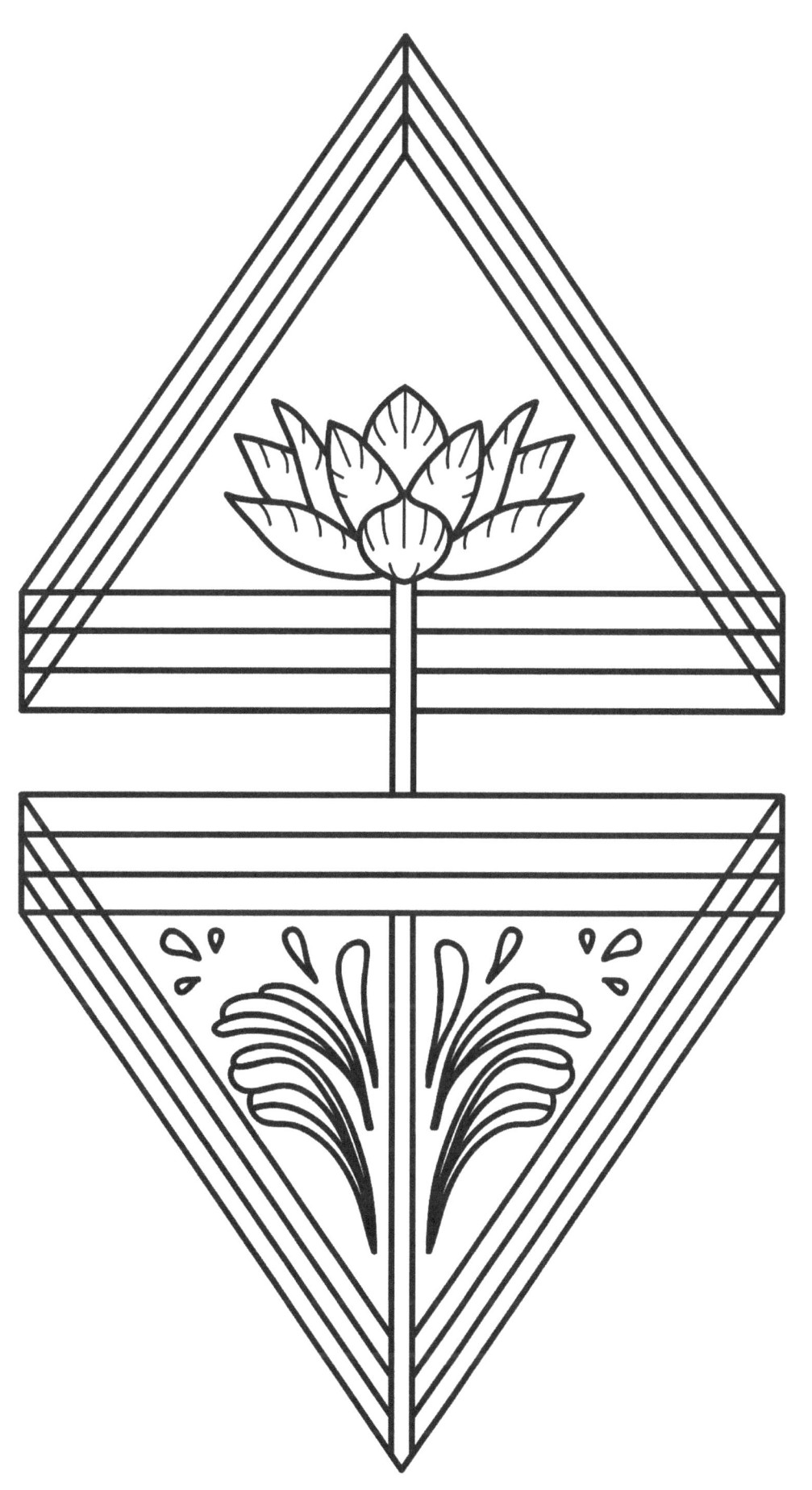

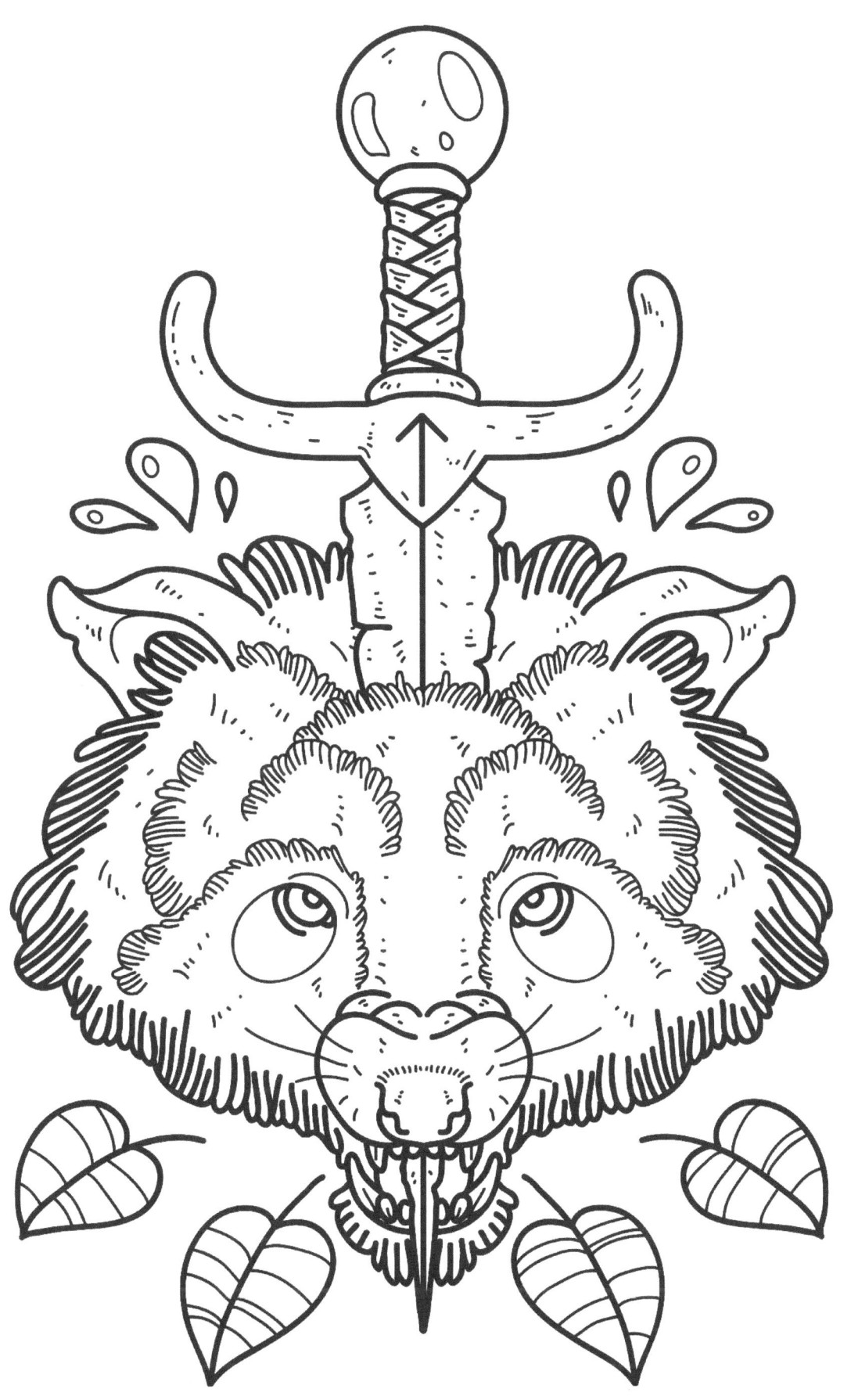

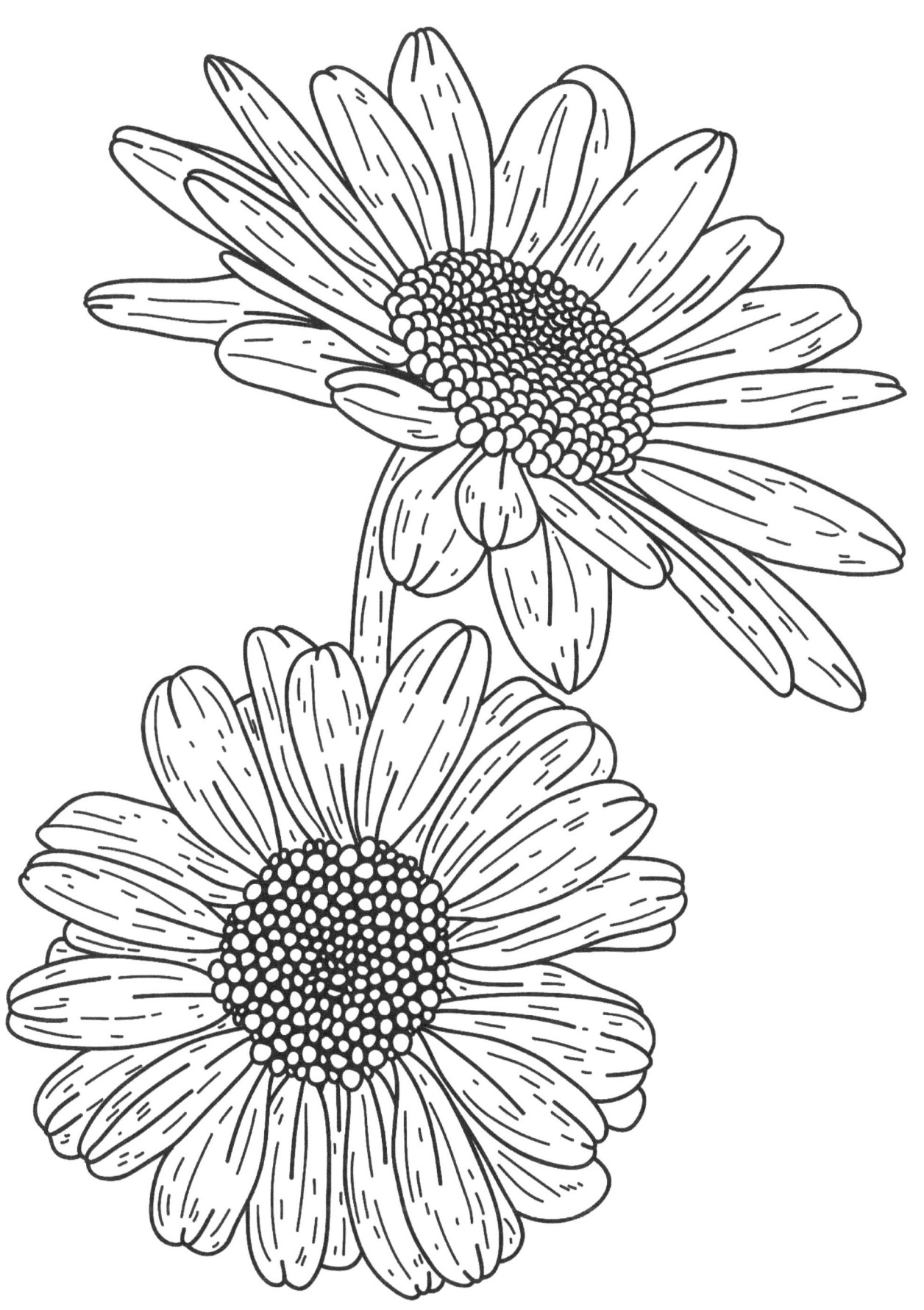

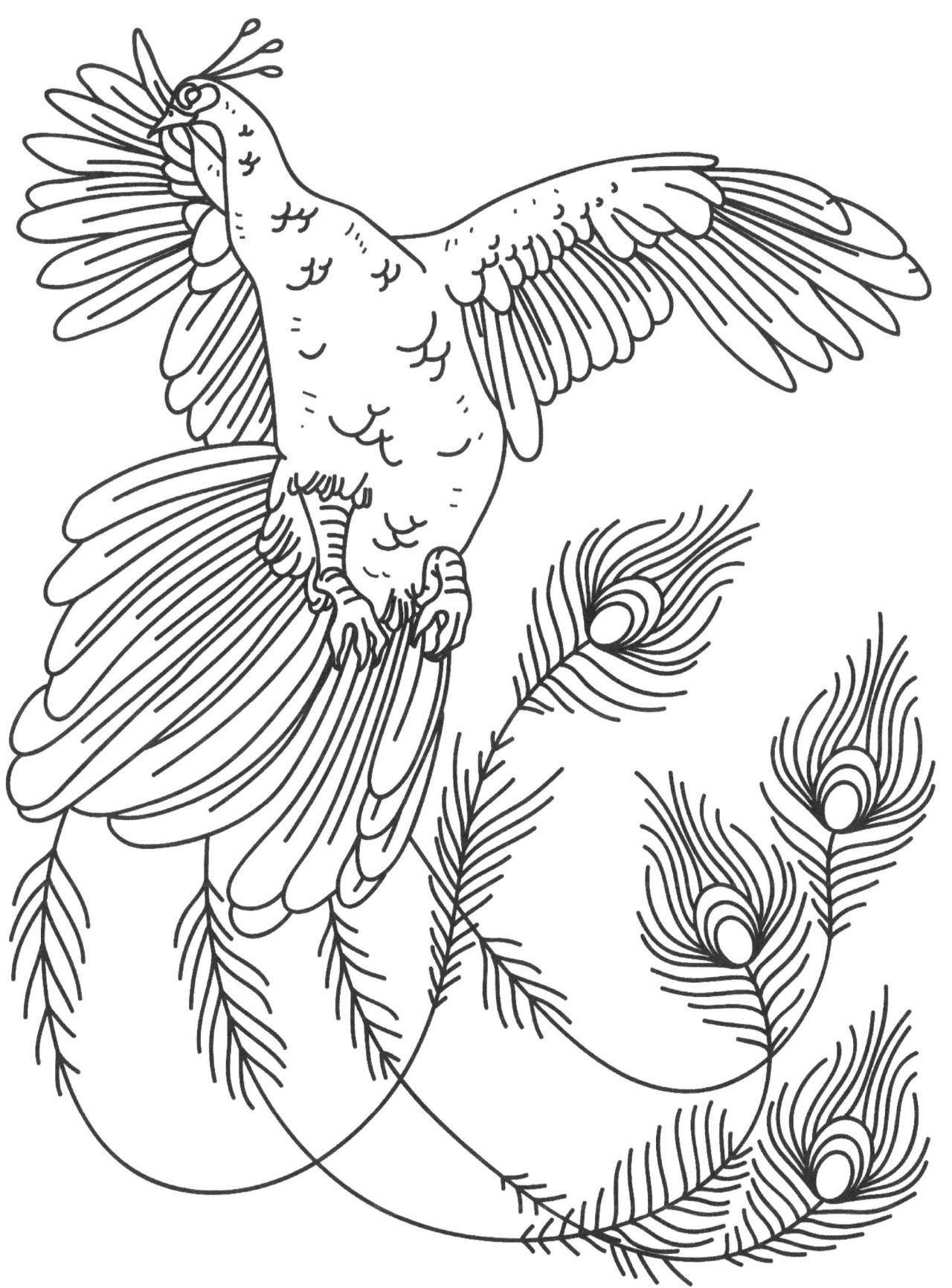

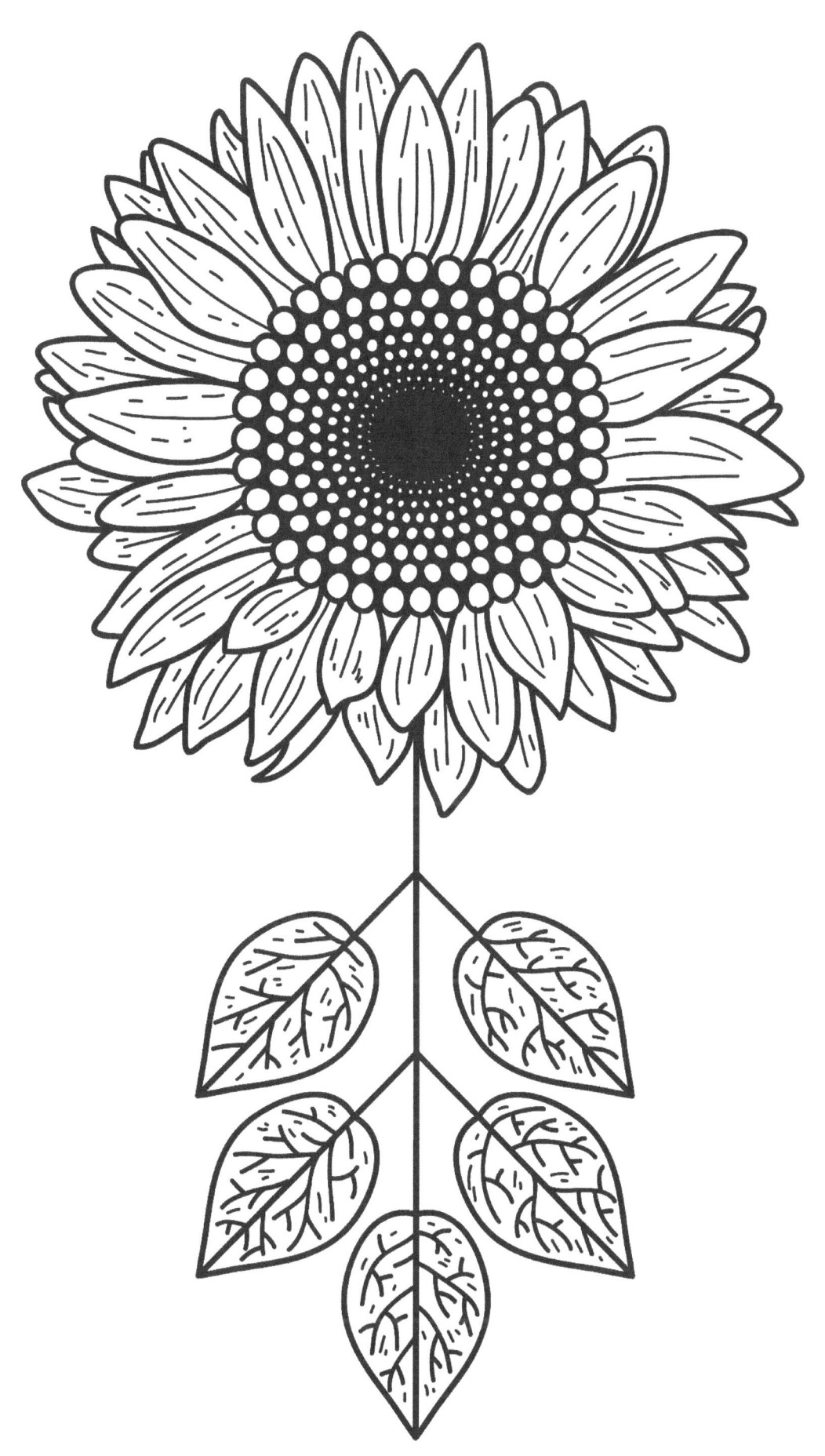

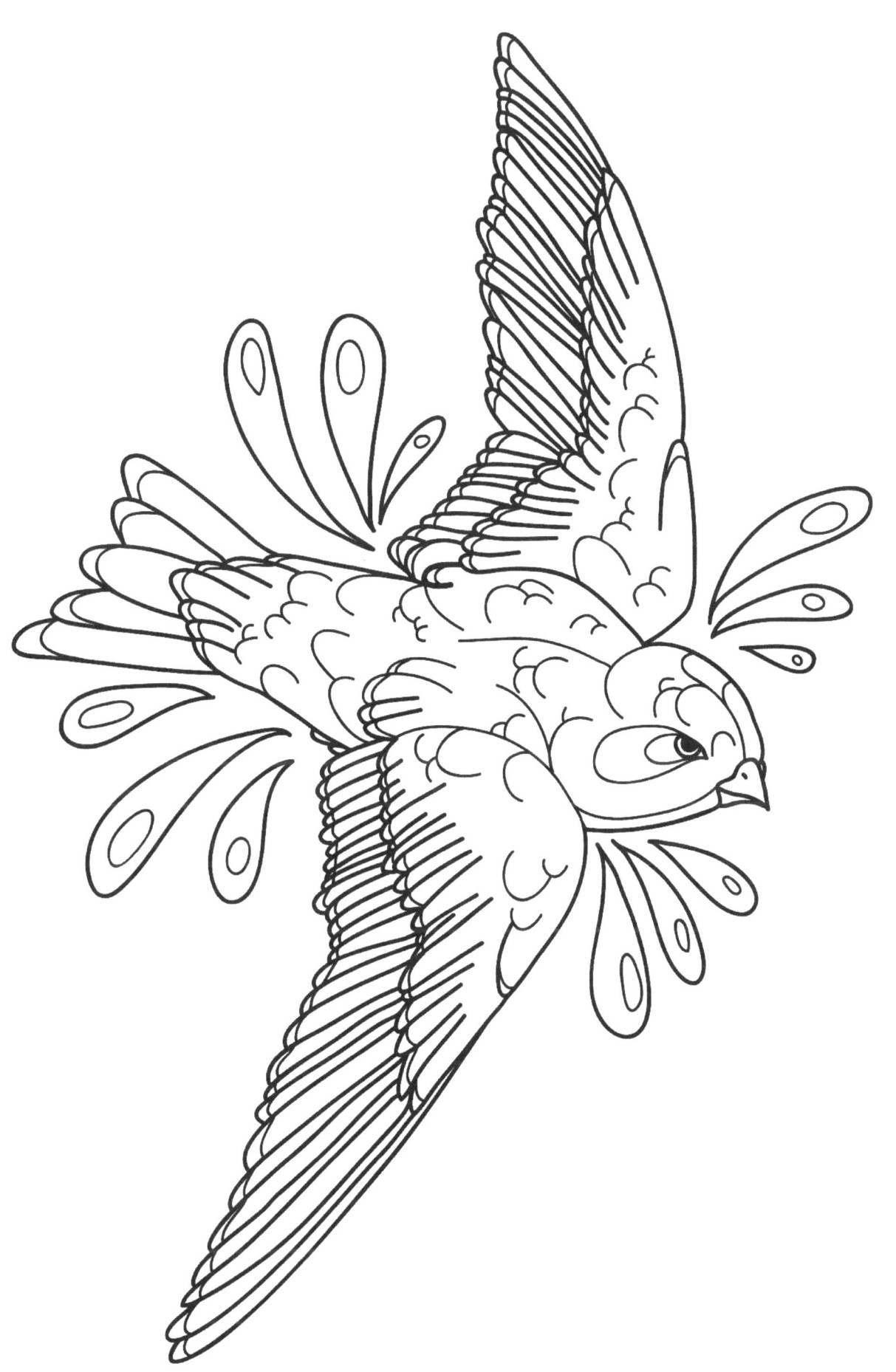

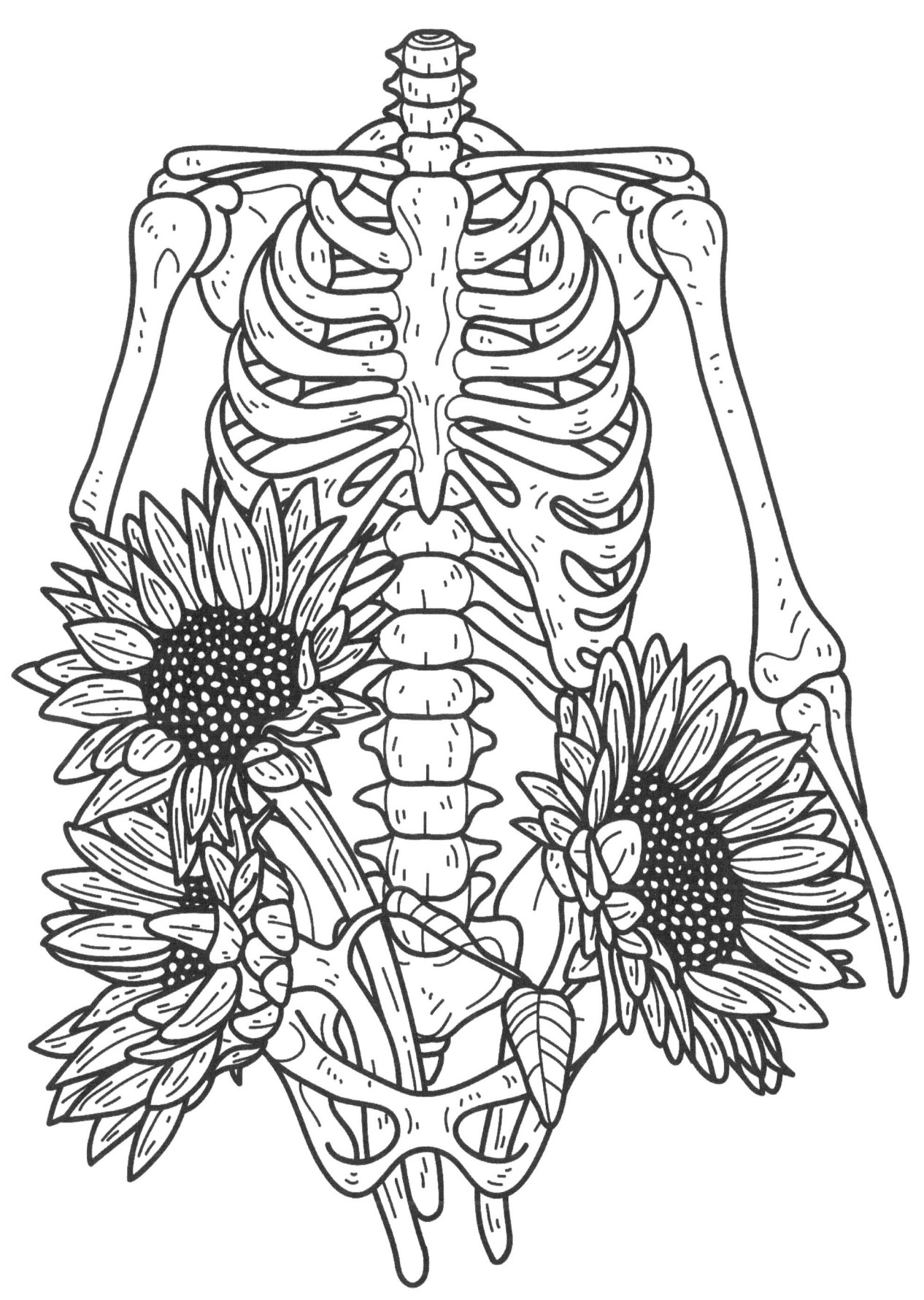

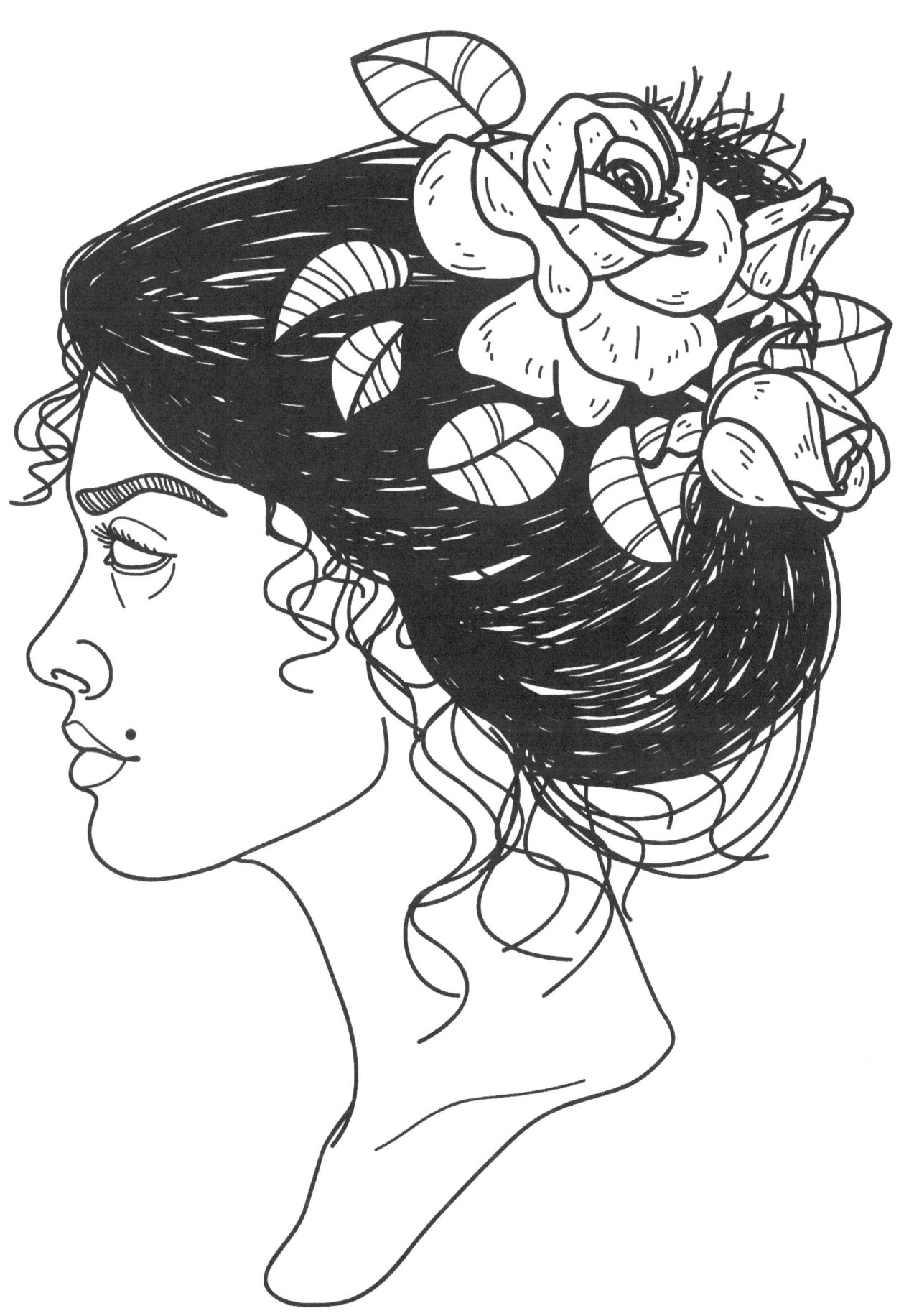

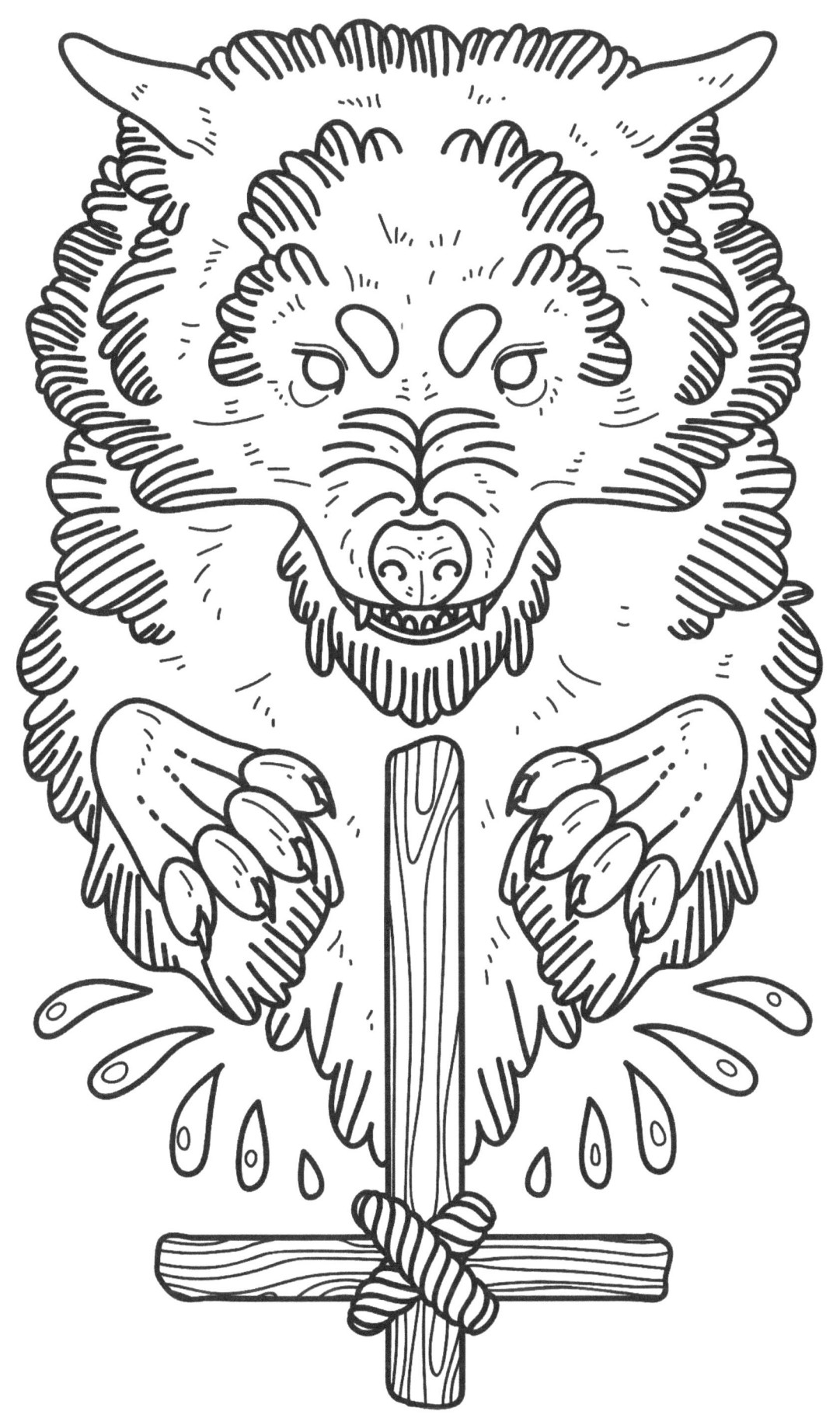

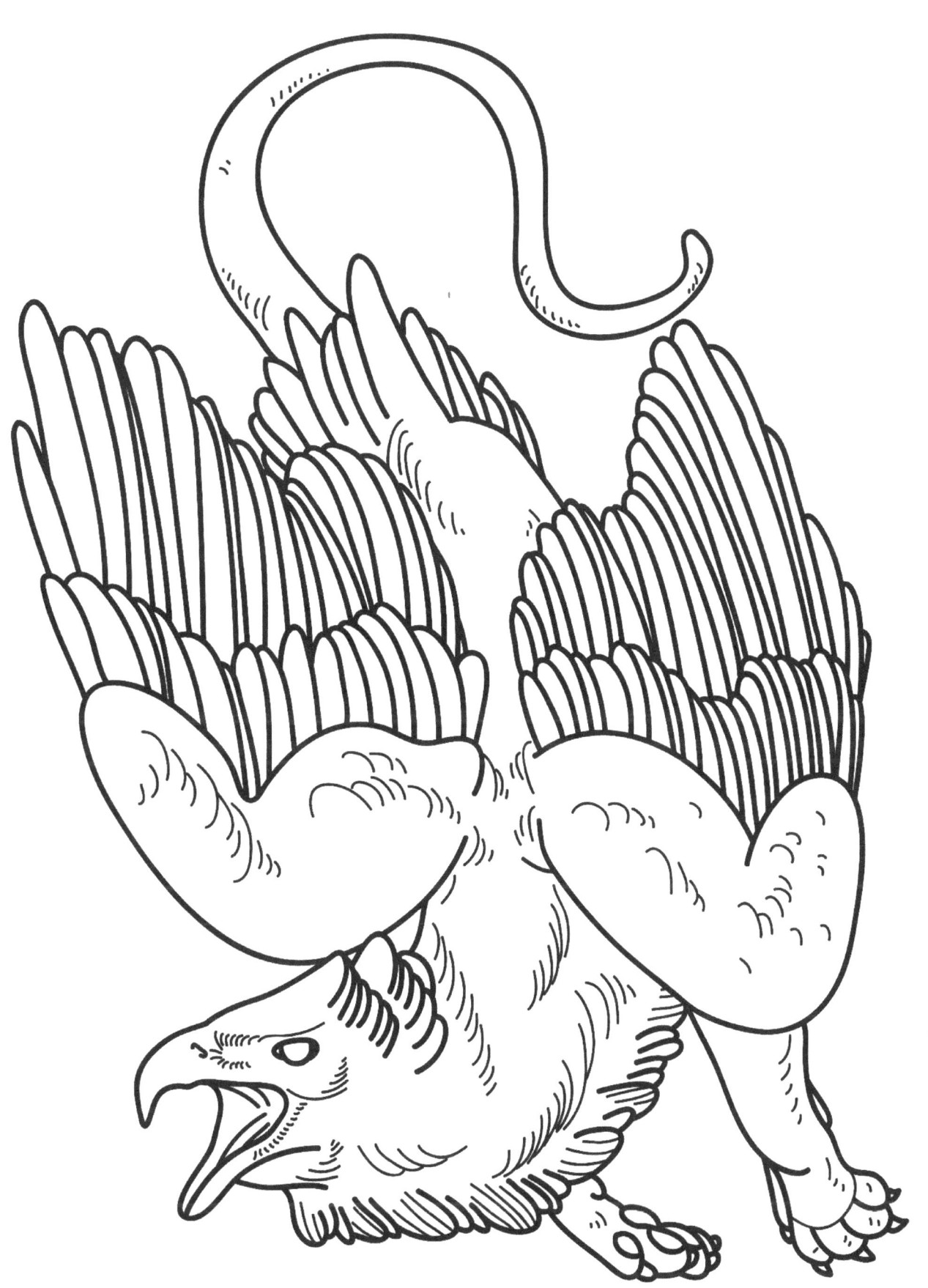

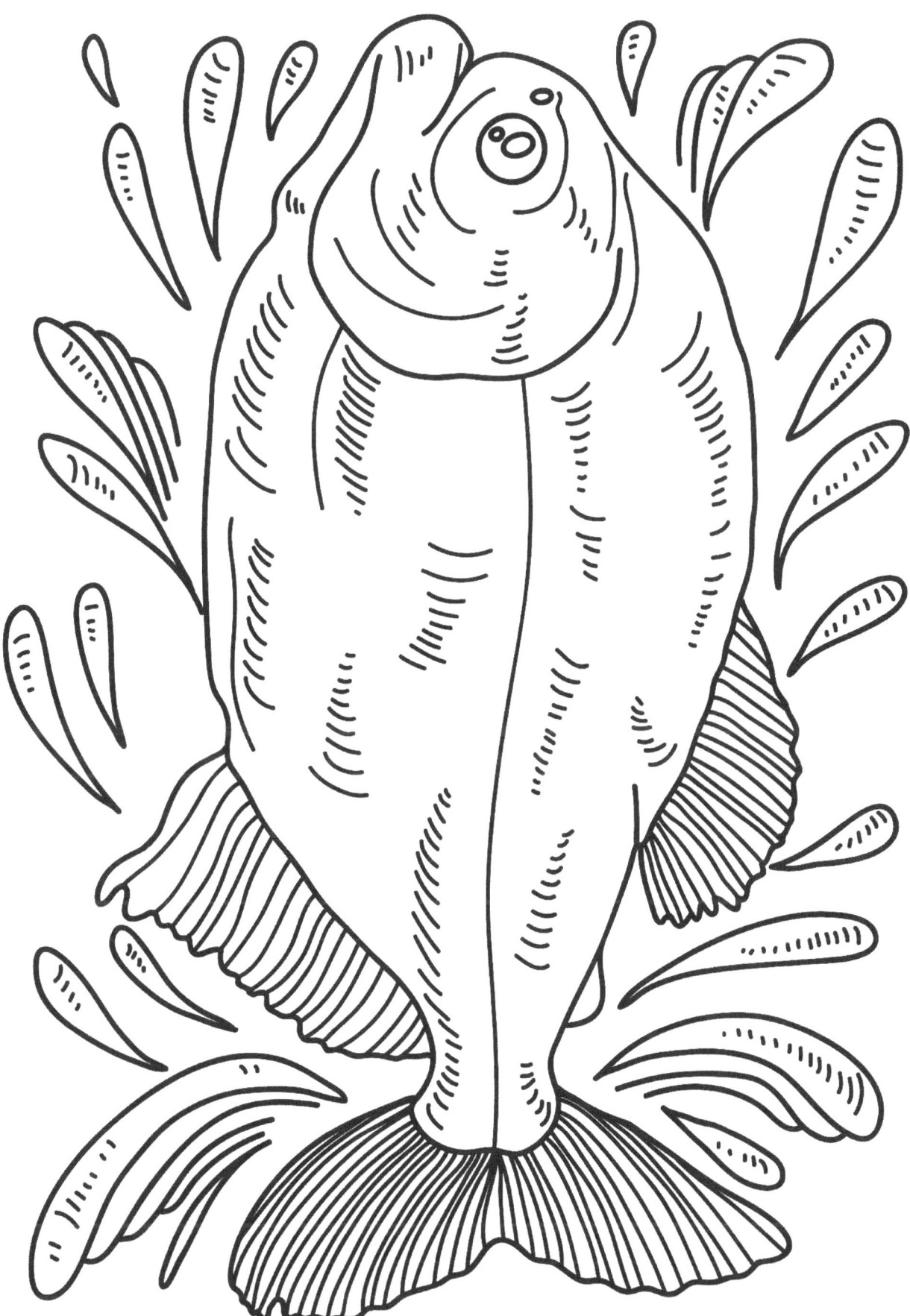

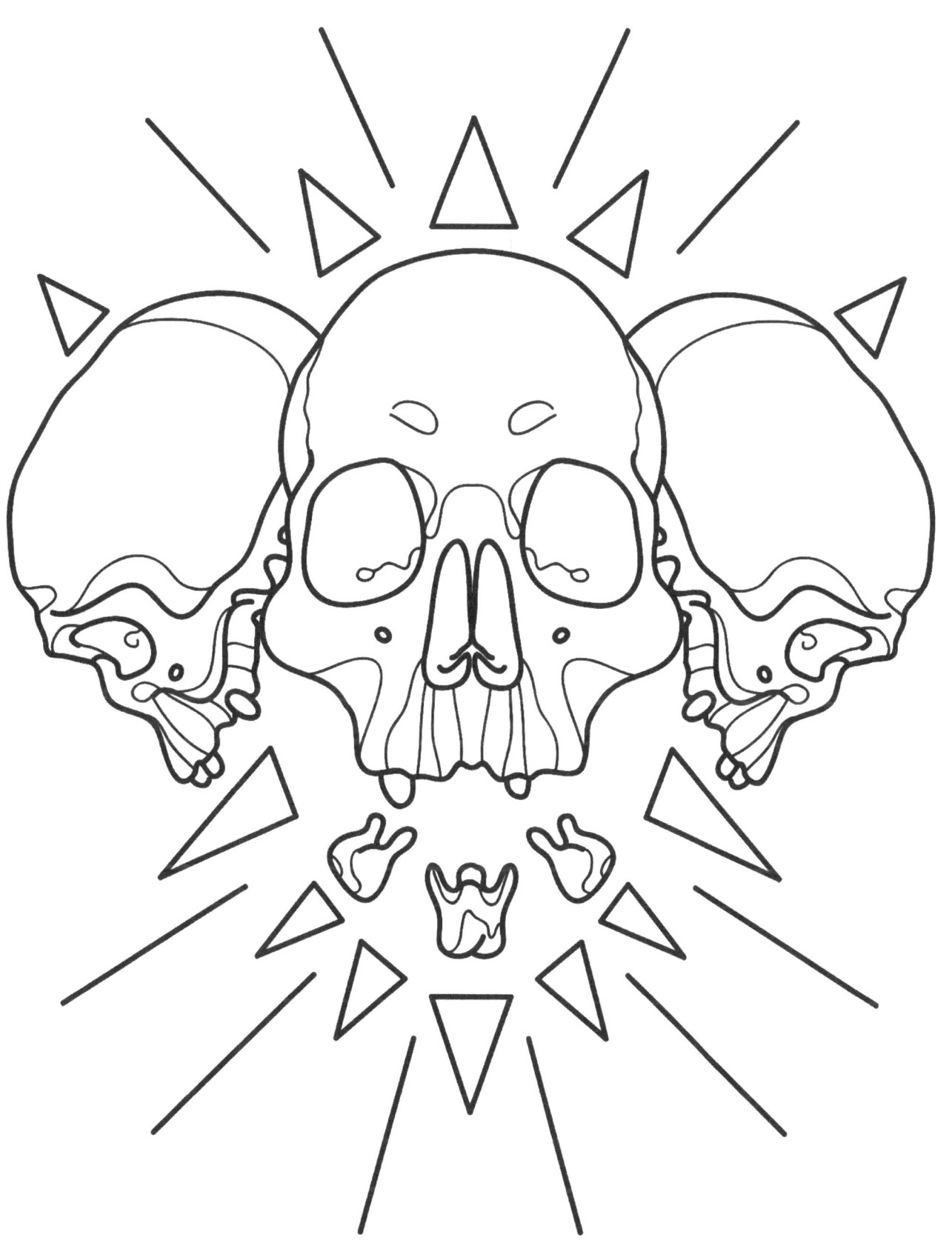

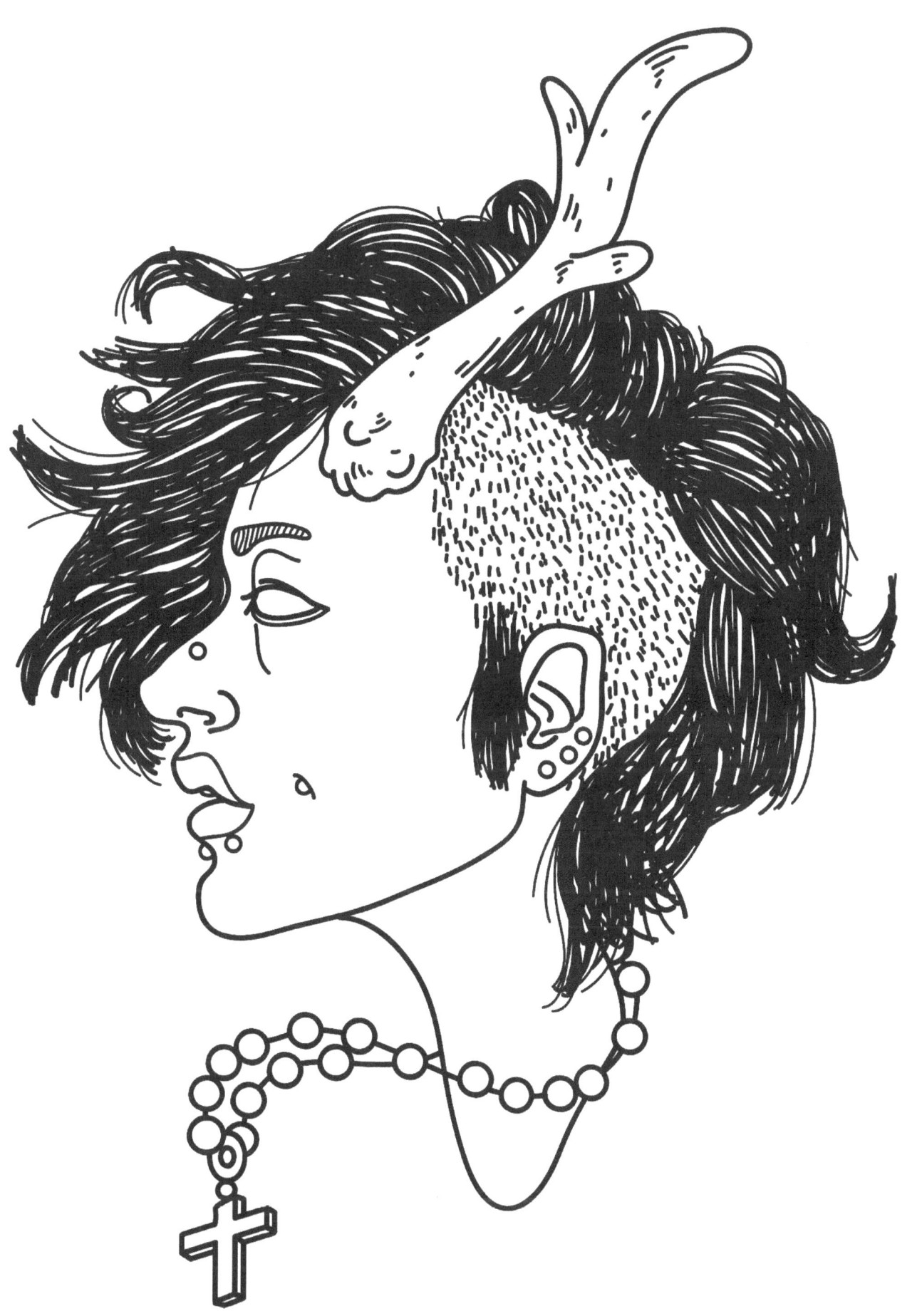

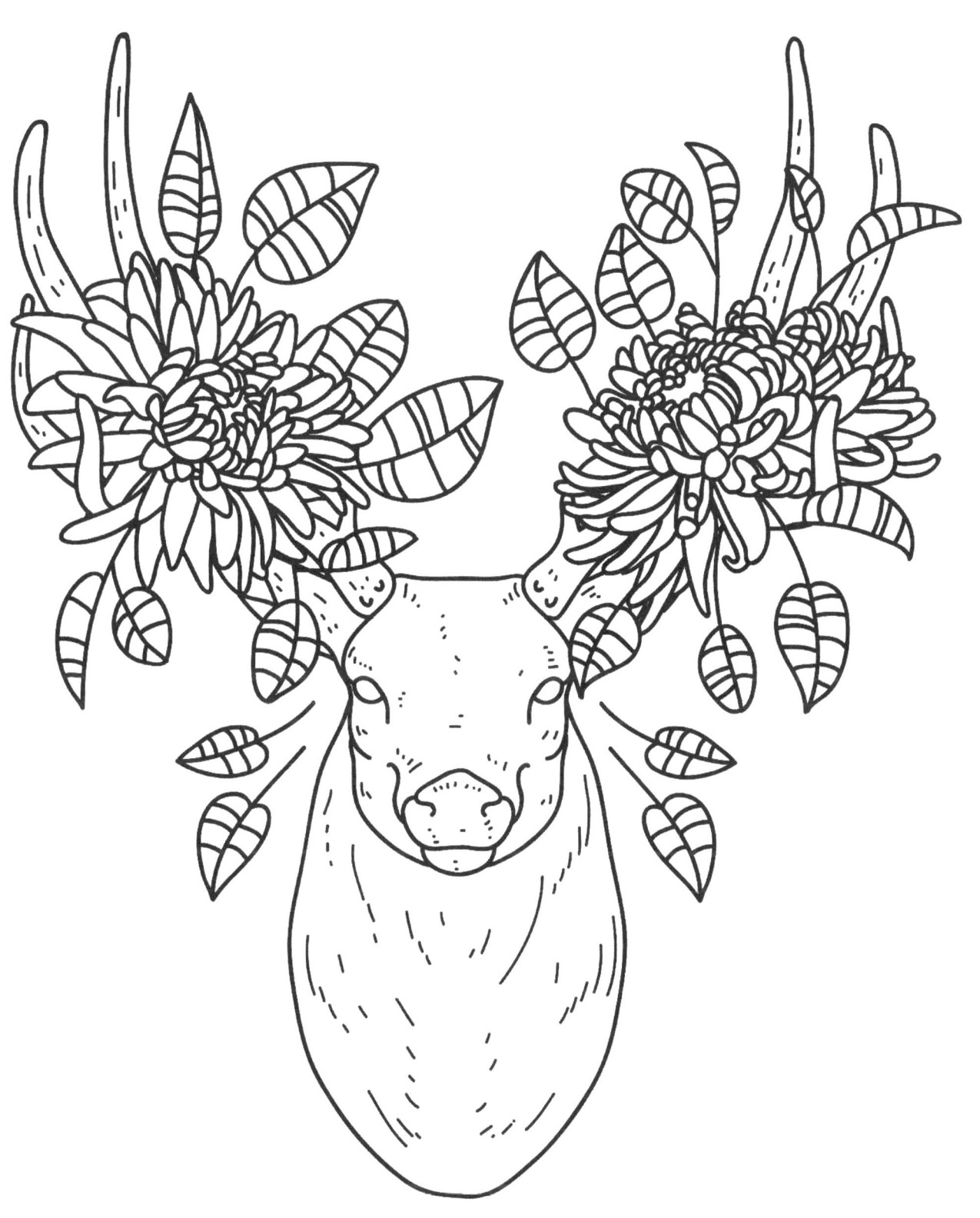